Moment of Action

D1603066

Moment of Action

Riddles of Cinematic Performance

MURRAY POMERANCE

Rutgers University Press | New Brunswick, New Jersey, and London

To Marilyn Campbell
il migliora fabbra
With so much gratitude!—M

Library of Congress Cataloging-in-Publication Data
Pomerance, Murray, 1946—Moment of action : riddles of cinematic performance /
Murray Pomerance.
pages cm
Includes bibliographical references and index.
ISBN 978–0–8135–6496–8 (hardcover : alk. paper)—ISBN 978–0–8135–6495–1 (pbk. : alk.
paper)—ISBN 978–0–8135–6497–5 (e-book (web pdf))—ISBN 978–0–8135–7517–9
(e-book (epub))
1. Motion picture acting. I. Title.
PN1995.9.A26P6537 2016
791.4302'8—dc23 2015032500

A British Cataloging-in-Publication record for this book is available from the British Library.

Copyright © 2016 by Murray Pomerance
All rights reserved
No part of this book may be reproduced or utilized in any form or by any means, electronic or
mechanical, or by any information storage and retrieval system, without written permission from the
publisher. Please contact Rutgers University Press, 106 Somerset Street, New Brunswick, NJ 08901.
The only exception to this prohibition is "fair use" as defined by U.S. copyright law.

Visit our website: http://rutgerspress.rutgers.edu

Manufactured in the United States of America

Give a man a mask and he'll tell you the truth.

—Ben Kingsley to Harrison Ford

He never wavered in his fundamental conviction that the smallest cell of observed reality offset the rest of the world.

—Theodor Adorno, about Walter Benjamin

Contents

Acknowledgments

Sincere thanks to Joan Allen (New York), Yoram Allon (Brighton), Eric Bana (Toronto), Robert Barker and Jill Schneider (Springs), Lisa Bode (Brisbane), Nadia Buick (Brisbane), the late Henry Bumstead (San Marino), Barbara Caffery, M.D. (Toronto), the late Herbert Coleman (Los Angeles), David Conley (Wellington), Joe Dante (Los Angeles), Doris Day (Carmel), Tom Dorey (Toronto), Melissa Dozois (Toronto), Victoria Duckett (Melbourne), David Ehrenstein (Los Angeles), Lucy Fischer (Pittsburgh), the late Dorothy Foster (Hamilton), Joseph Frankel (Toronto), Evans Evans Frankenheimer (Los Angeles), Krin Gabbard (New York), Steve Gaunson (Melbourne), the late Daniel Gélin (Paris), Elliott Gould (Los Angeles), Michael Hammond (Lymington), Matt Hauske (Chicago), the late Arthur Hiller (Los Angeles), Charles Hsuen (Halifax), Sarah Keller (Boston), Mark Kermode (Southampton), David Kerr (Toronto), Bill Krohn (Los Angeles), Gillian Leslie (Edinburgh), Norman Lloyd (Brentwood), Adrian Martin (Vilassar de Mar), Kathryn McCormack (Toronto), Joe McElhaney (New York), Jonathan Miller (Toronto), Drew O'Hara (Toronto), Christopher Olsen (Orange County), Polo Ornelas (Culver City), R. Barton Palmer (Atlanta), Victor F. Perkins (Coventry), Lisa Purse (Reading), Simon Rainville (Toronto), Hugh Ritchie (Toronto), William Rothman (Miami), Steven Rybin (Atlanta), Daniel Sacco (Toronto), Will Scheibel (Bloomington), Perry Schneiderman (Toronto), Campbell Scott (Toronto), Vivian Sobchack (Los Angeles), Jonathan Soja (Toronto), James Spader (Toronto), Owen Stahn (Toronto), Lesley Stern (San Diego), George Toles (Winnipeg), Nick White (Toronto), Evan Williams (Los Angeles), and Linda Ruth Williams (Southampton).

I am also grateful to Barbara Hall, Linda Harris Mehr, Jenny Romero, and the hard-working staff of the Margaret Herrick Library, Academy of Motion Picture Arts and Sciences, Beverly Hills.

One of the great pleasures of my experience has been working with the staff of Rutgers University Press. Leslie Mitchner, Marilyn Campbell, and Anne Hegeman shared warmth, kindness, and sensitivity in a most helpful way.

And to Ariel Pomerance and Nellie Perret, my undying gratitude for wisdom, patience, insight, and love backstage.

Moment of Action

Preamble: Saw the Air

The first beings I saw onscreen were gargantuan, glimmering, happy (or at least striving for happiness), and unspeakably beautiful. If they vaguely resembled people I knew, their proportion as giants, the smoothness and harmony of their movements, speech, and song, the brave colorations and shapes of their garments, the exoticism of the spaces in which they moved—it all made them inhuman, unreal, phantasmal. Only sometime later did screen performances begin to show me the abysms of life: the kinds of performances that, when the movie was done and I emerged onto the sidewalk, I might find replicated on the street.

I came of age with cinema in the magical time before *Psycho* (1960). For this film, fearing that patrons arriving late for screenings would fail to see onscreen the internationally celebrated star whose name had been the principal box-office allure, Janet Leigh, because in an act of modernist daring he had killed her off early in the film, Alfred Hitchcock struck a contract with distributors stating that no person could be admitted to the theater after the film began. This was the beginning of the age of scheduled motion pictures. But I learned to see movies at a time when one entered the theater absolutely at will, sitting down quietly, watching from whatever scene was onscreen at the moment all through to the end, then waiting through the intermission, then seeing cartoons and newsreels and trailers and the film itself from the beginning, leaving at the point where one had

come in. Obsession with a film as a coherent single entity, with a film story as the central content of the "film package," as it were, was unknown to me. Typically, one went "to the movies," not to see a particular film as such. It was the world of cinema—the darkened arena, the smell of popcorn, the vibrant images, for me often the spectacular Technicolor—one craved to enter. Another world.

Magnet of the Screen

The experience of watching screen performance involves a confrontation with, and denial of, knowledge. In watching, we eventually come to *know* that these characters aren't really there, not in the sense that we are, watching them. But we set aside that knowledge, displace it, in order to open ourselves to experience. Experience, not delusion. This is more than the oft-cited "suspension of disbelief." It is a willing, even heroic entry to a hitherto unknown and unanticipated world, a giving of the self over to wholehearted (if brief) belief, a surrender. In my own considerations of acting I have found myself transported to what I believe to be philosophical climes, the sorts of context that inspire profound thought. But what is the source of this strange reality in which we can live and breathe with sensation and reflection? How is our experience of it layered and secreted within itself? What is being done by performers to open for us, eager but dependent as we are, the gates of cinematic experience?

Imagine or call back with me Natalie Wood's Judy trapped in Ray Fremick's (William Platt) therapeutic interrogation in the police department, at the beginning of *Rebel Without a Cause* (1955). Her body seems imprisoned in a chair, but her spirit is only infrequently inhabiting that body. We come to meet the real Judy as we discover her too-red lips, positioned too clashingly against her too-red overcoat, and then we learn from those lips themselves that they reside at the center of her personal trauma with her father. Now the vivid redness vanishes to be replaced by a vision we cannot prevent ourselves from having—notwithstanding that Nicholas Ray does not have a way of presenting it onscreen—of her trembling, insecure, desperately hungry, and fragile innermost self supplanting the lithe body of the teenaged girl. In this moment we are watching Wood's remarkable vocal control as she builds to tears, and her poise, the grace of her expression, her very musical sense of timing as she inserts pauses. In the architecture of

the film this scene is crucial. If she drops into mere stereotypy, we quickly cease to care about her; later we will neglect to care about the kids she cares about. But if in this powerful moment we can be brought to believe in, and side with, Judy we can believe in all the other characters who relate to her, and the story gains dimensionality and realism and pathos.

Natalie Wood was fifteen years old when she shot this scene. Her youthfulness, her capacious feeling, her tears—all these are more or less natural. But the control of the voice is something she knew how to work on and work out. The control of the voice, and the control of the gaze. We fear the advent of, yet find ourselves waiting for, every incoherent syllable. But cinema is all a matter of anticipating advents and waiting, waiting, grasping, then watching the traces float away, so Wood is embodying the art form in which she appears, as she appears.

There is no single reason why acting galvanizes viewers. The actor manages to express what under ordinary circumstances people hold back. She cuts the binding ribbon of social control: think of how Garbo exhibited a stunning ferocity and purity of expression, a distillation of language, that non-actors do not strive to manage. The actor amazes as an object upon which to cast the gaze, beautiful or monstrous but in any event worth keeping in sight: Orson Welles, Conrad Veidt, Bette Davis, Grace Kelly, Claire Danes, Julianne Moore, Eddie Redmayne. Actors are given the opportunity to play out scenarios the rest of us can only dream, so that in watching performance we set out on a voyage of discovery: Welles as Charles Foster Kane, richest man in America; Veidt as the man who laughs (and can only laugh); Kelly as the svelte socialite Lisa Carol Fremont; Danes as hapless Juliet; Moore as a dementia victim; Redmayne as a physically impaired theorist in physics. Actors typify predominant social types of an era and thus speak both to and of their times. They are iconic: Louis Calhern as the crooked lawyer in *The Asphalt Jungle*, Gene Tierney as the shy girlfriend in *Night and the City* (both 1950). Actors bring to life, and thus let us meet, the great characters whom writing has brought forward: Romeo, Camille, Tom Ripley, Dr. Jekyll, Dorothy Gale lost in Kansas. Actors lift our spirits with their ebullience: Carole Lombard as Irene Bullock in *My Man Godfrey* (1936). Actors shock our sensibilities with their raw truth and their apparent ability to go to the heart of things: Paul Newman in the title role of Hud (1963), Laurence Olivier as Archie Rice in *The Entertainer* (1960), Angela Lansbury as Eleanor Shaw Iselin in *The Manchurian Candidate* (1962). Actors reveal the subtle depth

of the human heart: John Barrymore on his knees in *A Bill of Divorcement* (1932). Even when, as Hamlet warned, actors "saw the air" too much, still we find the air exhilarating when they saw it.

Yet the contemplation of cinematic performance doesn't require measurement, certainly not the sort that floods lay conversations and publicity constructions, leading us to consider "terrific," "wonderful," "superior," or "bad" acting. Our confrontation with performance is, at bottom, a ceremonial of celebration, not a provocation to assaying and evaluation; the acting comes before criticism, fandom, and judgmentalism. Thus, as I hope I will not disappoint readers by confessing, this book pays relatively little attention to the problem of whether to call any bit of acting "good." To start with, not knowing the personality of the actor it is virtually impossible to discern the boundaries of the performance with accuracy. How much of the facework is pure biology, how much of the posture and rhythm pure personality? Then arises the question of how a performance can stun us one day, leave us cold another. We are also confronted with the tendency to see comparatively, so that when standing against what appears very bright other behavior might appear too dim (and, as I discuss below, brightness is often a function out of the performer's control). Nor are audiences almost ever in the know about the exigencies under which an actor commits his work: with Vincente Minnelli's *The Band Wagon* (1953), for but one example, the English actor, singer, and dancer Jack Buchanan pranced and danced, belted out his songs, and generally gave off a sheen of genial polish, all while working a very long way from home with a serious dental problem he was not able at the time to get fixed; here, the stakes alone made for an accomplishment much superior to what could have appeared to audiences. Another problem is the rank unprofessionalism of we who watch, generally touting one performance over another without really understanding the challenges being met and the level of skill involved. Actors I know have very often raved about performances I didn't notice, and shown me how some acting that appears exceptional is in fact a routine address to elementary problems of staging and presentation.

For all these reasons and more, it is not by way of offering evaluations of quality that I write here; it is our response to the performed moment, its ability to mobilize our attention in particular ways, and the challenges underlying that mobilization, that fascinate me. I pick up with performance the much broader critical task I began with *The Horse Who Drank the Sky: Film Experience Beyond Narrative and Theory* and continued with

The Eyes Have It: Cinema and the Reality Effect. It is not acting in general that I work to approach here: acting as a business, with its economic infrastructure and its internal logics of appearance management and career sustenance; acting as a universal package of techniques, including athleticism, elocution, the control of physique; acting as occupational investment, including the biography of the performer as his wellspring and mainstay. All these are no doubt vital, but what I feel the need to come to terms with—quite beyond the personal riddles such coming to terms might resolve—is the moment of performance as it influences the experience, feeling, and imagination of the viewer. I think it presumptuous to assume that any of us is capable of assimilating, then sustaining fully active memory of, the absolute entirety of any screen performance: every single flicker on the face, every single nuance of the eyebrow, every single blemish and blush, every single turn of the hips and swing of the arms and syllable of sound. When we refer to the work of an actor, what we are really pointing to is the memorable moment or moments that resonate afterward. The moment of performance—in this book I discuss a limited number of these, the ones I am moved to ruminate upon—is a nexus at which the intent and skill of the actor and the receptive energies of the audience collide, momentously touch, and spark.

Momentary Performance

The fascination that actors hold out for viewers—their many-sidedness, their intensities, their predicaments, their fastidious craft—creeps against us through the history of our experience with screen characters, and that history is experienced in terms of moments, not whole and integrated works or their technical building blocks, shots and edits. Even long after childhood it is moments that captivate and enrich us, moments that, when the dialogue has been forgotten and the dance steps dissolved, we refuse to forget.

The word "moment" has a special weight here. While the moment can be the outcome or thrust of dramatized action, borrowing its sense from usage in theoretical physics, as when an object with mass, moving, has moment (or momentum), I consider it here, instead, as a fragment of experience. Through moments viewers have access to a film: sometimes groups or long chains of shots, sometimes a mere shard of a shot. Think of Fred Astaire's leap onto that stone bench in *The Band Wagon*'s Central Park, his

cream linen suit radiant and his chestnut shoes modest as he stretches out an arm to accept the hand of Cyd Charisse in her pristine white dress, then leans in the opposite direction to gracefully lever her upward while he steps down, all in one fluid move. Or in *Titanic* (1997), the thrall of night after the ship has disappeared, a shroud of silence covering everything, and the huge vault of the sky with its meadow of stars resting eternally above. Or little blue-eyed Joey Starrett (Brandon De Wilde) calling off to the sunset, "Shane! Shane! Come back, Shane!" with the music swelling and his puppy at his feet.

The moment is sometimes sprung from a physical act, sometimes a color or object, sometimes a musical beat, a cacophony or a stillness. It is the elemental figure of film viewing and experience. The moment is what one carries away and what carries one away, the feelingful trace of the projection, and therefore the gist of the experience as one sits in front of the screen. Each viewer may have an idiosyncratic sense of vital moments in a film (*pace* John Fowles's misconception that the movie image, unlike the literary one, is "virtually the same for all who see it" [qtd. in I. Q. Hunter 206]). Still, through referential description the moment is open to apperception and study, so that it can be widely understood, discussed, and acted upon.

À propos of moments: to experience them is to experience cinema itself: cinema, not, as some writers claim, cinephilia, that "special" love reserved for only the priests in the temple, superfans, those in the "know." The experience of film watching is broader, more generalized, thus more democratic than cinephilia. Cinema is a momentous democracy.

The "shot" is invoked and reinvoked, with a strange casualness, by professionals, scholars, and the lay public in addressing movies. Puzzlingly, for example, Alain Badiou wrote in 1994, "After all, cinema is nothing but takes and editing. There is nothing else. What I mean is this: There is nothing else that would constitute 'the film'" (97). True, when it is assembled a film does begin with takes of shots. The *selected* takes—we tend to call them, retrospectively, the "shots"—are edited into narrative sequence. Yet if we theorized that viewers actually experienced shots we would have to presume they could detect edits, routinely and unerratically; and that they could withdraw a shot, no matter its brevity, from the flow of screen action in order to consider it alone. Were one to theorize the "shot" as the constituent element of film, one would have to take the labor involved in any hypothetical shot as equivalent to, interchangeable with, or comparable to the labor involved in any other.

elicits a radically different sensitivity:

> It is a sham that we have forgotten our dreams. In each particular one, even
> those we already lost in awakening, something remains for us, a quiet but
> decided coloring of our emotion. Remaining to us is the habit of dreaming,
> in which we are whole more than in habitual life with all our suppressed
> obsessions. . . . This whole underground vegetation trembles down to its
> darkest roots, while the eyes seize the thousandfold image of life from the
> glittering screen. . . . Before this dark view from the depth of nature, the
> symbol develops lightning-like. (267–68; translation mine)

It is as though, watching in the dark, he is brought back to sensation and
wonder, momentary qualities that spring and fade, to be replaced and also
remembered.

The "shot" is part of a language that was devised by filmmakers to expe-
dite the complex process of shooting and editing film, since organizing
the detailed work of a small army of professionals, each contracted to the
business at hand and thus available only within closely defined time limits,
required a system for making meaningful to professionalized strangers the
boundaries and demands of the work they would be doing. The continuity
script came into being by 1914, with its standardized way of describing
narration shot by shot, thus making it possible to photograph a story out
of narrative order by arranging together all the work involving particu-
lar individuals. Enormous financial savings could be realized. And actors
and technicians could have a common understanding of any spate of activ-
ity that needed repetition, refinement, rearrangement. Further, as Janet
Staiger writes, "The representation [in stories] of a continuous time and
space started to permit direct cuts between scenes not spatially and tem-
porally contiguous, as long as cues to the gaps were present. Cues included
timing of the entrances and exits of characters and the insertion of inter-
titles"; but "with a standard of continuity and conventions of achieving that
continuity, the mode of production faced greater demands on its system of
memory" and continuity scripts "provided the means to ensure the conven-
tions of continuous action" (139).

Breaking action into shots made possible skipping through space and
time. By the advent of sound, everyone in Hollywood spoke effortlessly of
the "shot" as the fundamental compositional unit of film, and by the 1980s,

with wide-scale public exploitation of behind-the-camera life that began to take place in journalism and television entertainment-news programs, actors, fans, and journalists alike were freely using that same language— "We were making a shot on the soundstage and I remember I was worried that ...";"Oh yeah, that was a hard shot to do";"What a great shot!"—even though the "shot" is far from the glimpse of "underground vegetation trembling" to which Hofmannsthal points. In experience we plunge into, recall, and anticipate moments, not shots. James Stewart once mentioned "pieces of time"; time, but more than time: moments. That is, "pieces of time" with mass and movement.

The psychoanalytic theory that overtook thinking about the cinema in the 1970s had to deconstruct our experience of the filmic moment, and accomplished this task by positing hypothetical gaps into which viewers were inserted by means of "suture." The "shot" was ideal for this insertion. Lived experience of film was seen as merely false, a delusion produced secretly (that is, through a process that was itself hidden) by workers who stitched shots and countershots together in such a way as to convince the viewer that she was magically resident in the invisible space between them by virtue of the power of her imaginary. Another way to say this: every look was executed by someone *other than* the viewer. And Jean Narboni said more: "The practice of montage is absolute manipulation" (in Narboni, Pierre, and Rivette 31); in short, as two pieces of film are adjoined something is being done to bypass our intelligence, hoodwink us, and cheapen our love.

What such an approach must mask is the actuality and depth of the spectator's present experience. To see film only or principally as a manifestation of bourgeois ideology is to stop seeing film as we experience it and notice instead only the self watching, a reduction that is offered not only by apparatus theory and suture theory but by any theoretical formulation that leads us to stray from our actual watching as we know and feel it. In considering the moment as a structural monad of the cinematic experience, we could be tempted to ask reductionist questions such as, "Where does a moment begin?" or "Where does it end?" thus framing moments as tightly delimited material entities rather than aspects of the viewer's experience. Categorizing moments might produce a shorthand for making discussion of film facile, but it cannot produce a system that artfully and fully encapsulates the nuances—cultural, autobiographical, historical, atmospherical—any viewer might know in watching. As with the oneiric, filmic moments are always *present*, expansive, and plastic. And they bear

not only thinking but rethinking, through memory or rewatching. Actors are fully sensitive to the fact that while they labor to execute shots that will be edited into sequences they are creating moments. The moment is the real setting of filmic performance.

The actor's performance finally builds, shapes, defines, fills, and becomes the cinematic moment. It is the moment actors work to achieve, the moment that touches us and lingers in our thought. Workers operate in production space and time, under constraint, in collaboration, affected by agents and forces from outside themselves as well as by their own sense of desire and the past: but what we are left with, to call up and meditate upon, is something more transcendent than technical, more aesthetic than economic, more phantasmal than real.

Acting Action

The most obvious sense of "action" is that it refers to the point in time when a director has called out that fateful word, and the actors and crew are instantly hard at work filming. Beyond this it means the carry-through of feeling through contingent circumstances onscreen, the outflowing of a gesture, the riddling of identity and personality.

Perhaps no more vital distinction can be made about performance than between *action* and *activity*, a distinction one is urged to make in Nicholas Ray's diary entry for 3 October 1977 (60). Ray cautioned his students not to confuse the more superficial *activity* with the profounder, more deeply motorizing *action*. While activity is the physical movement of the actor's body in an organized frame, action comes from the still truer self, lasts longer, has a broader and profounder arc. So, the character has a project and projects herself toward its fulfillment. Dustin Hoffman shuffles around the stove as he teaches Justin Henry to make French toast in *Kramer vs. Kramer* (1979). If we ask, "What is Hoffman doing?" and think, "Making French toast," we have found his activity. If we think, "Bringing his son close," we have found his action, one that will necessarily occupy scenes beyond this one. The cooking lesson is a node in a much larger arc.

At the same time as moments of action are personal to the viewer, they are public, because there is an actual film playing upon the screen in such a way that a crowd of strangers can watch it. Our memories, Stephen Jay Gould notes, "are not the work of one private person, who may suffer

himself to be prevailed upon by his own opinion, who can hardly perceive what contradicts his first conceptions, for which he has all the blindness and fondness which everyone has for his own children. . . . Our memoirs contain only matters of fact that have been verified by a whole Society" (75, 78). The acting we watch in films has a "matter-of-fact" quality to some degree: it is what the screen reveals it to be, and thus resides outside our imagination as much as inside it. There is something verifiable in performance, so that it pays to watch carefully.

However personally apprehended and tasted, acting is finally experienced, recognized, and "verified by a whole Society"; and however socially verified, it is apprehended personally. One has a personal, autobiographical view of screen performance, yet there is something in an actor's work to which we all respond together, something replicated in all the prints of a film, lodged into the filmic surface for its duration. I write here—can only write here—about how I see certain performed moments, and in doing this I take myself to be in the most common way human, that is, nothing more than the sort of observer who could be guided by actors' work to have such thoughts as play out in my attempting to express them. If my approach does spring in some way from my personality, nevertheless it is also not merely mine, since what I address is visible on the screen, there to be seen and treated as though it exists.

However objective performance is onscreen, in my seat as viewer I am subjective as I experience it. And both subjectivity and objectivity obtain at once. If I point to a facet of performance that my readers have not noticed, I am true to both myself and the vision I see. The film performance is out there on the screen—not in my private imagination of the screen; it is in the record. With stage acting, there is of course no such record, only the traces of experience borne by each member of the audience when the moment has lapsed.

A certain antipathy infects the possible objection that a not wholly objective framing like this one drops us sadly into the terrain of the idiosyncratic. Such an argument was put to James Boswell by the playwright Thomas Sheridan, who said that a short-sighted man "will maintain that there is no such object as other people declare that they see plainly; and he would continue obstinate in his denial did not the application of a glass to his eyes impress him with irresistible conviction. . . . But we have not the same assistance to show people their mistakes. We have no glasses for the mind" (Boswell 182). Sheridan's idea of imposing spectacles, corrective

lenses, upon those whose personality obstructs them from "seeing plainly" is a war cry in the name of scientific objectivity, as though some artificial mechanism (theoretical lens) might succeed in removing the stain of the personal from the fabric of observation. Without the personal, such an argument goes, we would have a purer, more honest, more useful passageway to truth. But with or without his "spectacles," the gazer watching a moment of performative action is locked into his own feelings, memories, hopes, and methods of evaluation. Those of us who cannot escape this imprisonment may choose to revel in what is visible through the window of the cell.

Is anybody anywhere an actor? David Thomson suggests there isn't any acting in movies, that "the barrier of the screen certainly gives the impression of acting, but what we are seeing in the cinema are people" (*Movie Man* 123; qtd. in Klevan 3). Could one reasonably argue, for instance, that celebrated film performers simply possess privileged access to the relevant gatekeepers, have found their way into the sacred territory? A certain physiognomy did it; or the capacity to undergo reconstruction (we all know how much work was done in the studio era and is done still today to remake, recolor, reshape, and generally refashion a person's face and body so that they *become* what Hollywood needs). Or social connections played the key role: available telephone numbers and invitations to certain parties. Is acting entirely *being who you are* (while other people watch), with some of us gaining special license to do that? Or could it be that acting is not what actors do, it's anything the experts—the television network, the Weinstein brothers, the reviewer for the *New York Times*—say acting is? This rather critical, deconstructionist view would not be difficult to substantiate, at least in reverse: when the network cancels your show, the big producers are not interested in lunching with you at The Ivy; and when the *Times* gives you a solid pan, you have a career headache.

Consider the illustrative case of Linda Darnell, by 1946 already becoming, as Ronald Davis has it, "the most-often-killed actress in Hollywood—shot in *Buffalo Bill*, stabbed in *Summer Storm*, strangled and burned in *Hangover Square*, bludgeoned in *Fallen Angel*, and burned at the stake in *Anna and the King of Siam*" (*Darnell* 91). As the young teen Monette Darnell, pushed by a frantic stage mother, she had gone to Fox in 1937 at the beckoning of the casting scout Ivan Kahn. But Hollywood's gates would not be opened: she was too young for the studio to feel comfortable (legally) putting her to work. Two years later, however, she was brought

back and welcomed to the "family" in *My Darling Clementine*. When she was making *Hangover Square* she confessed, "I've had to act, appear, and behave older than I was ever since I came to pictures" (Davis 84). François Truffaut mentions that she was the inspiration for *The Barefoot Contessa* (325), the girl who came out of nowhere because some powerful men led her. Might any young performer, suitably prepped and shoved, have caught the eye of a scout like Kahn, been invited to the Mecca, found a way in?

One actor, who wished anonymity, spoke to me at length about this issue, which finally turns on the body and how it can look to those in control:

> You can work really hard at piano. It doesn't matter what you look like. If you have talent and you work you can be successful. . . . But with acting, it's a lot about who you are and where you can go with that. The instrument is your body—with piano, the instrument is standard, everybody plays on the same piano. But if you look at Stallone, there are places to go with that, but Alan Rickman would go somewhere else.
>
> I remember a girl in acting class who was, like, sort of frumpy, and the teacher said to her, "With your look, you're going to have to be really fucking good, because no one's writing those parts." Some people are just more castable. Some people have certain things that they get for free. Social class comes into it a lot. People with a working-class background: there are things they know, things they get for free, because they grew up with it, while someone with a middle-class background would have to research that and work at putting it on.

This kind of statement reveals the workaday practice of acting, as it is actually undertaken. Gatekeeper theory is finally insufficient to account for such actuality. The young actor grows by learning what, exactly, he "got for free," what it is that he represents to those who scrutinize him. He knows what he is likely to be cast to do, and what role, off the beaten track for him, would require extraordinary work. Even for the chosen few who get past Cerberus because an uncle or cousin is a producer on the lot had better be able to cut the mustard when the film is winding through the camera. The casting agent isn't just passing people she knows and likes: they have to fit, and the fit is a broader problem of social typing, cultural currency, hegemonic identity and conventional scripting, character stereotypy, and the economic imperative to find actors who can be counted on to work

dependably, efficiently, and successfully for producers who are spending considerable money, since one minute of time on a soundstage, with a full crew in attendance, is a fabulously costly venture and nobody wants a performer who squanders resources of that kind.

But aside from these considerations is Darnell's real glow on the screen, regardless of how it was produced. The actor does something we see being done, and finally our seeing it is the bottom line. When in *Hangover Square* Laird Cregar strangles her with a drapery cord, we are stunned and shocked because that glow of hers seemed invincible and immortal. Quickly he rolls the body up in a carpet.

1

Fantastic Performance

Many who think and write about screen acting want to demystify it, turn a light on the dark workroom where it is born. In their many ways they ask, What is this behavior being played at by otherwise ordinary people? Or: How through acting is wool being pulled over our eyes?

Following from the groundbreaking 1950 work of Hortense Powdermaker, for example, Danae Clark examines the economic logic of actors' labor in the context of capitalist production: who controls and molds it, who profits from it, who is exploited when actors act, and how? Peter Krämer and Alan Lovell ask different questions: "What do actors do to create a performance? What are their specific skills? What are the general ideas which inform the use of those skills?" (1). Cynthia Baron and Sharon Marie Carnicke look at the process whereby screen performance is fashioned and crafted in the context of studio filmmaking. James Harvey analyzes the prevailing cultural context as it informs performance. Andrew Klevan, Vivian Sobchack, and Stanley Cavell devote themselves to thinking *about* rather than *of* acting, Cavell, for instance, meditating on the fact that screen actors are projected but cannot really project (qtd. in Klevan 3). But this book emerges from quite another wellspring of curiosity.

At its best, the work of the actor is and must be mysterious and unclear. The critical question is thus not what acting is—what actors are paid for;

what the critic takes them to be doing; what password was whispered to make it possible for some persons to slide through the gate and become screen actors—but what acting can be as we watch it; how it works upon us and we upon it: a meditation on the acting effect.

When we consider performances that have touched and provoked us, we call up biography, memory, desire, feeling, and orientation—in short, the self. Since cultural studies began to exert its hegemony over intellectual life it has seemed unfashionable, even futile, to enunciate the self. One's point of view might establish one's socioeconomic status, point to the thrust of procedural movement or alignment, or articulate some brief and curtailable reaction, but it should not, apparently, be thought to emerge from a deep sense of being, memory, and experience. Indeed, in some circles "self" has become a dirty word, and the idea that experience is in important ways personal, idiosyncratic, and ineffable is treated as old-fashioned, uninformed, and unperceptive. Individual expression and sensitivity are taken to gain currency, to achieve value, only when they are based on systematically rationalized expertise, credit, or method. Thus is the System made the basis of all that we see and know, and the contradictory, offbeat, or uncohering perspective outlawed and finally lost.

Style and Culture

If performance is universally attractive and revealing, the nuances of acting style vary culturally, so that as audiences from different parts of the world look at film acting they find local characteristics. With stage performance this has long been well known: the stolid, gestural, masked Kabuki style differs from Indonesian dance-acting, French declamation, and British spoken stage work. But screen acting is no less variant. Hollywood production fosters certain recurrent patterns of augmented physical posture, enunciatory emotionalism, and declarative body movement all seen under typically unrestrained lighting. Here, actions are central to filmic structure and bodies are doted upon as formal objects. Consider Elizabeth Taylor, lithe as a flickering ray in *A Place in the Sun* (1950) and then chubby and flamboyant (in the role Bette Davis said she would have killed for)[1] in *Who's Afraid of Virginia Woolf?* (1966). Or Jerry Lewis, contortional and artfully poised in *The Nutty Professor* (1963) and then depressive, withdrawn, and sedate in *The King of Comedy* (1982).

In Italian film we see the body and persona of the actor highlighted (Marcello Mastroianni, Anna Magnani, Monica Vitti) but the moment of action is scenic, not personal. Look at Federico Fellini's *8 ½* (1963) and the way Guido (Mastroianni) finds and expresses himself in terms of the balletic action and elaborate locations behind him; or Roberto Rossellini's *L'Amore* (1948) with Nannina's (Magnani) passion on the mountainside; or Vitti's obsessive meandering around her estate in Michelangelo Antonioni's *La Notte* (1961).

If we look in depth at the work of Yasujiro Ozu we find an obsessive formality about cinematic space, stasis, and etiquette: frequently his actors express characterization by the angles at which they sit in relation to one another, or by the length of the silences between their statements, elements of performance masterfully articulated in *Tokyo Story* (1953; see Desser). Or consider the angular and energetic lateral movement through the forest of Toshirô Mifune in Akira Kurosawa's *Rashômon* (1950).

In French screen performance much attention is turned to the way actors vocalize tonally and rhythmically (the bold and golden grammar of Philippe Noiret in *Coup de torchon* [1981]; the slur of Jean-Paul Belmondo in *À bout de souffle* [1960]; the crisp silences of Marcel Dalio in *La règle du jeu* [1939]). The moment in François Truffaut's *Stolen Kisses* (*Baisers volés*, 1968) when Jean-Pierre Léaud stares into a mirror and vocalizes repetitively, and more and more rapidly, the name of his own character, "Antoine Doinel Antoine Doinel Antoine Doinel," that of his girlfriend, "Christine Darbon Christine Darbon Christine Darbon," and that of an older woman who has captured his fancy, "Fabienne Tabard Fabienne Tabard Fabienne Tabard," is a kind of critical discourse about conventional French performance of the 1940s and 1950s, a statement of Truffaut's affiliation with the *nouvelle vague*.

The British actor's extraordinary capacity for playing with language—dialects, vocal amplitude, diction—structures much performance as a type of geographic evidence: where exactly a characterization is set in terms of social and topological space (no clearer examples being available than the work of Roger Livesey, Deborah Kerr, and Anton Walbrook in *The Life and Death of Colonel Blimp* [1943]; Trevor Howard and Celia Johnson in *Brief Encounter* [1945]; or David Warner, Vanessa Redgrave, and Robert Stephens in *Morgan: A Suitable Case for Treatment* [1966]).

If we look at the Burkinabé films of Idrissa Ouedraogo (such as *Tilaï* [1990]), we find relatively little facial or bodily expressivism on the part of

the actors. More is achieved by way of interactional posture, directionality of movement, the body positioned against natural space, and (as in Hitchcock) the use of color design to variably separate the characters from their surround. In the work of Thai filmmaker Apichatpong Weerasethakul, for instance *Uncle Boonmee Who Can Recall His Past Lives* (2010), the actors frequently work by waiting, holding back speech or gesture, as though receiving guidance from another dimension.

A notably forceful concentration on the delicacy and depth of physical gesture is evident in the work of Scandinavian actors such as Liv Ullmann and Max von Sydow (for example, in *The Passion of Anna* [1969]) or even of the American actor Elliott Gould, reducing his American-star facial work to become tenderly gestural, in tandem with Bibi Andersson and Von Sydow, in *The Touch* (1971). Here, gesture and silence play significantly, particularly in a series of linked vignette shots as, after her morning coffee, Andersson tries on various dresses and accouterments to see if she looks right before going off to meet her American lover.

For commercial reasons, performance in Hollywood film has a glittering surface appeal, so that it is easily apprehended, digested, and evaporated (making room for new consumption). It requires little thought, recapitulating today what Goethe noticed already in the late eighteenth century, that flattering the audience, catering to their weakness, would bring popular success (64). Yet it is a mistake to simply summarize Hollywood screen performances as thin and inauthentic, as though no rich experience lies in wait for the viewer who patiently reflects on them. Hollywood cinema can be penetrating, moving, and revolutionary even in its glitz and gleam, as believed the *Cahiers du cinéma* critics of the 1950s, today often snidely denigrated by "aficionados" of cinema whose devotions affix to esoterica and recursive image analysis. Scholars and critics now often choose to fashionably spurn the commercialized Hollywood style. Thus, insufficiently elevated and insufficiently attractive for them is run-of-the-mill Hollywood product, for example, the sort of rhythmically recurring physical movement we can see in Harry Horner's flashy black-and-white B-film *The Wild Party* (1948)—where, first, Anthony Quinn affectionately catches Nehemiah Persoff's throat in his bent arm; then later Persoff seizes Quinn by the shoulder; then still later Jay Robinson throws his arm around Arthur Franz's throat and half-strangles him in a car. But even in our age of aggravated capitalist merchandizing, in which movie screens of all sizes are flooded with imagery that we are meant to consume rapidly

and quickly before passing on to something new, new, and everlastingly new, patient reflection remains possible and worth striving to achieve—especially reflection upon performance.

Working actors openly regard their performing as performing. The rest of us, who surely perform in everyday life, do not regard what we do as being neatly staged for a view (although anyone surveilling us might not agree). We know we *can* be watched but we do not assume that we *are*. As Alfred Schutz noted: "I, you, we, are . . . carried from one moment to the next in a particular attentional modification of the state of being mutually oriented to each other" (156). In watching screen acting we explicitly tag the performer, make him into a supremely valued thing. Every celebrity actor was once only an unadorned citizen (aging, indeed, he might become one again). That the biggest stars in Hollywood were once unrecognized as such shows the power of our recognition in denoting and contributing prestige.

Innocent and Scientific Watching, and "Falling In"

Discussing 1950s art criticism in *The Painted Word*, Tom Wolfe implicitly warned that one could no longer see without a theory. Writers about cinema have often subordinated deeply rooted sensations and responses to canonized grids of thought, categorizations, typifications, linguistic models, or magical incantations reified and accorded dignity, with the overriding result that discussion about cinematic performance has aimed to explain, context, and demystify actors' work as though nothing could be more important about it than what can be catalogued.

As science encroaches upon experience, the world becomes, as Max Weber taught us, rationalized. Dreams, myths, wonderments, suppositions—all these diminish in the face of factuality and data collection. On the hunt for indications, some viewers labor in front of the screen to assemble an index of some reality. Instead of "What is going on in front of my eyes?" to ask, instead, "How might it be if . . ." is a profound philosophical step, to be moved to wonder about conditions presently invoked, their implications, their origins, their peculiar flavor and affective qualities. Such reflection has come to seem a waste of time as we press forward to watch more images every day, often through devices that preserve the pixels of indication while erasing aesthetic provocation. Decoding has become a principal piety. Analysis triumphs.

Most casual viewers of film employ an "innocent" practice: technically uninformed, conventional, and sincere. Things are taken as they seem, and the narrative is treated as a window onto some (entertaining) world. The "innocent" watcher accepts performances completely, as though they are "just there" to be seen. Actors not well known enough to be identified as stars are closely aligned with their characters, even absorbed into them. The "innocent" viewer doesn't think about actors working to repeat themselves in take after take, or waiting for the lighting to be set and reset, or having their hair or makeup touched up, or quickly studying a script, or chatting about the news with one another. "Innocent" film viewing is so culturally diffuse it can be taken for granted as a "natural" way of watching, and is thus invisible.

The scholar and critic, by contrast, do not adopt an "innocent" perspective in watching. Even very astute scholarship is prone to swinging to the radically "scientific" end of the spectrum. In *From Caligari to Hitler*, Siegfried Kracauer describes Emil Jannings's performance as the old hotel porter (in F. W. Murnau's *The Last Laugh* [1924]), proud of his position in his grand uniform but who learns one sad day that he has been replaced by a younger man. Having noted that the porter's work involves "not only usher[ing] the guests through the revolving door, but also offer[ing] candies to the children in the yard of the tenement house where he lives with some relatives," Kracauer moves on to archly point to the Weimar social context:

> All the tenants, in particular the female ones, are awed by his uniform which, through its mere presence, seems to confer a mystic glamour upon their modest existence. They revere it as a symbol of supreme authority and are happy to be allowed to revere it. *Thus the film advances, however ironically, the authoritarian credo that the magic spell of authority protects society from decomposition.* (100; my emphasis)

Adducing broader, extra-filmic social issues (in this case, structures of authority and tradition in Weimar Germany), Kracauer peers far beyond the Jannings performance, finding the actor only a kind of game piece, the movement of which promotes a tacit authoritarian credo. Through a similar critical distancing, Barbara Stanwyck in *Stella Dallas* (1937) and Joan Crawford in *Mildred Pierce* (1945) were linked as self-sacrificing mothers in feminist theories arguing Hollywood's collusion in sustaining female powerlessness (see Cook; Williams "Something"); and during the 1980s, performances by Arnold Schwarzenegger, Sylvester Stallone, Jean-Claude

Van Damme, Dolph Lundgren, and Chuck Norris came to be typified as examples of the Reaganist military-conservative type thanks to the influence of Susan Jeffords's groundbreaking book *Hard Bodies*.

Beyond "innocent" and "scientific" viewing, or somewhere between them, is what could be called "falling in." One viewer typified this to me with a passionate account of having watched Mads Mikkelson, an actor whose work was very familiar to him, as, at the beginning of Nicolas Winding Refn's *With Blood on My Hands: Pusher II* (2004), he ambled down a street with his back to camera and a tattoo at the rear of his head. "Oh, Mads has a tattoo!" he began saying to himself. But then, quickly, he changed his view. "Oh, that's not Mads. That's a thug." A kind of transformation occurred, certainly a movement into the diegetic sphere but one that was initiated and energized on a platform outside, in the everyday. Is this movement not something like what happens as, relinquishing the world of our quotidian concerns, we fall asleep, entering a journey we cannot predict or hope to understand? Marcel Proust wrote of "thoughts of the future which would carry me, as on a bridge, across the terrifying abyss that yawned at my feet" (28). When we are positioned and prone to falling in, the difference between the actor and the character perhaps evanesces, so that indeed, as William Rothman has suggested, it is only as a result of a dedicated labor on our part that the difference can be composed again and made relevant. In falling in, my interlocutor praised Mads Mikkelson for his power as an actor. Perhaps one thing an actor accomplishes is ceding over to his audience the permission and opportunity for falling in—giving them the necessary space and time. As much of the responsibility again goes to the viewer, who takes the opportunity to release his knowledge and his coordinates, so that he may enter the sacred territory.

Predictive and Transcendent Acting

Watchers of screen performance can find it variably fresh. It can be spontaneous, unheralded, even shocking and *unheimlich*; or, alternatively, repetitive, familiar, packaged, and recognizable. Acting designed to be immediately and perduringly recognizable I would term "predictive." At stake here is the identity of the star, not the characterization. Audiences pay for the pleasure of seeing once again star figures they know and value in advance. The viewer may even have a sense of the actor giving a "default" performance;

but the repetition of appearance and manner are central to the capitalization of films. The market value to studios and producers of the star identity lies principally in its consistency over time and thus its marketability as product. "Economically," writes Janet Staiger, "the star may be thought of as a monopoly on a personality" (Bordwell, Staiger, and Thompson 104), a monopoly, one might add, temporally extended through calculated reiteration in a chain of identifiable performances. Thomas Schatz has shown how because of its recognizability the star identity formed a distinctive part of the genre formula, by which in the 1930s, 1940s, and 1950s studios were able systematically to engineer stylized films guaranteed in advance to please the public. With predictive acting the viewer has a distinct sense of facing prior experience. The present case thus offers the chance to renew earlier pleasure (and look forward to similar pleasures to come). Predictive performance summons and addresses recognition.

Recognition can seem confining. When predictive experience is subjected to a long process of socialization, when marketing and media coverage "teach" young viewers to see film acting this way, it becomes a much-rehearsed activity in itself, an experience one knows in advance. No matter what the film or what the performance, it is known "already" how to receive and digest it. In this way it can be difficult even to detect the acting, however skillful, of strangers who do not fit the star formula that repeated moviegoing has taught us to relish. With genre filmmaking, for example, when studios had stables of star and character performers who appeared repeatedly in film after film—at MGM in the 1940s Edward Everett Horton, Eugene Pallette, Edward Arnold, Alice Brady; at Paramount in the 1950s Kathleen Freeman, Millard Mitchell, Harry Carey Jr.—it was especially difficult for newcomers to break in, except as "renovations" of already-accepted personalities. Carol Ohmart, to name but one such actor, was cultivated to be competition for Marilyn Monroe but didn't succeed. She was too spontaneous on camera, too variant to be labeled.

Predictive performance seems canned, not fresh: Clint Eastwood pointing his gun inexpressively in the general direction of the lens; Robert DeNiro shrugging as he turns up his bottom lip; Julia Roberts nervously grinning; Bette Davis with the corners of her mouth painted downward in a little grimace and her eyes drawn wide open. Indeed, the dominating articulateness of Davis, like the strident, bravura poise of Katharine Hepburn, the suave sleekness of Cary Grant, the macho directness of Clark Gable, the apish and gesticulatory expressiveness of Jerry Lewis, and the

voluptuous silences of Monroe, iconize and isolate the star personality of the actor beneath. In predictive performance, recognition leads immediately to placement. The star is always first and foremost a public self (on stars and star theory see Butler; Dyer; Desjardins *Recycled*), a personality type that must be continuingly (and always nostalgically) available. Stories are scripted to fit the premeasured dimensions of the star, and to make possible continuous chains of predictively acted moments that will culminate in the "star image" as a recognizable, exchangeable commodity.

As he works, the movie actor is transformed into pictures of himself. Normally, when we test a person against his photograph—as with passport inspections at airports—the photograph is taken as ontologically prior: an individual looks like her photograph, rather than her photograph looking like her. In cinematography, special lenses and lights are used, and with prodigious expertise, so that the pictures are of very high quality; enormous in proportion; and readily marketable. The lambency of the imagery is what lends to our certitude that we are watching "fantastic" performance. The more intensively publicized, thus visible, a film actor is, the more "fantastic" will seem his performances; further, the more likely his slightest move will seem a star turn to those who watch it.

Predictive acting one sees by knowing. What I would call "transcendent" acting one knows by seeing. The transcendent performance stuns watchers by virtue of a seemingly sharp originality, a spontaneous burst of attitude and feeling that, springing out of—and away from—the narrative moment, brings a quality of intensity, novelty, and purity: Sal Mineo in *Rebel Without a Cause* (1955), cuddling with Natalie Wood and James Dean in the mansion; Gregory Peck in *To Kill a Mockingbird* (1962), introducing his daughter to her neighbor, Arthur Radley (Robert Duvall); Angela Lansbury in *The Manchurian Candidate* (1962), kissing her son Raymond (Laurence Harvey) on the mouth; Kristen Stewart refusing to remove her underwear as she goes skinny-dipping with Juliette Binoche in *Clouds of Sils Maria* (2014). These moments seem transcendental, even ornamental, ascending above, eclipsing the common, pedestrian process of the story. This quality is central to transcendent performance: one has the sense of a gesture or action leaping away from the plot, perhaps making reference to film in general or the actor's situation, perhaps making reference to the character and her condition in a deeper, and markedly more engaging, way. Suddenly and abruptly, the viewer can feel co-present with the character, hanging upon the subtlest nuance of action.

William James pointed to a kind of isolation in our experience of "reality": when events seem real, he claimed, they are entirely uncontradicted by ancillary knowledge and phenomena; uncontradicted yet fully discriminable. They stand on their own, immediate. Transcendent performance leaps out of the same fluid time as that in which we watch it, the time in which our own breathing experience and also the music of the film's movement are counted out, so that the performed gesture and the observer's reaction are wedded and even abstracted in directness, arbitrariness, and pulse. The "transcendent" performance seems to skip a beat, or to freeze the action. John Barrymore speaks of "doing and saying the thing as spontaneously as if you were confronted with the situation in which you were acting, for the first time" (593). In transcendence the viewer feels as though the dramatic happening expands to occupy not merely a fragment of time but all present time. Beyond what is seen, here and now with these fabulous beings, no world exists.

Stars both do and do not give "star" performances. From the 1940s until the early 1960s Cary Grant successfully mobilized a predictive star persona, all of his performances calling up the Cary Grantness that such scholars as James Naremore and Stanley Cavell have acutely (and quite differently) discussed, although with some notable stylistic modification between his RKO work and his films for MGM (Naremore 213–36; Cavell, *Themes* 152–72). But he occasionally jumps out of the predictive persona and becomes momentarily, spectacularly vivacious and transcendent. The moment at the Lord estate in *The Philadelphia Story* (1940), for example, when in a surprising gesture and with stunning gentleness he asks Mary Nash if he can borrow her wedding ring; or in the Townsend library in *North by Northwest* (1959) when he cautiously, somewhat fearfully circles the room while gazing into James Mason's face, are both transcendent. The moment in *Charade* (1963) when he takes a shower fully clothed is another.

Neither predictive nor transcendent acting constitutes an unreflected performance style. Giving either sort of performance, actors are conscious of technique and willfully participant in a process that is greater than themselves.

John Wayne's Predictive Performance

The intensity and purity of John Wayne's gazing into the lens while he speaks, structured to replicate his eye contact with his conversational

partners, early on became a quality simple and observable enough to be predictive for big audiences. As prediction circulated and generalized, Wayne's taciturnity became legendary. In his star persona he coupled the forward gaze with a measured slowness in pushing out sounds. Every few words he inserts a half pause, so that full questions or statements come out of him in a chain of "telegraphs" that must be held in suspension by the listener before they can be added together to make up the message. This way of speaking encourages listener engagement and heightens the excitement. It also packages the actor as a discernable product, in the sense that well-known, repeatable vocal gesturing can be used as the basis for marketing Wayne and the films attached to him (or, later, for parodic imitation). Wayne's ocular focus brings emphasis and bearing to his speech, lends it authenticity.

Wayne's utterances are usually on the pedagogical, not the witty, side even when they are responses to comical moments. Edward Countryman finds him "avuncular" (219). We will find this whether he is dressed in buckskin and speaking to Angie Dickinson (while preposterously modeling a woman's scarlet underwear) in *Rio Bravo* (1959) or in his huge Stetson facing off with Lauren Bacall in *The Shootist* (1976); in tweeds romancing Maureen O'Hara in *The Quiet Man* (1952; or, in khaki, Patricia Neal in *In Harm's Way* [1965]), or in fatigues and speaking to Anthony Quinn in *Back to Bataan* (1945). Through his look, he is weighing, not watching people. When he moves, whole or wounded, he betrays no regard for self, no sense of his own pain or disability, just a keen focus on trajectory, a brutal and unreflective forward thrust. "Delicacy is not something you normally associate with Wayne . . . but in a way, it was his secret weapon," writes James Harvey (95).

As to Wayne's trademark breaking of fluidity when he speaks, he was entirely aware of the procedure as a focusing tactic. During the 1930s, according to Randy W. Roberts, he "began to develop his familiar cadence" and started staying away from long—as he saw them, intrinsically boring—speeches. But more, he "slowed down his speech and began to pause in the middle of sentences" (136–37). Roberts cites the actor giving a precise example of his own stylistic maneuvers:

You say, "I think I'll . . ." (Now they're looking at you, and you can stand there for 20 minutes before you say) "go to town." If you say normally, "I think I'll go to town. Umm (pause) then we can go over and see something,"

the audience would have left you. But if you say, "I think I'll go (pause) to town and I'll (pause) see those three broads," now they're waiting for you. You can take all the goddamn time you want if you choose your time for the hesitation. (qtd. in Roberts 137)

"There's no way of being natural on the screen," concludes Wayne, with what might seem like self-contradiction to the many fans who take his screen persona as an epitome of naturalness. "You lose your tempo. You have to keep things going and try to get your personality through." And Roberts weighs in, "The cadence he developed did just that. It permitted him to maintain an even tempo and present a character that at all times appeared deliberate, thoughtful, and deadly serious" (137).

Yet we can see in Wayne's work that his "tempo," his calculated stammer, worked to achieve something else. As his own claim shows, the performer was thinking about grappling with his audience's attention, grasping, twisting, holding, and releasing it, in short concentrating on the proximal relation between his speaking voice and his listeners' ears, even while the impression he fostered was of a man cogitating on his own meaning, working out his utterance not as a vocal production but as an idea. Through the broken delivery, Wayne established his characters as thoughtful, reflective, and ultimately wise. In every scene he played, Wayne's character was the one to whom we looked for the final arbitration.

To audiences unfamiliar with the methods of motion picture filming it might not be evident why "losing tempo" and devising a strategy for preventing this would be a matter of concern to an actor like John Wayne. When a performance builds onstage, one's tempo of speech and one's movement emerge from the motions and processes of the body, and while these can be shaped and controlled to some real degree the tempo of a performance is indigenous to the ongoing unfoldingness of behavior in place. Shooting a film, however, is a very different business. It is only very rarely that scenes are put before the camera in diegetic syntax. When the budget is ample, and it is possible to book a number of soundstages simultaneously and thus have a number of different sets fully constructed and at the ready all at once, filmmakers might be able to put their scenes before the camera in the order in which they would appear in the final edit. More typically, however, it is a budgetary necessity to use relatively few soundstages for a production; and this means shooting all the scenes that take place in one particular setting back to back, then striking the setting and replacing it

with another. Added to this complication are the contractual arrangements between the producer and the performers, not all of whom are obligated to be present while the others are. There will be economies to be achieved if all the scenes involving a particular actor who is doing a supporting role can be shot within a few days, on whatever (ideally small) number of sets or locations are required, at which point, usually after a twenty-four-hour hiatus in which the laboratory verifies that his takes are good enough for editing, the actor is freed to leave the production (until, perhaps, sound looping, which takes place after principal photography is done).

Therefore, whichever of the many possible patterns of production is used for a film, an actor cannot count on being able to play his scenes in narrative order. The flowing development of a character from scene to scene is something that must be thought through by actor and director and planned for meticulously in advance. Commonly, actors begin their work on a picture with a scene in the middle or near the end of a film, and end with one near the beginning. Given this scrambling and fragmentation of the daily work, it is easy enough to see why "losing tempo" could be a peril to be feared and avoided by knowledgeable workers. Wayne's flatness of enunciation, his simplicity of diction making possible sentence breaks without loss of intelligibility, and his steadfast gaze during speech all contribute to shots that will intercut beautifully no matter when they are made. He found a locative way to standardize his performance method.

A great many screen actors use some technique or other for accomplishing this objective, Wayne perhaps more ostensibly and self-reflexively than most. His acting is thus distinctly cinematic, not only in its effect but in its very posture. With each utterance, he articulates the situated meaning for his character but also the general situated meaning for him as an actor at work. In this way, a resonant honesty is achieved in the voice, and the character takes on the quality of trustworthiness, one of the hallmarks of Wayne's star persona.

The ocular focus was less a spontaneous personal expression of interest on Wayne's part than a knowing borrowing from Hollywood production lore and wisdom. Ronald Davis observes of Wayne that "he understood that the core of an effective screen performance came from the eyes. 'If you don't believe it in the eyes,' [Wayne's frequent scene partner Gabby] Hayes said, 'you don't get the point across'" (*Duke* 59). Further, when they made *Stagecoach* (1939), "Claire Trevor remembered Ford's grabbing Wayne by the chin and shaking his head: 'Why are you

moving your mouth so much? . . . Don't you know that you don't act with your mouth in a picture? You act with your eyes!'" (83). The ocular focus has a certain technical merit. With proper lighting, a character's eyes can center the composition of a screen image. Further, in actually producing action in front of a lens and in the company of other actors, with whom one must register and negotiate one's beats of feeling, no device is more easily readable or more instantaneously accessible than a scene partner's gaze. Harry Carey Jr., who had to play scenes with Wayne in *The Searchers* (1956), said that when he looked at him in rehearsal "it was into the meanest, coldest eyes I had ever seen" (Davis, *Duke* 204). The eyes embodied the character (in this case, the gruff and determined Ethan Edwards) but also telegraphed for all his working associates the actor's principal intent.

There is yet another way in which the richness of a character's gaze onscreen can play to an audience's deep sensibility. As Wheeler Winston Dixon explicitly shows in *It Looks at You*, "In the cinema, reception involves the human agency of the viewer locked in a photocentric counter-transgressive act of reciprocity with cinematic apparatus; a perfect, sealed, seemingly flawless construct designed solely for us to witness." Further, "Countless replications of this transgressive, passive spectacle will leave it essentially unchanged; it is the narrative removed from accident." Dixon concludes: "While cinema narrative structure may superficially take its rudimentary structures, then, from the stage, cinema syntax and suture have rapidly developed their own heterotopic alternity, far removed from the immediacy of live performance" (135). As we look at Wayne looking, Dixon's thinking suggests, the looking Wayne is "looking" at us looking. As he constructs his gaze, he knows his audience (temporarily replaced by the camera), apprehending it. He is gazing for, and in a sense *at*, them and also for, and *at*, their capacity to gaze at the gaze. In seeing Wayne gazing at his interlocutors, we recognize that he is committing an act of which our own fascination with the screen is a direct duplication. In exactly the way that he does not avert his gaze—this constancy being another of his trademarks in stardom—we do not avert ours appreciating him. Wayne's acting works not only to establish his character's connections but also to reflect and cue the very idea of staring at the visible, in this affirming and aggrandizing our own act of watching. In the very act of his stardom, at each screen moment he moves us to regard him as a star (and acknowledges that regard).

To contrast with the scenarized body that we can find visible again and again in predictive work, that operates to build and solidify a star persona just as it sets up and ongoingly resolves narrative tensions, let me focus on some vivacious moments of what I am calling transcendent performance. Here, a deep generation of physically manifested feeling seems to explode upon the dramatic present, flooding over the remainder of the narrative, swelling our experience, and even, sometimes, obliterating stardom altogether. A notable case, involving both Katharine Hepburn and Cary Grant, is to be found in Howard Hawks's comedy *Bringing Up Baby*.

Generally speaking, Hepburn—the Hepburn of *Sylvia Scarlett* (1935), *Bringing Up Baby* (1938), *Woman of the Year* (1942), *Adam's Rib* (1949), *The African Queen* (1951), *The Lion in Winter* (1968), *The Madwoman of Chaillot* (1969)—never loses a sense of the dramatic moment as singular and unrepeatable, worthy of special attention, an opportunity for her to muster some apparently spontaneous gesture of vocality, movement, portage, or tone. And Grant—the Grant of *Born to Be Bad* (1934), *Sylvia Scarlett*, *Topper* and *The Awful Truth* (both 1937), not to say *His Girl Friday*, *The Philadelphia Story* (both 1940), *Arsenic and Old Lace* (1944), and numerous other films leading up to *North by Northwest* and *Charade*—is generally urbane, sophisticated while retaining an odd innocence, and mannered with refined polish. It is therefore not the typical and predictive, spunky and feisty, energetic and purposeful, direct and unreserved, clarion and confident Hepburn, Hepburn the "combative, high-spirited androgyne" (Naremore 175), or sleek and confident Grant who call for consideration here, but creatures different, even contradictory.

Hepburn had a particular problem by the late 1930s. While she had been one of those who displayed "clean, neat, and sleek hair, tailored clothing, the athletic body, the beauty of realism" (Ohmer 190), there grew at the same time a feeling in Hepburn's audience, especially that part of the audience distant from the cultural centers of the East, that her "Bryn Mawr patois" (McLean 6) and erudite elocution, her sophisticated wit and her snippy, even contentious bravura, were distasteful, even loathsome. In 1938, an exhibitors "revolution" culminated in the production of a full-page advertisement that explicitly trounced on Hepburn, among a group of other too-elevated types: "We dust-bowl dwellers do not appreciate English conversation" (6). Because she was seen too clearly as one of those

"female stars who are 'too intelligent' for their own good" (Desjardins, "Not of Hollywood" 42), her pictures suffered at the box office.

As to her "femininity": at the time this attribute conventionally meant a kind of radiant docility. Many films of the decade had mocked it "as a mere masquerade" (Mann 299)—Gregory LaCava's *My Man Godfrey* (1936) is a good example. Public response to Hepburn's work had been sufficiently tepid to show that as far as her career prospects were concerned storm clouds were on the horizon. Perhaps audiences found it hard to admire the scathing social critique that her snippy brilliance implied. To make matters worse, George Cukor's "quite somber" *Holiday* (McLean 12) "was rejected" by a movie audience "still reeling from the Depression" (Mann 300). At this time in her life Hepburn was suffering on the personal side, too. Her flighty love affair with the tycoon Howard Hughes was heading for land; her somewhat strained relation with Ginger Rogers—they had worked together in *Stage Door* (1937)—was becoming a lost cause: "Hepburn left RKO in 1938 just as Rogers's solo popularity and critical acclaim were cresting" (Lugowski 149–50). And soon, too, in late September of 1938, the Long Island Express, the worst hurricane to date to slam the East Coast, would ravage the Hartford, Connecticut, area and flatten the Hepburn family home that was a bedrock of her emotional life.

The pretext of *Bringing Up Baby* is the ostensibly unlikely (but for audiences the perfectly desirable) love affair between Susan, a headstrong girl of the upper class (Hepburn), and David, a bewildered, clumsy, well-meaning, "overgrown schoolboy" paleontologist (Grant) (Higham and Moseley 95). She courts him by indirection, not without the bizarre help of her pet leopard, Baby, of whom David is signally terrified. They find themselves at the Connecticut home of her Aunt Elizabeth (May Robson), a typical daunting dowager, whose Wire Fox Terrier George (Asta) manages to pilfer one of David's sacred dinosaur bones. Susan and David have already been on the hunt with George, trying in characteristic ways to persuade the pup to dig for the bone. David snaps, as though poor little George is trying to thwart him, while Susan opts for calm and rational language, all the more hilarious for the dog's apparent accession to her. But the bone is not found, a problem that does not distract the viewer from taking pleasure in the ridiculous sight of Grant waltzing through the park around the house in white riding pants, a pink jacket, and white athletic socks capped off with Japanese slippers.

Soon enough both Baby and George have run off into the woods, with Susan and David set off on a nocturnal hunt to find them. Grant's David, thickly bespectacled, is now garbed for his hike in an incongruous shirt-tie-wool-tweed-suit combo and brandishing a coiled length of rope and a croquet mallet. Hepburn's Susan, in a flowing white silken peignoir, has equipped herself with a butterfly net. As they make their way forward, David loses his footing, but Susan, frequent visitor to these climes, is more sure of herself, until, moving through a thicket where she is thrice slapped in the face by branches—the beginning of Hawks's strategy of dismantling the star's porcelain public persona by leveling her—she finds herself crawling on hands and knees. David's vision is pathetically weak: "Where are you? Susan, this is no time to be playing squat tag." Now she has caught her gown on a branch but he won't make a move to help: "That's poison ivy." And finally, barking that he didn't come out here for a discussion, he came out to look for George and he's going to find him, David slips and crashes down an unseen slope, so suddenly that as he hits bottom his tumble moves Susan to uncontrollable laughter and she loses her balance at the top and crashes, too. The pair are splayed in a dusty jumble, Susan laughing uncontrollably, and again and again, especially when she notices that her butterfly net has snagged David's head.

This moment beautifully illustrates how acting for camera can fall out of the performer's control. Making this scene required that Hepburn execute a long series of apparently "unshaped" laughs, verging on delirium (though of course meticulously phrased by the actor). But the effect of having her upended is to replace the carefully poised, intentionally articulate Hepburn with a persona whose visceral-emotional response entirely dominates her rationality; whose tumble, a categorical example of Henri Bergson's "We laugh every time a person gives us the impression of being a thing" (33), shows not only the character but also the actress unpreparedly bereft of the ability to look good, to display posture, to hold elevation over her circumstances. This arrangement of contingencies, moved through willingly by Hepburn, is staged and visualized meticulously by Howard Hawks, and her performance and Grant's are rendered accessible to the viewer thanks to the lighting by Russell Metty. Hepburn's beautiful gown (by Howard Greer) has been besmirched; her beautiful language (by Dudley Nichols) is rendered childish and elemental in the extended guffaws; her athletic body is made helpless, shapeless, and ridiculous; and her quality of elegant superiority is reduced to a joke.

Much the same happens, and in much the same way, with the dignified, suave, and articulate star persona of Grant, as he finds physical reality at war with his serious proclamations, the woods a territory in which he cannot easily navigate, the precipice a danger he could not have foreseen, and the elusive George and Baby continually barking or growling taunts, as though Nature itself had set itself to combat his earnestness.

With both stellar identities now thrown into disarray, the film could lose its footing but for Hawks's sense of grace. What happens next is anything but deflating: the viewer is treated to a sublime moment in which, star personae loosed and flying off at will, the razor edge between actor identity and character identity seems to glow. One is caught in the hilarity, the physical delight, the sacred dirtiness of the fall. The camera puts the viewer down on the earth, where the puppy and the leopard tread. Lost, at least for the moment, are the silly social pretenses of Aunt Elizabeth and her chum Major Applegate (Charlie Ruggles), the brittle status of the country house, the marital hopes of Susan, and even David's ultra-devoted attention to putting his cherished dinosaur together in the museum. All the structures of the everyday dissolve in the instant of hilarious release.

It is possible that Hepburn's convulsive laughter was neither desired by the filmmaker nor admired by her co-star. Charles Higham and Roy Moseley report a certain concern with which filming began, namely that in laughing at herself in character Hepburn was making a mistake. "She took the comic situations *too* comically. The great clowns . . . do funny things in a completely quiet, somber, deadpan way," said Hawks. Hepburn agreed. "I did keep laughing at my own lines. Cary Grant taught me that the more depressed I looked when I went into a pratfall, the more the audience would laugh" (93). Yet the transcendent moment I am referring to is not one calculated to produce audience laughter. For viewers it is a deliberate and swift unshackling from the constraint of having to take Hepburn and Grant too seriously in their preestablished personae. With the two of them flat on their backs, the audience is granted a license to believe in their simple humanity.

Another such moment of transcendental performance occurs in Irving Rapper's *Now, Voyager* (1942) with Bette Davis cradling a young neurotic girl in bed. Davis's Boston Brahmin Charlotte Vale, the desperately introverted daughter of a demanding harridan (Gladys Cooper), falls under the spell of Dr. Jaquith (Claude Rains), who brings her to his therapy camp and imbues her with a signal sense of self-confidence, so much so that she

changes her style of dress and self-presentation and heads off on a luxury cruise where she meets and falls in love with Jerry Durrance (Paul Henreid), distinguished, suave, and estranged from his wife. Much later, she wishes to work with Dr. Jaquith in order to pay back some of the good he has done her and he introduces her to a pathologically shy, introverted teenaged girl with whom she agrees to spend considerable time. This is Tina Durrance (Janis Wilson), in fact Jerry's daughter, who does not know that her now-cherished friend is still in love with her father. In a critical moment, Tina is having nightmares and cannot sleep by herself so Charlotte lies with her and comforts her. But in a portrait shot, Rapper shows Davis with her head next to Tina's, gently soothing, holding, and mothering her. Given that Davis's screen persona was typically that of a bold, expressive, self-controlled, self-assured, even in some cases dominating personality, the moments in *Now, Voyager* where we see her as a timid and self-effacing victim and then later as a compassionate, tender, and generous mother figure seem to stand apart from the progression of the narrative even as they contribute to it.

As to Charlotte's timidity: Dr. Jaquith was informed by Charlotte's mother what sort of person her daughter is, so we know what to expect when we see her for the first time: but Davis trumps all expectation by the stuttering hesitancy of her gait as she descends the staircase and the way she cannot look forward without a glazed fear in her eyes (accentuated through the use of thick-lensed spectacles). As to the maternal caressing scene, we have a physical sensitivity and gentleness from Davis that go far beyond her character's desire to help the young girl, a desire that has been fully spelled out in previous scenes. Here she is bonding with Tina and with Tina's father at once: letting all her reserves of tenderness flow. But at the same time Davis is letting loose her strict and controlling personality, relaxing into a moment of pure feeling that powerfully, if briefly, seems to transcend the movement of the plot.

Even the frequently stolid John Wayne is transcendent in *El Dorado* (1966), as, paying a call to the closely guarded haunt of the malevolent rancher Bart Jason (Ed Asner), and finally ready to take his leave yet wary that Jason will have one of his boys plug him in the back if he just turns and rides off, his Cole Thornton puts his horse in reverse and backs him out of the Jason compound in one fluid pan shot that shows off Wayne's skilled horsemanship.[2] Here the action is emanating from the actor's thighs and lower spine, since his eyes must remain fixed ahead on Jason and company,

his hands at the ready if he needs his gun. While otherwise in this film Wayne's performance is a predictive "star turn," a call for the viewer's recognition and affiliation, at this particular moment and for just a few seconds he inserts a phrase of virtually silent transcendent performance.

Wayne was eminently capable of eclipsing his star image. Edward Countryman astutely observed of his 1940s work that Wayne "did more than play to his emerging stereotype. . . . His cultural power by the end of the decade stems not only from his enduring 'John Wayne' qualities, but also from the complexity that he brought to many of his roles." Moreover, "Duke had made John Wayne into a mature, accomplished actor of depth, complexity, and skill, not just a persona or a star" (218; 234).

Wondrous Strange

Transcendent and predictive performance can be spotted across the spectrum of film performance, a companionship between the uplifted and uplifting character, who moves us to engagement and thrilling sensation, and the performer displaying technical prowess in a wholly recognizable way. For a young actor—Hepburn playing Linda in *Holiday* (1938) or Susan in *Baby*—the long breathy speeches or spectacular physical upending constitute a transcendent cadenza, displaying technical craft principally to mobilize dramatic involvement. Therefore, given that there are many different kinds of performance in play when we watch acting on the screen; given that performance styles and contexts are so variegated, that a viewer's biography and sensitivity can so influence the fluctuations of the moment, and that any performance might be infected by the memory of other perhaps quite dissimilar performances (for actors and audiences alike), it is not strange that the moment of action can be confounding. When we are touched by it, the moment of action is a riddle that goes to the deepest core.

Italo Calvino observed in *Invisible Cities* that no one of us is so very unlike other people: "And the mind refuses to accept more faces, more expressions: on every new face you encounter, it prints the old forms, for each one it finds the most suitable mask" (95). Every time we watch a star onscreen—Cary Grant, Sandra Bullock, Jake Gyllenhaal—we are witness to a body that somehow resembles one we have seen before, even (and this is the movie star's ideal) a body that resembles *this* body as we have seen

it before. To think deeply of the freshness of a performance is to begin to see how variable it is—even, sometimes, how surprising. Theorizations of screen performance can fail by leading us to think the predictability, conventionality, and institutionality of an actor's persona are invariate. Hepburn's generally staunch and brusque energy and heady personality may occlude her powerful feeling and airiness, of the sort we see in *Baby*. Wayne's strong masculinity and halting speech may obscure his balletic grace.

I have considered performative freshness here, noting "predictive" and "transcendent" moments, merely for the purpose of demonstrating one way of thinking seriously about cinematic performance. Freshness is but one of a number of aspects of the challenge that confronts actors and those who watch their work. Other aspects might claim our attention, too: originality (quoted or unquoted performance), embodiment (performance indicative or passive), reflexivity (self-conscious or innocent performance), encasement (performance addressing costume or neglecting it), to suggest only a few. When we take account of the myriad narratological demands of the performance; add to these the technical details which make acting torturous or easy, and the requirement in film that some scenes be played very precisely, even at the expense of numerous rehearsals and takes, since the lens can make a gesture seem so very proximate; and remember that when we see acting we are seeing a record of real people really laboring in real conditions; then suddenly the biography and career of the performer become less interesting than the specific experiential happenings of the moment. So many and so varied are the moments of fantastic performance we can remember, that no volume, no single theory or group of theories, no one history, no one observation can encompass them all. And the difficulties involved are sufficiently daunting that, in some way, all performance is fantastic performance.

Screen acting has its own special place. Every acted moment, finally, is put into the record once, and, given the technical features of that record—the film stock, the storage conditions—endures through time. While often in screen acting we catch a trace of life, we may just as well be catching a trace of death. As vivacious as the actors seem to be in their character work, they are also ghosts. And as much as we feel we know them, recognize them, understand them, they remain indecipherable, unmet, and wondrous strange.

2

Beaux Gestes

Before language comes the gesture. Inherent in the body, exuded as an unfettered expression of the body or a manifestation of the body's intention, the gesture speaks more directly than words. But when we see performance, from which body is the gesture emanating, a spiritual body or a rational one? Victoria Duckett reminds us how by the late nineteenth century "the old oratorical style of acting that had associated physical gesture with the animation of spirits that accompanied a song-like chant of verse was replaced by a new emphasis upon the physical body as an expression of rational intellect" (28). And in *The Body in Question*, Jonathan Miller writes perceptively of the "pantomime of complaint" performed for their physicians by patients experiencing pain (33). If in performance the body of the actor and the body of the character are co-present, could we take a pantomime of complaint as evidence about the character only? Or might the actor be speaking in the character's stead?

Frank Tashlin's *The Disorderly Orderly* (1964) is a funny but insightful essay on gesture and its topology, with the principal character, Jerome Littlefield (Jerry Lewis), suffering from an "empathy disorder" that causes him to intensely feel any symptoms the patients report in the sanatorium where he works. Because Jerome is Lewis, by the time of this film internationally known as a physical comedian who stretched his gestures as part of his comedic persona, it is virtually impossible to be certain whether the extremities of expression he offers are coming from (a) Jerome in his professional capacity, putting physical shape to the patients' symptoms as a way of confirming and registering them; (b) Jerome in his private, inner

capacity, as a young man actually feeling what he shows as possible in a feelingful body; (c) Jerry in his professional capacity, making broad gestures to maintain his public persona, not infused into this particular character; or (d) Jerry as a person, who while the camera turns is actually in pain (for years Lewis was medicated for spinal agonies because of early pratfalls). Is Jerome Littlefield genuinely gesturing, or is he a mere puppet being worked by another J. L.? (See further Fischer.)

When we see what someone looks like—pose, expressiveness, connection to other bodies—what can we hope to know of the deepest sensibilities lying within? The clue to the relationship between inner and outer worlds is gesture, the shaping of body that is taken as an expression of meaning. In the *geste* lies more than a mere spontaneous contraction of muscles, a mere enervation or spasm. The *geste* speaks, but also shows what cannot be spoken.

A Performed Gesture: Norman and Norman

In Hitchcock's *Psycho* (1960), just after Marion Crane's experience in the Bates Motel shower, Norman (Anthony Perkins) comes flooding into the scene, looks into the brightly lit bath, then recoils back into the darkness of the bedroom, spinning his tall and lithe body—clothed in his wide-wale corduroy sports coat—through a hundred and eighty degrees, so that his back is flush against the wall adjacent the doorway, and jerking his hand up to cover his mouth. It is his left, not his right, hand. This is important graphically since the doorway is just screen left of him and his right hand coming up would have partly occluded that patch of brightness and interfered with the elegant composition. But also, he is "bending sinister," in the particular sense of showing urgency, fever, and panic; retraction rather than dexterity. If Norman was on the point of screaming (or projecting a more visceral gesture, such as by regurgitation), he is stifling that urge, holding it back, packaging it. His body has now become a girdle for his sensibility. The fingers are rigid as bone, providing for an ultimate stop with which to plug the potentially gurgling tub of his emotional self. What is affecting about Norman's movement is that he throws himself fully against the wall, quite beyond simply backing away from the door. There in the shadow, where only we can see him, he retains something with that hand as his eyes open wide in a double rictus of apprehension.

Does one not wish him to release that hand, and scream? Is there not desire for the voice that is being withheld—not for the content of its potential utterance, but just for the quality of the voice itself, the quality such as was revealed and offered by Chaplin when in *Modern Times* (1936) he sang his nonsense song and dissipated the world audience's imagination of hearing the Tramp's voice by replacing it with the gesture of the voice itself? ("It's vulgar!" we hear a woman complain in *Singin' in the Rain* [1952] after a preview of sound cinema.) In *The Man Who Knew Too Much* (1956), with Doris Day's Jo McKenna in the Royal Albert Hall, we heard at a climactic moment a rending scream when we didn't want to; and now with Perkins's Norman we don't hear one when we do. This image as a world that accords with our desire (as *Cahiers du cinéma's* Michel Mourlet once described it) does not transgress or defile us, but it also does not fully satisfy. It signals the confounding of desire.

It is conventional in both everyday and scholarly discourse to save the word "gesture" for a notably and sharply expressive bodily posture or movement, such as Norman's recoil. To read about gestures is to find descriptions of tilted hips, raised fingers, cheeks sucked in, and eyebrows raised in terror (Darwin), hands moving in front of the body as one speaks, and so on. Gestures of this sort—call them "indicative embodiments"—are a staple of the actor's trade, or surely were, before the late 1990s when action cinema flooded them away with extravagances of staging and repetitive use of the long lens. A classically trained actor will have a repertory of indicative embodiments for inserting into dialogue and action, to color the character's intent, alignment, and feeling. Fascinated by the "imperceptible passage of attitudes or postures to 'gest,'" what he calls "the link or knot of attitudes between themselves," Gilles Deleuze quotes Jean-Louis Comolli speaking of John Cassavetes's cinema as being one of *revelation*, "where the only constraint is that of bodies" (192) and where characters "define themselves gesture by gesture and word by word as the film proceeds. That is to say that they are self-creating—the shooting is the means whereby they are revealed, each step forward in the film allowing them a new development in their behavior, their time span coinciding exactly with that of the film" (326). Jodi Brooks suggests of *Love Streams* that "like so many of Cassavetes' films, [it] is built around and through the gestures of crisis and a crisis of the gestural sphere" (77).

The "catastrophe of the gestural sphere," Brooks points out, was defined by Georges Gilles de la Tourette (in 1885) as the "staggering proliferation

of tics, involuntary spasms and mannerisms" constituting the syndrome that came to bear his name. The sufferer "is incapable of either beginning or fully enacting the most simple gestures; if he or she manages to initiate a movement, it is interrupted and sent awry by uncontrollable jerkings and shudderings whereby the muscles seem to dance (chorea) quite independently of any motor purpose" (Agamben 150, qtd. in Brooks 78; see further Sacks "Witty"). Through intensification, the gestural act becomes a tic, a symptom.

As the same gestures that actors employ are already gathered in cultural modes of expression (Tourette was interested in measuring conventional modes of gesture as well as cataclysmic ones), audiences are "naturally" capable of reading actorial gestures directly, and are in a position to treat them as back-channel communications that either bolster or contradict what is said in the dialogue. The scene in *Psycho* where Norman undergoes polite interrogation from Arbogast the private investigator (Martin Balsam) contains in Perkins's work a masterpiece of gestural back-channeling, with Norman's stuttering, staring, lip twitching, and gaze flicking denouncing the words coming out of his mouth. A masterpiece on an even higher order is the silent love scene played out by Audrey Hepburn and Gregory Peck in the finale of *Roman Holiday* (1953). The rigid formalities of grand protocol prevent Hepburn's princess and Peck's newsman, who have fallen in love, from openly speaking their feelings to one another, so they are forced to communicate by means of increasingly desperate gazes, seen through close-ups.

Actors are perennially searching for ways to move out of, through, around, and beneath the text, by means of contradiction, augmentation, embellishment, denial, or the planting of ambiguity. Linked to but not contained within speech, gesture can provide a convenient way of handling this essentially decorative problem. Through gesture, possibilities are broached for sarcasm, mockery, and other forms of play. In *Le Weekend* (2013), Jeff Goldblum carries on a serious conversation with Jim Broadbent while incessantly nibbling hors d'oeuvres, a gesture that both separates his attention from what he is saying and leads us to think of him as a man who thinks about many things at the same time. Speaking musically, the gesture enacted playfully is an orchestration of the spoken or acted melody, a way of fleshing it out that adds color, nuance, and personality. In prose this particular form of gesturing is impossible, since prose contains no channel by which an author can signal from his body to contradict or otherwise

embellish what he writes. Oddities of punctuation, poetic metaphors, and the like can be useful for making "textual" gestures, but not authorial ones, except insofar as we tend to take texts as emanating from, and thus intrinsically associated with, authors. When an author wishes to deny what he is saying in a sentence, he must compound it with other sentences between which there is a calculated incoherence. Goldblum in his performance can vary the rate at which he pops tidbits into his mouth, or the speed of chewing, or play with holding things on his tongue, *as* he speaks. It is a virtual cadenza of gestural expression.

"Real" Performance

Toward the end of the nineteenth century, there was a significant cry for performative realism.[1] This came from Nikolai Gogol in Russia, J. M. Synge in Ireland, and Émile Zola in France, the latter of whom, prefacing *Thérèse Raquin*, "stated his determination to base dramatic work on scientific methods of observation" (Crawford, Hurst, and Lugering 214). Zola "wanted to open the eyes of the public to the possibilities in new forms and new subjects, . . . wanted segments of life (*tranche de vie*, or slice of life) to be represented onstage in exact duplication, as in a photograph" (215). This impulse appears in painting as Impressionism from the early 1870s, and is fulfilled, of course, in the earliest cinema, especially in the works of the Lumières, who "caught" life in its flow and revealed personae in beautifully flickering spasms of quotidian reality.

The earliest "actors" in cinema were not actors at all, in the sense of the term we use today. They were people of the everyday, temporarily behaving in front of the camera. It wasn't until the end of the first decade of the twentieth century that D. W. Griffith began to film stories using "performers," and Lillian Gish, for instance, didn't work for him until 1912. As acting for camera developed it became more and more expressive (because it worked through mime), posture and gesture reaching an interesting apotheosis with noir films of the 1940s and 1950s in which lighting, editing, and lens choice worked together to help form and frame the actor's expressivity. In his *Touch of Evil* (1958), for just one example, Orson Welles has Russell Metty photograph the bedroom chase with Akim Tamiroff and his own excessively bloated Hank Quinlan using wide-angle lenses, and from below, with very high-contrast lighting. By the 1960s actors were "relearning" what originally

had not been learned at all: how to simply be in front of the lens, or how to give the impression that that was what one was doing.

In *Reframing Screen Performance*, Cynthia Baron and Sharon Marie Carnicke work to establish a theory of realist acting—"acting choices that seem natural" (182)—while balancing to some extent on the intellectual "shoulders" of James Naremore's *Acting in the Cinema*:

> The physical details of a performance become more noticeable when they include strange, overt, or what Naremore refers to as ostensive gestures and expressions. By comparison, the concrete details of a performance can be easily taken for granted and thus overlooked when they include gestures and expressions so familiar to audiences that they seem to be drawn from everyday life. (182)

Suggesting that "when actors use naturalistic styles, moments of 'expressive incoherence' violate realism's demand for consistency of character and expose actors' use of physical and vocal signs to portray characters," Baron and Carnicke assert in summary that "contemporary forms of realism and naturalism give priority to creating transparent performances that draw attention away from the concrete, opaque aspect of performance elements" (183). These and other theorists of realism—in acting and in imagery— frequently elide the problem of indexicality that sharply riddles perception and thought. What leads us to think of one gesture as exaggerated, thus fake (and dramatically expressivist), and another as "just like" the actual world we already know?

The Flower of the Gest

The bodily gesture as a foundation of characterization: where is it germinated? Given that with cinema we can never really see *in*, that, as Sylvie Pierre writes, "one of the weaknesses of the cinema" is "its right and proper inability to explain the inner world, since all it can literally grasp are external signs" (324), how can the gest be attached to a motivating force? Indeed, is it not important to reach inward and backward in the hunt for such a force? Must the gesture's "origin" reside in its effect?

One interpretive possibility—the one most viewers employ most of the time—is a direct read, in which the actor's body is located by means of

the avenue of gestural embodiment. A scene in Hugh Hudson's *Greystoke: The Legend of Tarzan, Lord of the Apes* (1988), illustrates. John Clayton (Christophe Lambert) is heir to the Greystoke fortune and estate, having been abandoned as an infant by his parents during a horrible raid in the African jungle, having grown up with the beasts there and become their equal and their friend, and now having returned to the greenswards of England. He is being feted by his doting grandfather (Ralph Richardson) at a huge, quintessentially Victorian banquet table surrounded by pompous guests. Demure chatter, elegant postures, wavering candlelight, delectable—if often animal—food. When the soup is poured, John does not grasp a spoon but instead picks up his bowl and artfully slurps. Deathly silence from the tuxedoed and begowned guests all round, until the old man breaks into a cheery grin, giggling, "Right! Of course!" and tries out this newfangled way of dining himself.

With his extended array of gestures, Lambert is fully convincing of his alienation from a surround such as this, his homesickness for the animal world here so artfully suppressed. When he picks up his bowl with both hands there is thus nothing untoward in the movement; it is what is to be expected of the deep soul (Tarzan) beneath the superficial shell (John), cut off now from his true community. As the old man slurps, however, we know from his own dignified, slightly brittle posture that his is a fresh, even virginal gesture, a recapturing of the joys of unfettered boyhood. The old man is mimicking John much as, showing his remarkable ability to imitate the animals of the jungle, John mimics nature.

Yet the gestures are so profoundly embodied their source must reside in the most embodied presences, that is, the actors' physicalities. What John does is coming from (newcomer) Lambert; what the grandfather does is coming from (aged and much esteemed) Richardson. Just as the grandfather is happily imitating the grandson he is so happy to have back home, the elderly Richardson (this was his final film performance) is overjoyed to imitate the fresh young discovery who has been cast to play against him. To go a step farther, it is by means of the gestures that we sense the actor's presence.[2] In *Vivre sa vie* (1962), Godard has an unknown man make the case that thought is impossible without language, but here Richardson and Lambert vivaciously give the lie to this. The thought is entirely embodied, entirely spontaneous—and fluid.

A wide range of filmic moments support a similar way of seeing: James Dean lifting a glass milk bottle, fresh from the refrigerator, to his forehead

in *Rebel Without a Cause*; John Travolta swinging paint cans as he strides the sidewalk in *Saturday Night Fever* (1977)—both eventually iconized, but not iconic at their origins; Marilyn Monroe reaching for a flask strapped to her thigh in *Some Like It Hot* (1959). Not only is Jim Stark overheated and off-balance, Dean is, at this moment, as well. Not only is Tony Manero happy as he moves musically into his future, the young Travolta in his breakout film role is, too. Not only is Sugar Kane showing the lucky talisman strapped to her body, Monroe is (she and Billy Wilder weren't getting along while this movie was being made).

Also possible is a reading strategy that takes the visible gesture as evidence not of the actor's presence and personality but of his training, a telltale sign of skill. The gesture shows not what the actor expresses, then, but what he knows how to simulate expressing. When in *Marathon Man* (1976) Laurence Olivier stares into Dustin Hoffman's sweaty face in the dentist's chair, the penetrating clarity of the gaze is pure technique, of the kind that can also be seen from the same performer in *The Prince and the Showgirl* (1957), *Rebecca* (1940), *Richard III* (1955), or *Wuthering Heights* (1939). Far from only pointing to characters, this brittle, cold, bladelike gaze is an Olivier trademark. It indicates his character's acuity, but at the same time his own deftness in controlling, with tiny modulations, the action of the *orbicularis oris*. John Barrymore was able to vary the elevation and amplitude of his voice with prodigious skill, and his phrasings thus act as acoustic gestures pointing perhaps not so much to the emotive content of the dramatic moment as to the preparation and concentration of the actor.

Effects Gesture

Direct gesture flows out of the actor's body without mediation. But there is another possibility, remote from direct gesture, involving the performer's connection to visual effects. Effects gesture is especially riddling. In what is called "motion capture," we see the character making gestures that originate in an actor's musculature, but that actor is not sharing a body with the character as happens in conventional performance. Strictly speaking, the character has no body at all. The motion capture makes possible "a vision of matter itself as animate," as Tom Gunning notes ("Gollum" 348); and does this without requiring the performer's person to be available beside or beneath the effect. While Stephen Prince writes that "the actor is there

but must be discerned through the digital make-up, at the interior of the
effects rather than their exterior" (116), I think we shift here to a certain
rendition of discernment itself, not actually seeing the present actor but
imagining him by way of a concerted effort to move through the "mocap's"
rendered characterological surface, which in itself is typically dense and
all-absorbing. This imagination becomes our new "discernment."

David Conley, who was responsible for the tiger animation in *Life
of Pi* (2012) and much of the ape animation in *Rise of the Planet of the
Apes* (2011), as well as animation in *Avatar* (2009), *The Lord of the Rings*
(2001–2003), and numerous other films, noted to me how in the process
of keyframing, only every hundredth frame is actually photographed. The
intervening material is computer generated, with "plot points"—tiny nodes
on an elbow, a wrist, a hand, etc.—inserted every five frames or so to indi-
cate how a limb must move. Mechanically the process works by having a
performer in a gray or colorless suit, covered over with little colored ping-
pong-sized balls or LED lights, moving around a space called a "volume."
Tracking marker dots are laid onto the performer's face with facial paint,
cream, or latex paint. Cameras are "usually loaded up onto a grid that is
hanging from a truss on the ceiling. Those cameras capture each ball and
track them through space. This creates a 'data cloud' or 'point cloud.' From
that we can determine each point as a representative value." "Some actors,"
Conley said,

> absolutely despise the process, don't want to have anything to do with it.
> Some, like Andy Serkis in *Planet of the Apes*, embrace the technology fully
> and find it an immersive experience. It helps them become the charac-
> ter. . . . Some try to go somewhere but are uncomfortable in the latex outfit.
> The vain actors realize we are keyframing their performance and they want
> to wear a head rig with an extender bar that puts a wide angle in front of
> their face, so it films every single movement of the performance. The peo-
> ple who embrace it a lot more are typically theater actors. They're used to
> working to an empty space, having minimal sets. Movie actors tend to be
> very still, they know the performance is in the close-up so they don't know
> how to move through space. (conversation)

The performer mobilizing for animation requires a considerable imagina-
tion. *Avatar*, for example, was shot in a warehouse: "We would give them
concept art," said Conley, "so they could understand where they were going

to be." Still another problem involves character interactions. In shooting *Lord of the Rings*, "Ian McKellen was fantastic, hit his mark every single time, but he didn't know who he was talking to or what he was seeing. It was frustrating for him . . . he's a classically trained actor acting opposite somebody who isn't there."

There are other types of "effects" acting beside performance capture. In the various early chapters of the *Star Wars* saga, some scenes are played out by human actors posed in company with puppets (Princess Leia with Jabba the Hutt). As in other cases of puppetry, the puppet's characterological strength is here typically derived from the living actor's careful responsiveness (a technique that was notably developed by Fran Allison working with Burr Tillstrom's puppets on TV's *Kukla, Fran and Ollie* [1947–1957], then explicitly expanded, and with song, in Charles Walters's *Lili* [1953]). The more artfully an actor regards the puppet's fabricated "flesh" as flesh itself, the more fleshly the puppet becomes. "I am still not certain what it is that survives *in* the puppet," writes Kenneth Gross, "what spirit or what forms of possibility preserve themselves along with the material substance that shapes the puppet. Its hunger is not entirely a human hunger. The one thing that seems clear is that there is uncanny force inherent in the very poverty and transformability of the puppet, in how readily it offers itself to use, offers itself for a dangerous relation to the world" (107). In his film *The Errand Boy* (1961), Jerry Lewis plays a scene with a puppet that gains a "dangerous relation to the world" exactly by virtue of its interrelation with the fragile, always precarious being that Lewis incarnates onscreen.

As we experience it dramatically, flesh can also be phantasmal, therefore so can gesture. Gaby Wood recounts "F. Scott Fitzgerald having a violent reaction to the Siamese twins [of Todd Browning's *Freaks* (1932)] when they sat down next to him" at a social event (237), for example, and notes:

> It was once fashionable, in circles of what now seems like pseudo-science, to try to identify whether an oddity exhibited at a fair or dime museum was actually a new species, or a *lusus naturae*. The Latin term is generally translated as "freak of nature"; but the word *lusus*, taken in this context to mean a mistake, is actually a noun derived from the verb *ludere*, "to play." (238)

In David Lean's *Blithe Spirit* (1945) Constance Cummings performs gesturally as a traveling matte. Running out of a doorway toward a carpeted staircase on which Kay Hammond (in green ghost makeup) is seated,

Cummings mounts and passes clear through the sitter. The effect is accomplished by cutting from the establishing shot—in which both actresses are fully embodied—to a closer one as the runner approaches the ghost, in which Cummings is not a co-present body but an optically printed traveling matte. Cummings's form appears to pass through Hammond's on its way up the stairs. While Hammond, seated, is technically the one who is fully present, because of her garish green makeup she takes the form of a spirit so that her character seems only "present." Cummings's Ruth Condomine, in practical fact not there, seems to be fully present. The two "presences" are presented through variously effected presences, one during principal photography and the other in post-production (since a basic shot with Hammond alone on the stairs must be part of the final optical composition).

A sad if remarkable case of "effects" performance is to be found in Leo McCarey's *My Son John* (1952), the story of a young man (Robert Walker) alienated from his über-patriotic parents (Dean Jagger and Helen Hayes) because of his communist beliefs. Principal photography was completed in June 1951, but on 28 August, the day on which McCarey needed to film some additional material, Walker perished at home from an untoward medical injection of sodium amytal (which was administered, as some stories have it, against his will). Many shots were duplicated from Walker's starring appearance in Hitchcock's *Strangers on a Train* (1951) and inserted here, so that the "Walker" performing in *My Son John* is in some instances Walker himself and in others a cinematic ghost borrowed from another film. A similar ghostliness pervades Dean's iconic work in *Rebel*, seen by audiences for the first time a month after his death. With both films it is easy enough to imagine a living actor beneath the character we are watching; but what is problematic is linking the currently visible vivacity of the character to the troubling knowledge that the performer is gone. Of course, viewers today looking at movies from Hollywood's golden age have this experience all the time, with the gestures shimmering onscreen originating in bodies no longer alive; but the "classical" (read "old") quality of the film prepares viewers for the required juxtaposition of present sight and defunct performance. In *My Son John*, it is only the invisible substitution splice that inserts before the viewer's eye an acting body unconnected to the film.[3]

In *My Son John* and *Rebel* a character turns out to be embodied by an actor no longer alive at the screenings yet alive at the time of filming. The peculiar fascination of the McCarey film lies in its use of footage made

for another film, so that even though the performer was alive at the time of filming that material, he was not alive *for this director*. Here, as always in cinema, the actor remains "alive" to the viewer to the extent that the performing body expresses and moves in apparent real time as the film unspools. The life of the performance before the lens is extended through the reproduction of the film and its enduring through time (this a particular case of Walter Benjamin's more general observation about mass reproduction and its effect upon the distinctive aura). André Bazin had noted the "naturalness" in the plastic arts of "keep[ing] up appearances in the face of the reality of death by preserving flesh and bone," in the context of thinking through the relation between the cinematic image and mortality (9). In *My Son John*, considered *from the viewer's perspective*, death is defeated by cinematic tricks (until analyses such as this one, which give away the mortal secret).

Sometimes we can be looking at an actor who is not, and was never, alive but whose form, gesture, enactment, and manner all cleverly simulate aliveness in a way that transcends traditional drawn animation. For one case, the audio-animatronic models created by Disney's engineers for the Orlando theme park. These are elaborate mechanical servo-mechanisms covered over with a latex skin worked, modeled, painted, and then garbed for simulation. The audio-animatronics show up as diegetic characters in Bryan Forbes's futuristic misogynistic fantasy *The Stepford Wives* (1975), where the partners of a number of slick suburban businessmen seem suddenly too obedient and domesticated, far beyond what one might expect of any diligent human woman. It turns out the men are assassinating their wives and replacing them with robots. It helps not only the diegesis but also the production that the "new wives" are virtually identical to the living women they have replaced: actresses made up to look like robots made up to look like actresses.

Similarly challenging to a viewer's perception are the wax replicas in the Musée Grévin (in its earliest days, home to a *Théâtre optique* through which a picture strip could be wound past a projecting lantern [see Mannoni 380ff.]). Not only are the wax figures visible there today worked with extraordinary finesse to simulate recognizable people—Michael Jackson, Jean-Paul Sartre, Charles Aznavour, George Clooney, Marilyn Monroe, and Jean Réno when I visited in 2012—but they are artfully posed in beautifully made theatrical settings simulating some "natural" environment. Aznavour, for example, was sitting just in front of me in a perfectly executed small French theater, waiting patiently in his padded seat for a

performance to begin. I sat to have "coffee" with Sartre at a tiny café table: he would not turn to look at me, but when I could arrange to be photographed with him from the right angle, he seemed entirely and enthusiastically present as my chum.

All of these figurations stem from the automata that were a staple of entertainment and a pillar of fascination for scientists, artists, and the general public, with wind-powered devices dating back to the eighth century (and others considerably before). In his comprehensive volume *The Shows of London*, Richard Altick gives accounts of numerous entertaining automatons and their homes, including Jacques Droz's *Spectacle mécanique* and the fabulous mechanical flute player and mechanical gilded copper duck of Jacques de Vaucanson, the latter of which "executed accurately all [a natural bird's] movements and gestures, it ate and drank with avidity, performed all the quick motions of the head and throat which are peculiar to the living animal, and like it, it muddled the water which it drank with its bill" (Brewster 268, qtd. in Altick 65). Also, notes Altick, "it quacked, and spectacularly engaged in digestion" (65).[4] Similarly flamboyant automata are part of the Sultan's (Miles Malleson) rich collection in Michael Powell's *The Thief of Bagdad* (1940). A mechanical horse is animated not by the sorcerer Jaffar (Conrad Veidt) who has gifted it, as is made to appear, but by the film's editor Charles Crichton, who joins a shot of Malleson in the saddle, tugging on the reins, to one of him upon an actual horse. When the animal races off the parapet and into the sky, the filmmakers make use of a glorious traveling matte. Martin Scorsese's *Hugo* (2011) pays loving homage to the automaton as an equivocal being, at once mechanical and utterly spiritual, at once false and shockingly true, that in articulation of limbs, opening and closing of mouth, twisting of head, and so on manages to seem both robotic and personable in a "breath."

Stunt Gesture

More routinized in screen acting, more invisible, and thus in a way more disturbing is another sort of effect, which could be called the stunt gesture. A striking example can be found in Michael Anderson's *The Wreck of the Mary Deare* (1959).

Gideon Patch (Gary Cooper), former first mate of the sunken *Mary Deare*, is convinced that the ship's owners have stolen a weapons cargo

they were paid to transport. He consorts with a freelance salvager, John Sands (Charlton Heston), to voyage out to sea one night, while the ship is being raised hydraulically on court order, and they sneak aboard to check the hold. What Patch expects is that they will fail to find any weapons at all. Since this sequence of stealth and discovery is dramatically climactic for the story, it must be shown carefully. The viewer is treated to a rather long passage in which Patch and Sands, wrapped in scuba gear, make their way underwater to the skin of the wreck, then enter it through a gaping hole, and through the dark depths navigate their way into the cargo where they discover that, yes!, the boxes piled there all contain not weapons but rocks. Now, however, the evil company agent Higgins (Richard Harris) has sealed a watertight door behind them and their only escape is through a chamber where he stands in waiting with a harpoon. Through all of this exciting action we are watching the pair from above and from beside, as they swim with their flashlights in the murky, glaucque water.

The visual rhetoric is that we accept Patch and Sands more deeply as Cooper and Heston got up in diving gear; that is, we take ourselves to be watching a character Patch who is truly and deeply the actor Cooper, and a character Sands who is truly and deeply the actor Heston. Through considerable earlier work onscreen, Heston in *Touch of Evil*, *The Ten Commandments* (1956), *The Naked Jungle* (1954), and *The Greatest Show on Earth* (1952) and Cooper in *Design for Living* (1933), *High Noon* (1952), *Sergeant York* (1941), *The Fountainhead* (1949), and *Love in the Afternoon* (1957)— for both, among many other films—these two had established themselves as vigorously masculine, athletic, agile, and brave: men who really could be underwater on this long trek. But we are not (and actually cannot be) seeing Cooper and Heston at all. Until the culminating moment of the sequence, we are watching stunt divers at work (covered by insurance) and systematically denying their presence as we convert them into the actors we know from watching the film (who have been converting themselves into their characters). If to the viewer's expectant imagination Cooper and Heston were visible as themselves "beneath" Patch and Sands, the stunt divers are surely not. In *My Son John* an actor's former incarnation is duplicated and inserted into the action as a current one; in *Mary Deare* the incarnation of stunt doubles is inserted into the action, in an extended way, to replace missing actors: not just for a special shot or group of shots but for a whole narrative sequence. It is only when Patch emerges from the water, strips off his mask, and confronts Higgins and his thugs that we

discover the Gary Cooper who laid the plans for this expedition several
screen minutes previously.

These various exemplifications make clear not only that an actor need not always be present in order to appear in a film but also that the presence of the performer is a riddling and complex affair, although we take it straightforwardly as a constantly supporting and mobilizing aspect of the drama. The way in which an actor is *not there* when his character is *there* affects, as we consider and digest it, our deep experience of the filmic moment.

Cinematic Gesture

Gesture in cinema can be taken to mean a performer's accomplishment only: a production or excrescence of the performative body that renders a situation palpable and a character's attitude and motive physical, thus accessible and direct. Marilyn Monroe reaches down in a hopeless effort to keep that white skirt from flying up into her face in *The Seven Year Itch* (1955). Or, in *Taxi Driver* (1976), Robert DeNiro tosses his head, looking at himself in the mirror as he asks, "Are you talkin' to me?" Lesley Stern offers a keen analysis of the histrionic gestural code as employed by DeNiro as Rupert Pupkin in Scorsese's *The King of Comedy* (1982), noting how in the history of film performance "histrionic performers used stylized conventional gestures with a limited lexicon of pre-established meanings" ("Acting" 282; and see further Solomon, "Laughing" 19ff.). In *King*, this histrionic code, visible throughout, becomes the stuff and matter of Pupkin's finale stand-up performance, after he has emerged from prison and has gained an astounding reputation. Here, as in a scene only moments earlier when he stood in a bar watching himself on television with the sound off, the sound is reduced utterly, and what we see is a man in flashy garb moving his mouth and facial muscles to the accompaniment of simple but emphatic hand and arm gestures: "I gather up, I sweep away. I gather up, I sweep away."

Any screen performance in its final edited version is a long, fluid chain of expressive gestures taken in this elemental sense, each with topical meaning in a depicted or referenced circumstance. Through the gesture chain, we see or imagine the flowing linkages, first between the character's perceivable body and its double—an unperceivable "soul"—and then between

the lined-up circumstances in a causative order, the process of the story thus working forward from node to node. In *The Thin Man* (1934), Myrna Loy frowns playfully at William Powell; then Powell frowns playfully at her; a tiny chain is made. The film becomes an interweaving of such chains.

In conversational action, actors produce reflective gesturings that take account of one another's work and further the action of the moment. We can look at Stuart Rosenberg's *Cool Hand Luke* (1967), for example, and find Clifton James pacing back and forth in the prisoners' barracks, a cold damp cigar in his mouth, detailing infractions that will lead any of them to spending a night "in the box." As he paces, portly and grimacing, he is shown mostly in Dutch angles from beneath, and in wide angle, his large body spreading upward and across the screen as he goes through the litany of punishments. "Any man plays grab-ass spends a night in the box." Suddenly we jump to the face of Luke (Paul Newman), smirking at the idiocy of these rules. Newman's facial work, and James's vocal and facial work, are intermeshed, partly through the editor's cutaway and return and partly through the actors' foreknowledge that the scene will be edited in this way and commitment to making their respective behaviors inter-motivating. The same inter-motivational concentration is shown with Anton Walbrook and Moira Shearer near the conclusion of *The Red Shoes* (1948): the impresario Lermontov (Walbrook) has stepped onto a railway coach on the Côte d'Azur to chat briefly with Shearer's Vicki Page (the star who has left his domination for a life of married happiness), hoping that his sweetness and good intentions might bring her back to his ballet company. It is a two-shot. He has been in the compartment doorway at the rear of the shot, looking forward at her, and has now seated himself at her side. She sits in the foreground staring past the camera out the car's window. Every syllable he utters produces a deeply intelligible and feelingful response on her face—"Nobody else has ever danced *The Red Shoes* since you left"—but he cannot see. When Shearer makes these gestures of expression, she is aware that Walbrook is blind to them but that the camera is not.

Gesture is more than a sign or sign system cultivated in body movement and drawn forth by culturally shared convention. More affecting is something broader and deeper that I would call the "filmic gesture." By this I mean a gesture articulated by the film itself, or one that the filmmaker makes by way of the film, signaling something that is typically distinct from, very often contrapuntal to, what is in the officially recognized diegesis. Returning to the case of Anthony Perkins's hand, we can note

that Hitchcock could very easily have "authored"—that is, indicated— 53
Norman's withdrawal and shock, his repression and disconnection, with-
out resorting (or permitting the actor to resort) to covering the mouth. A
face-on shot of the young man peering into the bathroom could have been
followed by a facial expression of shock in countershot. But the camera, in
this case, does not move to make Perkins's face visible. We linger behind
him in the bedroom, watch as he looks in the doorway, and see him haul
himself backward against the wall. The camera is paralyzed by his entry. If
we consider the quality of the hand move; the quality of the lighting that
partially reveals and partially hides it; the tenseness in Norman's arm and
hand as he clasps his mouth; the length and suppleness of the fingers; the
pressure of the hand pressing inward; the eyes, bulging like balloons; the
bright, antiseptic cleanliness of the bathroom behind (that is, in the past);
the sound of the water still running; and the frozen movement, we get in
sum a more complex gesture that transcends just the hand work, indeed
transcends Perkins's body as a production site. The film itself seems to
inscribe an exclamation point.

While he does not refer to it as such, it is the cinematic gesture George
Wilson is invoking when he writes about *The Searchers* (1956):

> In the opening scene . . . Ethan's brother and his family file out of their
> cabin onto the front porch to await Ethan's imminent arrival. Their move-
> ments, as they do so, have an odd, unrealistic, ceremonial character: it is
> as if they were executing a pattern in a peculiar, solemn dance. Suppose
> also (as I believe to be the case) that this fact about the manner of their
> movements occurs purely as a small figure of narrational instruction. The
> only reason for its occurrence is that it is to be *an initial sign or signal from
> the director* that, in this film, movement and spatial relations will have an
> unusual weight and special significance. (141; emphasis mine)

We can say "signal from the director" but we can also say "signal from the
film." The point is that narrationally speaking, one would have a more com-
plicated problem explaining the "odd, unrealistic, ceremonial" movement
as a signal from the characters either to one another or to some as yet
unseen observer. This movement, if and as it speaks, can be aimed only at
the audience.

How many ways may we see Norman's gesture if we hold it up, as it
were, and turn it in the light of thought? Is it an indicator of politesse—the

Beaux Gestes

blotting out of the oral cavity (that unholy aperture) in deep and private feeling? Or, as some scholars of gesture have suggested, an indicator of Norman's suspicion (see Mahmoud and Robinson)? Is this young man, perhaps, preventing himself from uttering something? Raymond Durgnat calls it a "silent cry" (132). Or perhaps Norman *is* uttering something, but uttering a falsity, and his "hand covers the mouth as the brain subconsciously instructs it to try to suppress the deceitful words that are being said" (Pease and Pease 148). (At this juncture in the story, any of these readings would work well enough.) The hand gesture makes a conventional speech, too, since in some ways this use of the hand is socially iconic: "Speak no evil," some nefarious thought presumably lingering inside the body, not to be externalized. Norman, we are to believe, has felt a statement, question, or observation welling up and has swiftly, almost instinctually, calculated the inappropriateness of letting it out here and now. He has determined that the voice in his head—a voice screaming in his head—should not be permitted to escape; has made a moral commitment to lock it up. "It is much easier to *inhibit* what you reveal in your words," write Paul Ekman and Wallace Friesen, "than what you reveal in your face. . . . The facial expressions that are triggered during the experience of an emotion are involuntary (although they can be interfered with)" (136). All of these ways of looking and interpreting cite the gesture as Norman's.

But if the gesture belongs not to Norman but to *Psycho*, perhaps even to film itself, it penetrates our consciousness more profoundly. Norman, like the film, is toothless, which is to say, following Marshall McLuhan's analysis, a creature without language:

> The Greek myth about the alphabet was that Cadmus, reputedly the king who introduced the phonetic letters into Greece, sowed the dragon's teeth, and they sprang up armed men. Like any other myth, this one capsulates a prolonged process into a flashing insight. The alphabet meant power and authority and control of military structures at a distance. When combined with papyrus, the alphabet spelled the end of the stationary temple bureaucracies and the priestly monopolies of knowledge and power. . . . Languages are filled with testimony to the grasping, devouring power and precision of teeth. . . . Letters are not only like teeth visually, but their power to put teeth into the business of empire-building is manifest in our Western history. (82–83)

Norman does not easily put teeth into his actions, does not permit himself 55
to use his teeth for biting off morphemes, and in fact denies the power of
teeth. Under other circumstances, teeth might clamp together to hold the
tongue back, but here in this deep and manifest toothlessness the hand is
required. Is there not, also, a shudder that passes through his body as he
holds that hand to his mouth? The mouth is invisible now but the hand is
stilled in a rictus of negation and absoluteness.

Oliver Sacks cites William Stokoe's observation about signing as lan-
guage. "Only signed languages have at their disposal four dimensions—
the three spatial dimensions accessible to a signer's body, as well as the
dimension of time. And Sign fully exploits the syntactic possibilities in its
four-dimensional channel of expression." Thus,

> signed language is not merely proselike and narrative in structure, but
> essentially "cinematic" too. . . . The essence of sign language is to cut from a
> normal view to a close-up to a distant shot to a close-up again. . . . Not only
> is signing itself arranged more like edited film than like written narration,
> but also each signer is placed very much as a camera: the field of vision and
> angle of view are directed but variable. (*Hearing* 89)

Given that Norman uses his hands gesturally at other points in the film,
signing is perhaps second nature to him (is his mother, perchance, deaf,
and not only to his wants)? But because of the way it places and empha-
sizes Norman's handwork, Hitchcock's film is signing that signing. In using
the silent signing here, Hitchcock's directorial gesture is aimed to heighten
our awareness of the filmic nature of his exposition.

Norman (like Perkins himself) "was an only child who lost his father
at a young age . . . and who, as a result, was raised by an overbearing single
mother in a household of suddenly and drastically reduced means" (Clark
157). He discovered his world away from other kids his age, tucked off
the main road, beyond the flashy precincts of contemporary civilization.
With his delicate smile, his endearing stutter, his boyish posture, he is
an old-fashioned young man, living out the etiquettes of the nineteenth
century. The hand-over-mouth gesture is also, then, a token of his style,
now very worn and out of date, yet perduringly charming. While hosting
Marion to milk and a chicken sandwich, he gesticulated with his hand so
as to stretch and open those fingers, point them upward and outward like

the plumes of a bird in distress. Norman is ostensibly conscious of his hands, using them with grace and forthrightness in doing routine clean-ups around the motel, fetching the guestbook and flipping it around for signatures, snacking on his veranda. In all of this he demonstrates extremity of civilization, refinement, superior ability. Rather than nosing around he handles situations, takes a hands-on approach, puts a hand to the solution of problems. He is a manipulator. "There is more and more evidence in biologic research," writes Frank R. Wilson, "that handedness may be nearly as old and as influential as bipedalism was in shaping human development and orienting our subsequent history" (151). In his bedroom, Norman has a phonograph disc of Beethoven's *Eroica* Symphony on his record player, and we can swiftly (the shot is very brief) imagine him reaching in and placing the needle by hand; then, with those two bold opening E-flat chords, imagine Napoléon and *his* hidden hand. Norman also possesses a much-handled teddy bear. And all of this emphasis on handfulness is inherited, since on her dressing table his mother has a pair of bronzed hands, folded in grace, a memorial to, and icon of, the centrality of hands—hands for praying, hands for collecting, hands for abiding in peace or for snatching in desperation. When Norman is pensive, worried, or apprehensive, he puts a finger to the corner of his mouth. For his hobby, taxidermy, he concentrates on creatures who do not have any hands, but makes a neat articulation of how they come to be stuffed: by the use of sawdust and thread, that is, through a hand job. Wilson again: "Before the fingers begin to work independently, two critical and apparently separate events in neuromuscular development are necessary: the arm must have learned to move to a target under the guidance of the eye, and the hand must have learned to orient and shape itself in preparation for grasping the target" (99).

Lesley Stern writes of "transplanted gestures" in Giotto, and notes how "gestures come into focus through juxtaposition, and resonance" ("Always" 34; 27). In particular she is eager to watch how gestures "are inscribed, how they are traced in the body of the film" (40). Sabrina Barton has suggested, "The 'perpetual commentary' humming through Hitchcock films is complex, suggesting that configurations of hands, genders, and identities are far more subtle, variable, and shifting than one might think" (65). With that solitary hand-over-mouth Hitchcock renders Norman expressive and repressive at once, old but young, brittle but supple, afraid and shocked but graceful and adept: in short, a living cluster of conflicted dualities.

It is clear enough that in the scenario Norman Bates is doubled: virginal and satanic, youthful and ancient, receptive yet bluntly opinionated, male and female (the hand gestures alone give this away), passive and active. To press only a step further: a Norman and his inner Norman, which is to say, two North Men, explorers from the northern zone. Listen to Leslie Fiedler describing the mythicized North in fiction:

> The Northern tends to be tight, gray, low-keyed, underplayed, avoiding melodrama where possible—sometimes, it would seem, at all costs. Typically, its scene is domestic, an isolated household set in a hostile environment. The landscape is mythicized New England, "stern and rockbound," the weather deep winter: a milieu appropriate to the austerities and deprivations of Puritanism. . . . In the field of the novel, the Northern is represented, in general, by books easier to respect than to relish. (16–17)

The Bates Motel is nothing but "stern and rockbound." And the weather that brings us there is inclement. *Psycho*, of all Hitchcock's films, is easier to respect than to relish. Always pushing himself further in his intrepid explorations (like the hero of the *Eroica?*) Norman climbs upward, narratively upward into the twist of the plot and geographically upward from the hotel to mother's high room, upward to where fictive immortals reside, and always with a secret companion inside whom that clasping hand will assuredly prevent from coming out.

Under Direction

With *Psycho*, hands are everywhere. We can step aside from consideration of Norman's hand-to-mouth gesture and find that in almost every shot a signal action or expressive gesture is committed through use of the hand. Marion touching Sam in the opening sequence, then holding and stowing the forty thousand dollars in the real estate office, but not before we find her office mate (Patricia Hitchcock) fiddling with her own hands. The hands on the steering wheel during Marion's agonizing drive away from the city. The hand of the patrolman reaching for Marion's driver's license. Marion in the washroom of the used car dealership fishing for seven hundred dollars and seen in a pair of mirrors. Marion signing Norman's guest book, then examining her bedroom at the motel and folding the money into a

copy of the *Los Angeles Times*. Marion reaching for the shower curtain. Marion moving her hands about in the shower. Marion stabbed, reaching for the curtain again, clasping it, pulling it down. Hands on knives. Hands reaching into pockets. Hands popping snacks into the mouth. Norman's expressive fingers as he speaks to Marion of taxidermy and how a boy's best friend is his mother. Arbogast flailing with his hand to catch the bannister of the Bates staircase. Lila's hand reaching for the Bates doorknob, or opening Mrs. Bates's wardrobe, or striking out at the hanging lightbulb. The psychiatrist's hand gesticulating as he diagnoses. Norman under the blanket, not even lifting a hand. What we have in *Psycho*, then, is no mere assortment of hand shots. The film is an elaborate construction handing us the idea of hand usage, focusing for us on what sorts of things people do in their "highly civilized" state. Hitchcock himself is gesturing.

Directors are hard to pin down as creators of performance generally, and performative gesture more specifically, because aside from retrospective anecdotes and only very occasional written missives during a spate of working activity the actual dialogue between filmmakers and actors is routinely unrecorded. Daily production reports indicate who was on a set but not what they said to one another. While anti-auteurist theorizing delights in rejecting the overwhelming creative force of the director as a structuring principle, there is reason often given in actors' interviews and commentaries, where their vulnerabilities and sensitivities are revealed, for supposing that at least some directors in their working methods, demands, suggestions, and managerial actions do much to shape performance. What seems like the actor's work is thus very often mixed with input from above or beside, input it is not always an easy matter to isolate and describe.

A useful example of a director explicitly guiding action can be seen in John Frankenheimer's communication to Burt Lancaster about how he should work to recast a locomotive bearing in *The Train* (1964). (Here and elsewhere, Lancaster preferred to do his own stunt and physical work.)

> As to the scene we are going to do tomorrow, I have had Lee Zavitz check and find out exactly what the procedure would be to fix a bearing that was burned out. Lee has all the material that we are going to need, such as the hot lead, the dies that you pour the lead into, etc. The idea of the scene being that we open up with you pouring the lead into the mold on the drive shaft and then swinging the drive shaft over to the engine on the traveling crane. (Frankenheimer to Lancaster)

Writing this way, the director is struggling to find words that will point to, guide, and ultimately effectuate—in another man's body—a physical gesture he wishes to photograph. That Frankenheimer feels the need to write out instructions in this way suggests that however well learned and professional may be an actor's involvement in his gesturing and response to suggestions and pressures from without, what he does is never to be taken as purely unreflected, natural, automatic, or spontaneous; nor, with money invested in production time, is it to be taken for granted.

Beyond gestures he might call for in the name of the drama, however, the director's manner in working with actors can be a gesture in its own right, a way of expressing feeling and intent with regard to the meta-narrative that is or will be the action of making the film. Compassion, understanding, sympathy, fraternity, and reassurance all help, and directors are in a position to explicitly indicate these to actors who are missing the main road. The message "I am here with you; I am helping; you can count on me for support" is the content of the directorial gesture at its strongest. In late 1971, Charlton Heston was starring in and directing *Antony and Cleopatra* at the old Hollywood National Studios. To Hildegard Neil, who was playing his female lead, he wrote:

> I must ask you to do your post sync with Peter [Arne] and Eric [Porter]. It will be the last of the many extra burdens I've put on you with this Everest of a role, but I am confident you will surmount this last crest as you have all the others in the part. . . . There are perhaps ten lines which I am convinced can be re-voiced to creative advantage. Peter and Eric will go over these with you, and I'm confident you'll agree there's a valuable chance for improvement. I remember it wasn't till I did a film for Orson Welles that I was totally persuaded that this could be so; I can only tell you it is basic dogma with me now. It's surprising how many subtle changes in emphasis and colour you can inject into a new reading without violating the sync. I honestly think it will make a measureable improvement in the overall performance, and, when added in to the changes of the same sort we've already made during all the rest of the post-sync on the other performances, will improve the film even more. As the Man said in another context, this is surely a consummation devoutly to be wished. (letter)

Here we see directorial gentleness and firmness, as well as a clear illustration of how the moment of shooting and the moment of post-synchronization

can significantly differ. Heston's courtesy in suggesting particular operational tactics to Neil is respectful, even doting. And his personal confessions have a way of annealing any unanticipated wounds, since the actor is always for him only utterly professional, competent, sincere, and thoughtful about her work. By telling Neil she has been "surmounting crests" in an "Everest of a role" he is paying a compliment; and in admitting that inflectional changes in post-sync are "dogma" with him now, he is invoking a kind of religious personal conviction any actor would find it hard to neglect.

Hitchcock's Gestures

Gestural performance reaches a crisis in Hitchcock's films. Here I have chosen one particular moment from *Psycho* to indicate the immense power of the simple bodily movement in narrative space. But think how many sharply defined and extremely evocative gestural moments there are in the Hitchcock oeuvre, moments that work to build a film just as the Perkins gesture does. James Stewart recoiling in his wheelchair when he sees Raymond Burr suddenly looking at him, in *Rear Window* (1954); Ivor Novello turning the pictures of the women around in *The Lodger* (1927); the knife breaking off in Wolfgang Kieling's shoulder as Paul Newman works to murder him in *Torn Curtain* (1966); Cary Grant delivering milk to Joan Fontaine in *Suspicion* (1941); the painted jester pointing at Anny Ondra in *Blackmail* (1929).

By the time he had become vastly popular and had creative control in Hollywood, Hitchcock came to be viewed by actors as a favorable catch and they sought after him, even some of the most celebrated actors in film history, for furthering their careers. "My agent here in New York told me that you were going to call me at the Beverly Wilshire in regards to a film. My heart skipped a few beats at receiving such good news," wrote Lillian Gish about *Family Plot* (1976) (28 March 1975); and Cathleen Nesbitt reacted, after working on that film, "I've never ceased to thank my stars that I did achieve an ambition long held to effect the honour of appearing in a 'Hitchcock'" (3 April 1976). The great European actor Ludwig Donath, who played Lindt in *Torn Curtain*, wrote him, "The work on the set with you is so much to the point and without any trimmings, that for any real actor it is sheer pleasure. I am terribly grateful to you for this professional honeymoon" (22 February 1966). And the prima ballerina Tamara Toumanova, who had appeared with Gene Kelly in *Invitation to the Dance* (1956)

and was the jealous ballerina star in *Curtain*, wrote, "Please dear Monsieur Hitchcock accept my deep and humble gratitude for giving me a new light in my life and a step forward in my career" (16 December 1965).

Beyond Hitchcock's puckish wit we must consider his piercing intelligence, which knew ironic construction inside and out. He believed that "in any creative endeavor by more than one mind, cooperation is more important than authority" ("Actors" 2), but managing the gestural work of his actors could be troublesome. An illustrative case was his production of *Jamaica Inn* (1939), in which the star, Charles Laughton, was given notable freedom. A particular scene Laughton had to play with the younger Maureen O'Hara was not pleasing him. According to his biographer, Laughton was apparently "so heartbroken at his failure he sat in a corner of the sound stage and sulked like an angry child. Hitchcock did his best to commiserate with him, but it was useless. Then, suddenly, Charles leaped to his feet. 'Now I know how to play the scene!' he shouted. 'I'm going to feel like a boy of ten who has just wet his pants!'" (Higham, *Laughton* 92–93). A more revealing version of the event was recounted to me by Elliott Gould, who had been discussing it with the filmmaker:

> "Wasn't Laughton great?" I asked Hitchcock, and he said, "He was a pain in the ass. In one of my lesser pictures."
>
> "Oh?"
>
> "I made fifty-one."
>
> "I know."
>
> "*Jamaica Inn*."
>
> They were filming the scene where Laughton ties Maureen O'Hara's hands behind her back and says to her, "How does that feel, dearie?" Nothing was pleasing Laughton and they did it over and over and over again. They broke for lunch, and Laughton called Hitchcock to his trailer, where he was sitting on the floor in a corner. "Oh, Hitch, aren't we a couple of babies!" said he.
>
> "I don't know why he had to put me into that category," Hitchcock said.
>
> After lunch, Laughton leaned around O'Hara and tied her hands again and said, "How does that feel, dearie?" And then, "How was that, Hitch?" "That was very good," Hitchcock replied. "Then we can proceed," said Laughton.
>
> "Of course," Hitchcock said to me, "I thought every one was very good but if he wasn't satisfied I couldn't continue." (personal conversation)

Hitchcock was meticulous in preparing the script and mise-en-scène in advance of the actor's work and thus drew more from casting than is generally supposed. In this way the performative gesture is prearranged, even pre-specified—not that such anticipations fully close off audience response or fully direct it—much in the way that, as Noël Carroll has commented, our view of it has been prefocused by the camera (135–37). Eva Marie Saint points to such prearrangement in citing Hitchcock as a director who was "so prepared and so professional" (Raubicheck 35), whose ideas could be very specific, such as that she should wear a black dress with embossed red roses (32), or that, playing the dining car scene with Cary Grant, she should follow three rules: "One was to lower my voice, two was not to use my hands, and three was to always look directly into Cary Grant's eyes, which was not difficult" (39). And Hitchcock told Truffaut of that scene, "Every look was directed," such as her leaning forward with her cigarette and gazing at him (unpublished interview tapes, part 22).

Casting, however, remains an understudied aspect of directing, and becomes a palpable feature of our appreciation of performative gesture when we note that for every role numerous possibilities existed—sometimes as many as four or five dozen—each of whom could have committed the gross physical moves and expressions called for in the script. The repertory of facial expressions that one could see onscreen in the work of any particular actor, the physiognomy, the actor's way of holding and moving the body, and quality of the voice, the coloration of the face and the eyes—all of these were legible and transferable to Hitchcock's situations, and would instigate a clear reaction in the viewer. "Paradoxically," writes Siegfried Kracauer, "an actor who capitalizes on his given being may manage to appear as a candid non-actor, thus achieving a second state of innocence" (*Theory* 101). Hitchcock's attention was devoted diligently to the work of his character and bit players as much as to his stars. These secondary players were always selected with the greatest care (but commentaries about their working lives very rarely appear in print) (see Pomerance "Two Bits").

Vertiginous Gesture

Watching Hitchcock's *Vertigo* (1958), one is struck in the performative work of Kim Novak by a strange and subtle feeling that lingers beneath

the threshold of her articulation in both parts of the story. Madeleine Elster persists in seeming a propped-up little girl dressed for an important party, stiff and withdrawn under a bracing shell. Judy Barton, by contrast, is an epitome of relaxation and ease, that is, until in the film's finale she is made up, dressed, and coiffed to become Madeleine again. Indeed, in Judy's transformation at Scottie's artful command, she seems in moment after moment to shrink in fear of the fashion plate she is becoming. Here is a duality in performance, then, of which a subtle current of feeling under-paints Novak's work. Two reports can help our understanding of how this effect was achieved. In itself it is one of the deep gestures of this film filled with depths of gesture.

First, Edith Head's recollection was that when, cast for the part after Vera Miles's suddenly announced pregnancy stymied her involvement in the project, Novak initially asserted she would wear any color "except gray." Head's own reflection as costume designer was, "Either she hadn't read the script or she had and wanted me to think she hadn't." Hitchcock was blunt, according to Head: "I don't care what she wears as long as it's a gray suit" (qtd. in Auiler 67). Thus the diminution of Madeleine Elster's agency by way of the dissolution of Novak's, her forced obedience (in Madeleine's case, to a foreign call; in Novak's, to Hitchcock), her protected little-girlishness. Second, we have Stephen Rebello's account of Novak's response to the costume (as confided to him):

When Edith Head showed me that gray suit, I said, "Oh, my god, that looks like it would be very hard to act in. It's very confining." Then, when we had the first fitting of the dress, it was even worse and I said, "This is so restrictive." She said, "Well, maybe you'd better talk to Alfred Hitchcock about this" . . . I thought, "I'll live with the gray suit." I also thought, "I'm going to use this. I can make this work for me. Because it bothers me, I'll use it and it can help me feel like I'm having to be Madeleine, that I'm being forced to be her. I'll have it as my energy to play against." It worked. . . . I was constantly reminded that I was not being myself, which made it right for Madeleine. . . . He didn't say to me, "Now use that," he allowed me to arrive at that myself. . . . They had built the suit so that you had to stand very erect or you suddenly were not "in position." They made that suit very stiff. You constantly had to hold your shoulders back and stand erect. But, oh that was so perfect. . . . It was wonderful for Judy because then I got to be without a bra and felt so good again. . . . But then,

I had to play "Madeleine" again when Judy had to be made over again by Scottie into what she didn't want to be. I could use that, again, totally for me, not just being made over into Madeleine but into Madeleine who wore that ghastly gray suit.

The "ghastliness" and ghostliness of the suit, and of Madeleine herself, are palpable onscreen especially at that critical juncture when in the so-called "green shot" Judy Barton entirely reconfigured emerges from the bathroom at the Empire Hotel. Although there seems to confront us a complete restoration of the dead Madeleine, breathing and moving out of phantom mists, we sense powerfully that the breathing woman (Judy/Novak) does not belong in the shell, that the clothing is a prison. This is accomplished at least partly because for the actress the costume was just that.

Does this mean Novak is largely not acting? She is merely being herself, uncomfortable in one set of clothes and relaxed in another? Such an estimation would evaporate the entire elaborate, delicate tissue of the story so carefully woven for us, negate the visions, flatten the rhythm of the film, in short, reduce *Vertigo* to triviality. Novak has indeed been transformed into Madeleine by Hitchcock; made over in the way that Judy was made over (by his servant Elster, at Hitchcock's behest).

Clearly at play between Hitchcock and Novak as they planned, prepared, and worked *Vertigo* was a tension between expressive freedom and structural constraint. "In hindsight," Novak told Dan Auiler in the mid-1990s, "I think he's one of the few directors who allowed me the most freedom as an actress. That might seem hard to believe because he was so restrictive about what he wanted. But even though he knew where he wanted you to be, he didn't want to take away how you got to that point" (179).

At a profound level, however, the tension between a rigid sheath of requirement and the plastic freedom of choice and movement within it is elemental to expression itself. In 1969, Talcott Parsons told me he thought language was "a certain flexibility within a certain constraint." Teresa Wright pointed to the same kind of synthetic model when, regarding *Shadow of a Doubt*, she reflected that "Mr. Hitchcock had already built the character and all I had to do was play it" (Raubicheck 47). In *Vertigo*, by building the sheath within which she had to move herself, Alfred Hitchcock was directing Kim Novak linguistically, that is, speaking to her in the language that was the entire unfolding project of his film. But he was also making a profound gesture. The women she plays in that film are entirely

ensheathed, caught up in the skins that bind too tightly—as, in *Psycho*, Perkins's Norman will be. Hitchcock was conveying this message gesturally to Novak, in the transcendent silence of the double no one would ever see. She, of course, perfect as she was for the twin roles, conveyed the message gesturally to us.

3

Curtains

Who are these ghostly beings who engage us in performative moments—before, during, and after the performance that is the boundary of the encounter? Because acting as an occupation touches so delicately upon the profound issue of Being, studying it is both endlessly challenging and endlessly futile; yet because the grace of performance constantly allures one feels the compulsion to keep working at it.

A Scholarly Tale

Vivian Sobchack has theorized screen acting in a way that sheds light on the variable effects associated with our perception of actors in and out of their working state. In her insightful examination "Being on the Screen," she recounts an illuminating autobiographical tale, beginning with her walking up to the bar to get a drink one evening at a gala black-tie Hollywood event:

> As I edged toward a slight opening to get a glass of wine, my way was partially blocked by a very tall man, his black-tuxedoed back facing me. "Excuse me," I said to his back, trying to simultaneously sidle in toward the bar, and, then again, more insistently, "Excuse me, sir!" The man turned around and, now, confronted by his white shirt front, I looked upward to see a pleasant face so utterly familiar and so totally strange to me that, completely disconcerted, I blurted out, "You're not 'sir'! You're Jimmy Stewart . . . I can't talk to you."

Then, writes Sobchack, "I walked away."[1] She recognized

that the man standing before me had more than one body—the first, that of a familiar movie star (a reified "Somebody" I will later discuss as the Personified body); and the second, that of a completely unknown stranger who, also waiting at the bar for a drink like me, was living his life as "his own" (as his "My body," a "Personal body"). These two bodies, simultaneously perceived, seemed completely at odds with each other—and, thus, not knowing which one to talk to, I found myself literally at a loss for words. (430)

This scholar/observer was clearly perplexed, but she was also moved: by Stewart, by the moment, and by her own perplexity. I find something additionally perplexing here. Mentally toggling, as it were, between the famous movie star Jimmy Stewart and the body he was being as himself-taking-a-drink-at-the-bar, noting with a profound confusion the presence of what seemed to her two Stewarts at once and not knowing "which one to talk to," *nevertheless she did talk:* "You're not 'sir'! You're Jimmy Stewart . . . I can't talk to you." The fact that her little speech was itself about talk is phenomenologically fascinating, but what seems most pregnant in it is that, "unable to talk," she uttered speech.[2] Whom, one must feel pressed to wonder, was she addressing when she said that? The famous Jimmy was someone who occupied a domain to which she had no access through direct speech. The everyday James Stewart was a person to whom she had never been introduced. Might there have been someone else there as well?

Sobchack is clearly a Jimmy Stewart fan. I can attest that the raconteuse is, herself, considerably shorter than Jimmy Stewart was, and so the image of her confronted by his shirt front and then tilting her camera-eye upward to gain a Dutch angle of his face is a move I can perfectly imagine. It's utterly cinematic, and, in a filmed recounting, the low angle could be used effectively to simulate Sobchack's actual experience; or, to put this perhaps more intensively, Sobchack in her experience was pre-simulating what, under other conditions, a movie camera could or might do. The "presence" of the movie camera in my consciousness of the tale is, of course, emphasized by virtue of Mr. James Stewart's participation. Her point that she could not speak to him because he was One of the Most Celebrated Movie Stars in the World and there she was looking into his face was illustrated by the "camera view" she—almost naturally, I'd say—took. While working

with him on *Foreign Correspondent* (1940), Alfred Hitchcock (later one of Jimmy Stewart's good friends) told his designer Alexander Golitzen that looking up was the very best way to see things (B. Hall 54).

Of course, it might have been to herself that our storyteller was talking. As a writer and speaker, she is accustomed to a fulsome articulation of thought, and even her most private mutterings might find their way through the opening of her intelligence into audible speech. She meant, for herself, to say "him" as she referred to the tall gentleman; but, recognizing him physically present, instantly made the polite conversion to "you." The astonishment that could have led to her thought in the first place is not hard to understand given the distance of movie stars (even in Hollywood)—the distance and exceptional elevation of stars like Jimmy Stewart, born in the golden age and somehow made immortal by the sanctified light in which they were photographed (say, by Joseph Ruttenberg, for *The Philadelphia Story* [1940]); and then the blunt, even shocking physical reality of the confrontation in actual proximal space with so high a figure (made higher by virtue of his measurements).

The palpably inspiring nature of offscreen space could have played a role. Francesco Casetti usefully cites Victor Freeburg's *Art of Photoplay Making* (1918) to speak of a space beyond the image, in which the photoplay writer could "utilize the vague and subtle effect of distance" and, as Casetti has it, restore to a spectator "her power of imagination, which would otherwise be taken by a meticulous and exhaustive reproduction of reality"—a reproduction just such as Stewart's many films provided (48–49). There was perhaps a Stewart in this magical offscreen space, yet not the one taking a drink; someone the drinker silently invoked for Sobchack, someone who could live when the screen did not hold him, but who, even through the deepest of resemblances, was not the same as the man on the screen.

For Sobchack, the actor ultimately has, as she puts it, four bodies: the Impersonated (what could be called the "character": we speak of a performer as being "*in* character"); next, suitably magnified, the "Personified" (corresponding to what many theorists from De Cordova through Dyer to Naremore have called the "star persona," invoked when we recognize a continuous and noteworthy being carried over from one impersonation to another); third, the Personal (the actor's "civilian self"); and fourth, the Prepersonal, the body that "'acts' by means of its particular physical and biological structure and the general capacities for movement, action, gesture, and voice this structure both enables and constrains" (431).

We may consider that as a Personal, the actor has a passport and a social security number; he can be searched out in the streets. As a Prepersonal he has capacity, agency, and self-knowledge. Through the axis of the Personal-Prepersonal, I think it can be argued, the actor's social self is brought to its closest proximity to that of the interested viewer, since from the array of his own actions in everyday life the viewer may map himself into that of the actor, whose needs and circumstances are not dissimilar. Watching Richard Burton in the role of Leamas in *The Spy Who Came in from the Cold* (1965), as he enters a little grocery manned by Bernard Lee to purchase some tinned peaches, one does not sense this affiliation directly, the Impersonated dominating attention. Yet to understand Burton as a man who might on occasion eat from a tin of peaches is to grasp him in his civilian identity, an identity played out on the same interactional "turf" as we stand upon ourselves. As Leamas buys peaches we comprehend but do not identify.

Amplification

Much of our ability nowadays to discern any actor as Personal or Prepersonal flows from performers' conscious and well-structured presence offscreen in situations to which large audiences have access. Previous to the television talk shows of the 1960s (*The Tonight Show* with Jack Paar or, later, Johnny Carson, for instance), most viewers of acting tended to detect and recognize actors at, and in, their work (as Sobchack's Impersonateds), gaining access to the famed workers underneath the dramatic masks (the Personifieds) by way of occasional radio appearances, studio-generated magazine publicity (as could be found in such venues as *Photoplay* [see Higashi]), or, in cases of notoriety, through newspaper reportage. With the development after the 1970s of entertainment television, and the print journalism that in such venues as *Esquire* and *Vanity Fair* went into competition with it, actors made more and more "backstage" appearances in which they pointed to and talked "openly" of their transformations onscreen. Often they permitted producers to bound their onscreen conversations as Personified, then modulated into and out of Personal moments in which they could feel free to make reference to Prepersonal experience, as when the famed Katharine Hepburn sat with Dick Cavett, propped her feet up on his coffee table, and talked intimately—or

Often for viewers of acting, what is problematic about the performance worker's characterization (Sobchack's Impersonated) is the closeted nature, generally speaking, of the professional (Personal) and individual (Prepersonal) worlds that underlie it. While actors can make public statements linking off-camera and on-camera selves—"This is how I came to create such and such a character"—one is constrained to seek the truth value of such statements entirely within them, since no other territory is opened. One is made susceptible to the charm and logic of the account and the personality of the accounter, is forced to take what one hears at face value. Regardless of whether the actor's claims about his work are real or just made up for the occasion, they suggest the sort of culture-bound links between surface manifestation and underlying engine that audiences are prepared to accept and understand. In short, they reveal the expectations and mappings of the world currently in use, no matter their status in reality.

One keen example of a preparation story was given by the esteemed British actor Sir Alec Guinness in conversation with talk-show host Michael Parkinson in 1977. As he delivered this tale, Guinness's demeanor was the height of graciousness:

> That *Lavender Hill Mob* part, which we've just seen [in a clip], I did based on two things: I went to the zoo, and in the rodent house, in the small rodents, I saw some little round-eyed nervousy little character, rather sort of fluffy, and I thought, mmm, maybe that's . . . um . . . maybe something on those lines. And then I realized that a bank clerk at my bank looked very much like it, so I settled on the bank clerk's voice. . . . When I have got stuck I have very often gone to the zoo to see if some animal would give me a clue . . . the only place where you can find strange animals. When I did *Richard III* in Canada I spent a lot of time, I searched around . . . an eagle, maybe. . . . And then I found a creature called The Unsociable Vulture. I used to visit him, oh, every two or three days. He got to know me. He was very kind of inquisitive. He was quite a sociable chap. . . . I first sort of got the idea that animals might be helpful in my profession before the war in the Cairo zoo. I was on a tour playing *Hamlet.* There was a bird there called a shoebill. [Stands.] It stands about that high [indicating his chest] and it's gray—very soberly pale gray—and it doesn't like being watched.

That appealed to me no end. It likes to watch other people. [Proceeds to imitate the shoebill.] . . . I'm very devoted to animals. I love watching them. ("Parkinson")[4]

Here we are offered the personality of a sober, eloquent, modestly self-effacing working professional with a fascination for birdwatching, a man who disciplines himself to routine zoo visits in various parts of the world, whose meticulous observation focuses on the creatures' stance, psychology, even attention. But at the same time we are confronted with Guinness's reassuringly intelligent and engaging personality. He is palpably a man willing to hesitate now and then as he speaks, self-reflectively; who knows what casual and friendly talk is, and is meaning to be casual and friendly; who, we can tell from his chuckling at himself, finds himself roughly as entertaining as we find him, in short, a pleasing chap with no star ego (when this interview was taped, Guinness's world-star-class performance as Obi-Wan Kenobi in *Star Wars* was fresh in viewers' minds). This performer, then, is *not* his characters, and we can see him (as he rises to demonstrate to Parkinson, and shifts to take up an accurate one-legged birdlike footing) actually donning and doffing character as though it is a kind of ceremonial garment.

We gain an interesting insight into actors' characterizational work in the age of multiplex cinema if we contrast Alec Guinness's performance as bespectacled Holland in *The Lavender Hill Mob* (1951) with his Jedi knight in the *Star Wars* saga (1977, 1980, 1983). The Jedi benefits from what I call "amplification," which is the culturing of performance and dramatization so as to make it accessible across a wide spectrum of audiences, both educated and uneducated, of all races, ages, genders, nationalities, cultural experiences, and familiarities with cinema. The amplified audience is a world phenomenon, derived very largely from the mid-1980s burgeoning of independent film production in the wake of the studio collapse. As actors no longer subsisted under the protective umbrellas of lengthy studio contracts, and needed every earning opportunity to guarantee against possible future decline, their fees climbed and the cost of making film skyrocketed, producers needing to trade the Bank of America worldwide distribution rights in exchange for the massive level of funding needed to float their pictures. The result, beginning roughly with *Rambo: First Blood* (Carolco, 1985), was the creation of a world audience for film, an audience that had to be plied with sex and

violence, themes that would appeal to virtually anyone. While *The Lavender Hill Mob* had a dedicated and earnest audience of class-conscious Anglophiles, Guinness's work there could not strike the international chord that resonated with the more mythical, simpler, more physically engaging *Star Wars*. These two performances strike but one example of a much broader trend, of course. With amplification, the actor-character formula is opened to radical alternation, the backstage presentation of the actor—a construct in itself—now also being structured to be readable across cultural lines toward the greatest economic advantage. As characters are amplified, so, to a degree, must be the creatures mobilizing them as they are made accessible to the new, greater audience in so-called "private" moments.[5]

Because in the heyday of the studio era, and certainly prior to and during the Second World War, studios hoped vigorously to realize profits through sales of their films in global markets, there was a kind of proto-amplification on the minds of some filmmakers. They knew how broadly their stories would have to play; and writers wrote scripts that could be filmed simultaneously in more than one language. Ernst Lubitsch, for example, was canny and tactical about his productions:

> What so many people forget when they criticize the work of a film director is that he has to cater for varying tastes, all over the world. When a play is produced on the New York stage, for instance, the producer can stress certain points, introduce definite "business" which he knows will appeal to the New York audience. If he were to produce the same play in London, he might change his method drastically, because he knows that London would appreciate certain situations that a New York audience would miss; and vice versa. Imagine, then, the enormous difficulties that face a film maker. He has to produce a screen play that will appeal, not only to New York and London, but also to the Middle West towns of America, the Irish and Scottish peasants, the Australian sheep farmer and the South African business man. (444)[6]

Lubitsch's *Ninotchka* (1939) did $1.2 million domestically and another $1.1 million in foreign sales (not small potatoes at the time). To pick but a single recent example of worldwide marketing, with amplification in full effect, Peter Jackson's *The Hobbit: The Desolation of Smaug* (2013) did $258.4 million domestically but $702 million overseas.

Since performed moments stand upon circumstances that are hypothetical—Sanford Meisner told a student that acting was "living truthfully in imaginary circumstances" (87)—from the point of view of day-to-day actuality they are false. The "falseness" of the circumstances makes for the possibility of contextual transformation. As an ultimately unreal character is related to an ultimately real performer, the fictional place in which a drama is set, on film or on stage, is related to the cinematic or theatrical space that subtends it. The diegetical place—Munchkinland, for example—is what Erving Goffman would call a "keying" of the geographical space (*Frame Analysis*, chap. 3; see also Tuan), in this case MGM's Stage 27. Keyings can be confounding, especially within the tenets of realism, since any very competent designer (Henry Bumstead, Assheton Gorton, and Dean Tavoularis come to mind) can make diegetic places seem to be real however outlandish they are.

For rehearsal purposes, any piece of suitably large real estate will do, obtained through a producer's arrangements and then utilized with some functional regularity by workers who collaboratively pretend it is somewhere else.[7] In the rehearsal space, lines may be marked on the empty floor with colored tape, indicating where scenery, furniture, elevations, depressions, or characters will be (nothing preventing a scenic designer from using such delineations as the basis of a film's diegetic "reality," as we see with Peter Grant's work in Von Trier's *Dogville* [2003] or Mark Friedberg's in Charlie Kaufman's *Synecdoche, New York* [2008]). Wooden benches can take the place of padded wing chairs, windows hang invisibly in the air. Actors move around methodically so as to take up the positions that in proper diegetic place they will finally occupy once the show has begun and the lights are turned on. Indeed, in lighting or camera rehearsals, actors or their (often less sumptuously) paid stand-ins freeze position so that technical personnel can verify that sufficient visibility will be accorded relevant parts of their bodies at various nodes of the action. As measured against the ultimate performance, and like the propositions of drama altogether, all these preparatory activities seem false; yet they are also, in a deeper sense, true to the physical reality of production. It is because of this deep and elemental truth, indeed, that rehearsal can make for good performance. Finally, it is the performance that will be false, in a sense, because instead of being spontaneous and unstrategized it is built upon the choreographic,

demonstrative realities invented in rehearsal and laid upon the armature of the bodies.

What can happen with film and stage acting during the off-camera interview or the stage curtain call is, in Goffman's terms, a "downkeying" of performance back to the elemental physical and interactional realities of rehearsal: the character morphs into the actor, the setting melts away, and the gestures of performance diminish in scope to the point where they are as slight and perceptually interpersonal as a wink or a handshake. The experiential shock for viewers comes in seeing the indelibly recognizable face of the character mounted now upon a stranger who by his similarity and presence effectively confesses to having put on and taken off that character. While for adults, knowledge of the actor's transformation into and out of character is part of the expectation of dramatic performance, that expectation, and the knowledge that subtends it, is effectively forgotten during engagement. In the curtain call, it all comes back. The body of the actor attests to an eradication—a murder—of the character: ritual, repetitive, institutionalized, casual, as though the character, whom one cherished while watching, had no value beyond that of the sweaty mask worn at a festival debauch to hide away everything that is real.

Taking a Call

Curtain calls originated on the stage in the early nineteenth century. "The curtain call is an odd moment in many ways," writes Lyn Gardner. "Actors, who have often spent the last few hours pretending that the audience simply weren't there, now come forward, smiling and laughing, to acknowledge their presence. The Irish dramatist and critic Dion Boucicault wrote in 1889 of the 'small space' in front of the curtain which belongs to both the stage and the auditorium . . . , and in which the actors appear somewhere in between their lives on the stage as characters and their lives in the world as real people." This personal and spatial ambiguity springs from a transformation that is technically fraught with challenges and philosophically profound, since viewers must somehow be brought to see not only two incompatible creatures inhabiting the same space (and body), but two territories. Wolfgang Schivelbusch notes that seventeenth-century audiences experienced a continuity and unity between stage and auditorium, while in the mid-eighteenth century this "communication . . . was aesthetically and

morally displeasing"; as the eighteenth century wore on, the auditorium became darker and the audience sitting there "was no longer 'an audience,' but a large number of individuals, each of whom followed the drama for him or herself" (204–5; 206).

Stage actors play this ambiguity, this doubling, by effecting a distinguishable shift out of character in the process of taking their bows. One extreme example: Tom Conti in his costume pajamas but now with a bathrobe suddenly added, standing center stage after two and a half hours of being bedridden and completely paralyzed, except for his face, as in 1979 he played Brian Clark's *Whose Life Is It Anyway?* on Broadway. Or Ian McKellen and Patrick Stewart at the end of *Waiting for Godot* in London, 2009, doffing Vladimir and Estragon's bowlers and sliding into a little soft-shoe routine together—inside and outside the characters at once. The Barthesian *punctum* was the deliberate—yet at the same time not exactly unrehearsed—casualness of McKellen and Stewart's moves: not quite perfect while being, of course, absolutely perfect.

In cinema, there are usually no curtain calls as such—although I have read a list of some sixty films that contain end-title images or curtain call choreographies of one kind or another. There is a memorable curtain call sequence at the end of Sidney Lumet's *Murder on the Orient Express* (1974), where one by one the numerous characters bid farewell to one of their number (and simultaneously to us), all the while retaining costumes and mannerisms. Orson Welles narrates a set of de facto curtain calls at the conclusion of *Citizen Kane* (1941), in a rendition that has had some repetition: a brief portrait clip of each character, withdrawn from the now concluded film, is replayed while Welles elegantly and gratefully pronounces the actor's name. We find this again in *The Magnificent Ambersons* (1942). At the end of Mervyn LeRoy's *The Bad Seed* (1956) the audience is also treated to the actors in costume, stepping one by one into a domestic doorway while an offscreen voice announces their names (like a butler at a grand soirée). Things turn hairy when Nancy Kelly catches (her "naughty daughter") Patty McCormack on the living room sofa and gives her a "spanking" (or a spanking). Generally, however, as, watching the end credits of a motion picture roll, they climb out of theaters, audiences abandon the film and its world behind them without the equivocal transition that curtain calls provide.

While in the "behind-the-scenes" genre—musicals like *Gold Diggers of 1933* (1933), *Easter Parade* (1948), *Summer Stock* (1950), *The Band Wagon*

(1954)—the stage curtain can show up as a staple part of the set design,
theaters screening films once possessed a different curtain entirely, and in
contemporary cinema that curtain has vanished (to be replaced by pre-
show advertisements, quizzes, and other inane trivia). After the movie
palace heyday of the 1920s (see Naylor) and prior to the Cineplex phe-
nomenon of the 1980s (see Burnett), motion picture theaters were either
converted theatrical venues or imitations thereof, with fabric curtains that
could be parted for screenings and drawn together when the session was
done, in a "gesture" very often accompanied by manipulations of plain or
gelled lighting to produce emotional effect.[8] Front lights playing upon the
curtain could be brought down as behind it the film "came to life" and a
new kind of illumination dominated the arena (a procedure reflecting the
stage lighting treatment used to render decorative gauze panels suddenly
transparent). A marked change was brought about by the influence of Aus-
trian functionalism and Bauhaus design, as Lary May writes. The "temple
to art" had been designed to be "removed from the commerce and chaos
of the street" (107), but with the work of Frederick Kiesler and others,
designers "stripped the movie house of references to European high art and
symbols evocative of American nationality. In keeping with the principles
of modern science, the structure displayed the steel, wood, and glass of the
modern age and shed hierarchical settings in favor of an auditorium where
all sat at the very same level. Kiesler also eliminated the proscenium arch
that had separated the film from the life of the audience" (114).

Already by the early 1930s there were endeavors to cut out "dust-
collecting draperies" (May 116). With contemporary theaters today, the
"curtain" is the "*toile trouée*" described by Michel Chion, the mere projec-
tion screen itself, which is a stretched material punctured regularly with
tiny holes (through which some or all of the sound permeates). By the late
1930s, for some projection processes (such as rear projection), seamless but
highly flammable nitrocellulose was being used. The brilliance of the screen
is noteworthy in itself. Schivelbusch informs us that in theaters as late as
1825, stage light was paid for by the establishment while auditorium light
was provided by the state, with the effect that stages were dimmer than
auditoria. By the advent of cinema the front of the dramatic space became
more brilliant than any other spot, notably so. The "curtain call" of staged
theater provided a transitional mechanism whereby audiences could rene-
gotiate their orientation in everyday space, withdraw their attention from

the special zone of the stage and its occupants, and finally leave the theatrical fiction behind. When cinematic screenings used curtains and light to finish a séance, audiences could have some dilute experience of the same transitional mode, but after Cineplex only screen tactics could provide a pathway back to reality.

While extended credit rolls could work to lubricate the passage out of cinematic fiction, in principle the performer's work had to end abruptly with the last shots of the film: as characters, actors worked their way to the story's end and then lingered in the viewer's memory, but as performers they almost always merely disappeared. One tactic used for performance extension was a reel of mistakes, bloopers, or goof-takes, or an added "special" scene designed for the pleasure of cognoscenti, screened as the final credits rolled (a nice example with Peter Sellers concludes Hal Ashby's *Being There* [1979], Sellers's blown lines as Chance the gardener occupying a different, even antithetical conceptual space to him recognizing his mistakes and laughing with the off-camera personnel).[9] The performer still at work in character for one more scene, or messing up, cracking up, forgetting lines, missing cues, or otherwise deviating on camera stands somewhere in the space between the fully engaged role player and the worker striving beneath.

That in curtain calls we realize characters are not the actors who play them may seem too obvious to be interesting until with cinema, and the general absence of curtain calls, we experience, as the screen goes dark, the unmodulated *discontinuity* between extremely contradictory behavioral renditions from the selfsame body. Examples of this discontinuity are legion in our image culture: a vocal tone, linguistic affect, or accent radically changed (Matt Damon watching screened clips of himself in *Invictus* [2009], then speaking in his "normal" voice to an interviewer); the size of a body shockingly too small or too huge (I walked past Peter Graves in a studio corridor once—he was extraordinarily tall; I walked past Christopher Plummer on a sidewalk—he was extraordinarily short).

One might detect a disorienting personality change as unmodulated discontinuity, as in the case of Peter O'Toole. He frequently behaved onscreen with an explosive but extraordinarily articulate and gesturally flamboyant style: think of his courageous and noble Lawrence of Arabia (1962), or his slyly genteel, even fey Simon Dermott in William Wyler's *How to Steal a Million* (1966); his declamatory and magical, whirling-dervish Eli in Richard Rush's *The Stunt Man* (1980); his bloodcurdling Henry II in

Peter Glenville's *Becket* (1964); his amorous and extravagantly expressive Henry in Anthony Harvey's *The Lion in Winter* (1968); his palpably frail and touching Chipping in Herbert Ross's *Goodbye, Mr. Chips* (1969); his bizarre and wacky Jack Arnold Alexander Tancred Gurney, 14th Early of Gurney, in Peter Medak's *The Ruling Class* or his hopelessly idealistic, frail, sylphlike Don Quixote in Arthur Hiller's *Man of La Mancha* (both 1972). Not only are no two of these characterizations the same, while at the same time a distinctive actorly style is discernable in all of them, but a wholly different personality still is revealed off-camera when, "backstage" of all these, we meet "the man himself." In 1963, the BBC's *Monitor* hosted a discussion with O'Toole and Orson Welles, among others, about *Hamlet*, and here we find a quiet-voiced, professorially reflective, erudite young scholar in heavy eyeglasses. No bombast, no panache, no flair, no imposture: just soft-spoken, articulate elegance, tearoom etiquette, and perfect composure. Is not the break between a man like this and the men he becomes in front of the camera something to shock us and provoke wonder? How many civilians are living inside that body?

In the curtain call—whether formalized onstage or through off-camera interviews, encounters, and the like—the actor is given license to come away from character and suggest a hitherto hidden, or not yet fully drawn, presence. One stage actor told me, "The actor comes out as though fraternally related to the character." In that sense, the call gives watchers opportunity to meet the character's "family." We could say that characters and actors appear together and simultaneously, and that since the selfsame torso and appendages are being used at once by more than one being, a phantasmal quality attaches to the act of taking the bow or being seen in everyday life. The message addressed implicitly to the audience—"Thank you for your attention, you may go home now"—implies not only *a* real world into which viewers can retire (where motion pictures are financed, box offices rake in money, projectionists get paid for throwing light onto the screen) but *the* real world out of which actors have emerged, or within which they circulate, to make shows like that drama that is now done and like this special extradiegetic revelation, too. "At the close of each performance the play is set aside," writes John Gielgud, "for all the world like a Punch and Judy show, or the toy theatre of one's childhood; and each time it is taken up again at another performance it seems, even in a long run, comparatively fresh, waiting to be fashioned anew before every different audience" (402).

Jean Mitry sees himself being "everywhere at once" as he watches a film; does he not, perhaps, assume the position of the actor taking a call?

> I *know* that I am in the cinema but I *feel* myself to be in a world presented to me through my eyes, a world which I experience "physically" by identifying with one or other of the characters of the drama—with all of them in turn. That is the same as saying that in the cinema I am both *inside* and *outside* the action, *inside the space and outside it.* With the power of ubiquity, I am everywhere and nowhere. (80, emphasis in original)

The circumstance in which actors move in public uncoupled from their working personae sets up a particularly intriguing reaction (in *Birdman* [2014], Michael Keaton marches through Times Square in his underwear, embodying just such an actor). The actor's street persona as citizen need demonstrate no more relation to his professional identity than anyone else's persona would, but that professional identity may be prone to invocation by others as a tool for guying or manipulating the street persona from without. Consider the harrowing account of Winona Ryder picked up for shoplifting at Saks Wilshire in 2001. She was caught behaving as any (non-actor) shoplifter would behave, and none too skillfully. Arrested—as any non-actor/shoplifter would have been—she was then subjected to what amounted to a vicious and career-threatening recasting in the press, where she was accorded much more publicity than non-actor shoplifters get, largely owing to her prior, already well-established, susceptibility to publicity. Not only was her professional acting life now thrown into the spotlight of judgment but her thieving was framed in terms of it. Here we can see something of the intensive illumination normally provided professional actors as compared with other workers (a theme explored fully in Olivier Assayas's *Clouds of Sils Maria* [2014]). Many thieves work at day jobs (as actors maintain occupations), but upon being caught by the police are not illuminated in such a way that those jobs are dishonored. (Think of the Watergate burglars, some of them intimately involved with law practice but not used by the press to denigrate lawyers' behavior generally.) The first two sentences of the *People* report of the Ryder incident, for example, describe a "curtain call" from hell:

> Oscar-nominated actress Winona Ryder, 30, was arrested at the Saks Fifth Avenue in Beverly Hills Wednesday after store clerks said they saw

her place an estimated $4,760 worth of clothes and accessories into her bag with the security tags ripped off, Reuters reported. Ryder, who has appeared in more than two dozen films including 1999's "Girl, Interrupted" and 1994's "Reality Bites," is being charged with grand theft. (Young)

Contained here are not only details of the theft and its location but *four* separate references to Ryder's acting career, explicitly identifying her with the Academy Awards and two earlier films as well as indicating the size of her credit list. If in the public consciousness street activity and professional commitment are typically divorced, with actors the professional linkage seems comparatively unbreakable the more that public recognition comes into the picture and the more amplified the persona.[10]

Performers can thus seem to be at work always. When we recognize them, regardless of the magnitude of their careers, we re-engage with a figure we have seen before; we articulate an act of seeing and knowing *again*. From her own point of view, at the same time, the actor may always be at work in a different way, not being known and knowable but watching other people and thinking through the process of modeling them in performance. The actor is never free of opportunities for inspiration, nor ever safe from tickling.

The Fan

The ravenous fan can demand a curtain call, even take himself to be experiencing one, even when the actor is not compliant. Thus the hounds and stalkers who persist in tailing performers wherever they go, no matter the circumstances:

> About dusk the limousine gets back to the Sherry-Netherlands. Natalie Wood gets out and, boy, from out of the potted plants or somewhere, here come five photograph hounds, only instead of their usual state of ecstasy and exhilaration, they are almost belligerent.
> "Hey, Natalie! What about it!"
> "Yeah, we heard about it!"
> "That guy Clarence says you gave him a nice little session this afternoon!"
> "... a nice little session ..."
> "What about it! When do we get ours!" (Wolfe 290)

The fan, paparazzo or not, has a logic: if the celebrity is visible and conscious of being a celebrity, she is therefore open to being celebrated (and spied upon). A kind of generalized curtain call takes place, in which her screen roles having been shed the actor now stands as a self openly and generously available to her hungry audience. Television's zoom lens picking out Adam Sandler at a Los Angeles Lakers game, Film Festival crowds waiting outside the Windsor Arms in Toronto to catch a glimpse of Sandra Bullock strolling in from her limousine: these fan moments are demonstrations of a kind of professionalism, an aptness for catching the inevitability of presentation. Performers and their handlers know about this, and can play to, and upon, it.

How shocking it can be to find living performers sharing our physical space as ordinary persons,[11] or to find those founts of onscreen eloquence suddenly mute or babbling (since away from character they are also away from screenwriting). The shock brings both pleasure and oddity: pleasure because one can be afforded a special, private, touching, and idiosyncratic glimpse of everyday normality (walking down the sidewalk) suddenly become noteworthy through the involvement of charged personalities (Bradley Cooper walking down the sidewalk); and odd because, first, it is noteworthy already to be considering any everyday normality noteworthy, and second because in thinking performers' presence near us in any way remarkable we defend ourselves from considering remarkable our own presence near them.

As with the rest of us, in his street life the actor may pass unnoticed and unremarkable, common and invisible. In *seeing* the performer off-camera, in accepting and acknowledging the "call," we accord the invisible visibility. Because of the style of its emergence, the form we find is phantasmal, having previously occupied a different world, a stage, a screen, a magical space. In being here in the everyday, off-camera performers already accomplish a transition, an immigration, that we would not dream of accomplishing ourselves, since we are always already here and only here, and where else would we be? We *are* here; but the celebrity has materialized. Note that the actor's quotidian presence in the world, his civilian constitution, is not the same as an actor's open presentation of self *as quotidian* within a drama: at a dinner party with Mr. and Mrs. Alfred Hitchcock and Daniel Gélin, visiting from France, during the shooting of *The Man Who Knew Too Much* (1956), Jimmy Stewart sat down and played the piano, this as a civilian operating in civilian circumstances. But in Preminger's *Anatomy of*

a Murder (1959), he sits down and plays the piano in the role of a lawyer taking a break. Same fingers, same technique, but fingers operating in one case on behalf of the body mobilized as person and in another on behalf of the selfsame body mobilized as character.

Regarding actor-in-the-street stories, only in the case of celebrities does one pause to tell them, or does one anticipate being valorized for the account, since narratives centered on performers not already recognized by the listener fall flat. Thus, the very utility of the "Jimmy Stewart"-ness of Jimmy Stewart for bolstering my wee story about piano playing, and its vital importance in Vivian Sobchack's tale. Even the relatively unknown performer, however, his well-knowness surely diminished, in shedding the skin of a role reveals that role as a skin that can be shed.[12] While we may be cognizant of this provisional nature of dramatic roles, that they are impermanent and can be transferred and undone, our cognizance does not trouble the conviction with which we focus on roles while we are engaged in watching them turned: we know they are only a surface, but they appear to be everything.

Acting Audiences

One dominating function of the call is to provide for audiences an avenue by which they may exit the dramatic sphere. While in the intermediate space between the diegetic world and the audience—an off-camera interview—a character is openly converted into an actor, the sibling viewer (what Goffman calls the onlooker) may be transformed again into a theatergoer—we may say moviegoer (*Frame Analysis*, chap. 5). Suitably transformed, the moviegoer can find a path back into the continuity of everyday life. As an onlooker, by contrast, that viewer was abstracted from social and economic piety, at least to the degree that the performance "worked" and "transported" its audience. With stage work, the curtain call can make for a graceful and touching reentry to the everyday. But what happens when a film is done is a transformation altogether more abrupt and incomplete.

The lights come up to reveal the theater space, other patrons, popcorn on the floor, daylight peeping in at the exit doors. The screen is now no longer a magical vehicle but only an appurtenance helping to furnish an auditorium. While the names moving by on the credit roll indicate the street identities of those who fabricated the dramatic illusion, they are also mere

tags, linguistic hooks meant to apply to people one is not meeting, seeing, or (unless one knows them) fully recognizing. Each name stands for a person, yes, but all these persons exist "elsewhere" and in social connection to unimagined strangers. The chain of names flitting by over the exit music constitutes, as film, a transitional sequence, yet without bringing the profound dualism of performance into the audience's reach since in the material space of the movie house the characters are by now nothing but vapor.

Film audiences are therefore especially prone to carrying the performance with them into the everyday. Carrying it, remembering it, mentally reenacting it: *not letting go*. In this fashion are characters cherished and guarded, remaining untransformed in their heightened visible incarnations now etched into memory. Etched into memory, that is, where they can be altered at will according to the viewer's habits and predilections. When we see films we do not leave them absolutely behind. They remain with us—Gilles Deleuze suggests them as "recollection-images" that are "actualized according to the momentary needs of . . . consciousness" (80)—unspooling in the especially dark theater of private thought.

What results from watching screen performance, then, is an extension of experiential ambiguity, out of the auditorium's bounded diegetic space and into the world we call "real." An actor's work may still be intact for us, a breathing residue, even as we confront her everyday personality casually on the street.

But as actors in their everyday selves experience contemporary life as directly as their fans do, and this everyday life involves, among other things, going to the movies, we can foresee how just in the way that movie fans pay to watch actors magnified onscreen so might actors do the same. Not only may we see a scene in a film where characters are watching movies based on other characters, but we may see in everyday life an actor who has played such a character, sitting in a theater watching a movie based on other characters.

Indeed, when we watch the Academy Awards we frequently now have access to short films either about the motion pictures that are nominated or about Hollywood acting personnel, and as we watch these we can glimpse shots of the Dolby Theater, with the screen dropped upon the huge stage so that the hundreds of movie stars in the audience can watch the same film, too. We actually *see* movie stars watching movie stars onscreen; and then reacting to movie stars emerging in real life, striding out from the wings and playing to their audience upon that selfsame stage. Relatively

young ones like Tom Hanks watch relatively old ones like Laurence Olivier or Eli Wallach pace out before them, and stand in adulation for the "movie stars" they have always admired but at this moment are apparently not taking themselves also to be.

If for nonprofessional viewers of film the transition away from the screen is incomplete and fraught with ambiguities, may we not imagine that even for actors who make films the transition might be similarly strange? Why might not a screen performer, beneficiary of numerous powerful film viewings over a lifetime, bear within the performing self traces, molecules, mists of characterization enacted in stunning, even overwhelming ways? Indeed, why might an actor not carry traces of his or her *own* performances, seen in rushes or in a theater and powerful enough to produce a long-lasting effect? (One can think of Gloria Swanson's Norma Desmond watching an early Gloria Swanson film with William Holden's Joe Gillis in *Sunset Blvd.* [1950].)

Viewers can imagine a certain purity, an originality and spontaneity of the moment, infusing the creative act of the performing artist, whose work, after all, as Wilhelm Worringer predicted, "seeks to create for itself a picture of things that shifts them far beyond the finiteness and conditionality of the living into a zone of the necessary and abstract" (133). Of this, finally, there is no way to be sure. Equally possible is a deeper and more active resonance: that what mobilizes the actor's characterization is not only the river of feeling in an everyday self, a mere working personality, a celebrated self-image, or a biological capacity, not the actor's "I" whose self and body and spirit cohere in every way with those of the character in play, but lingering traces, echoing melodies, borne away from lost picture shows as memories now converted by feeling and recuperation into new flesh.

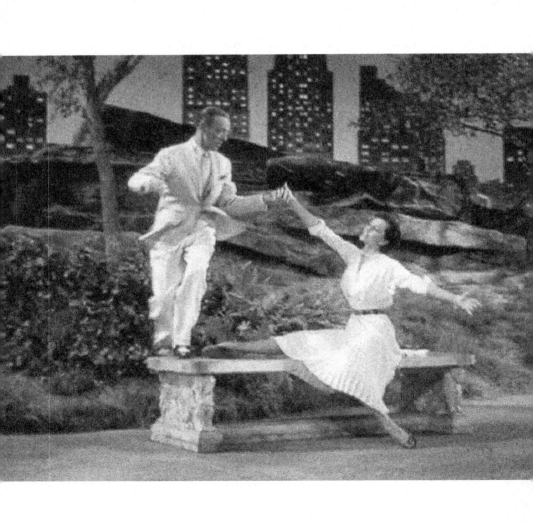

4

"It's Not a Man, It's a Place!"

Where does performance occur, and how is its placement important in the way acting works? How is the action of work fitted into, shaped and constrained by, or freed through the design of the work space? And what happens to the behavior and image of a dramatic figure as a result of its being placed within a particular fictional environment?

Setting and the Actor's Labor

Any serious discussion of film actors' labor and its setting will refer to a time well after the beginning of capitalism, filmmaking being capitalism's preeminent art form. Both pre-capitalist and capitalist work models are associated with the presence of requisite materials and tools and the requirement for preexisting knowledge and expertise, with expertise being favored more and more after the full development of the industrial revolution. In studio filmmaking (roughly 1915 through 1965), labor is intensively divided, and actors are continually striving to intermesh their activity with that of writers, cinematographers, and directors, not to mention the various craftspeople at work on or around a set. Here and more generally, the accomplishment of work is a situated activity. The amenities of clean air, healthy nourishment, warmth, and protection from the elements, not to mention pleasant décor,

are typically arranged to the limit of the worker's means in pre-industrialist models and according to the whims of ownership once, by the middle of the nineteenth century, capitalist production takes over.

The whims of ownership are typically bent toward decreasing costs and increasing profits. In the case of the film actor, studio bosses effectuate a workplace that will make production fluid and less costly than it might otherwise be, regardless of the pleasure and comfort of the employees. And unless an actor finds himself positioned to negotiate for particular comforts—by the mid-1950s, Cary Grant's contract stipulated that he did not work past 6:00 P.M., for instance—he is only an employee subject to the dictates of those who pay him.

Workplaces under capitalism could be perilous. E. Royston Pike quotes "Mr White's Report on the Lucifer Match Manufacturer" at Halsey's, Belle Isle, King's Cross, about a work site with a "yard" behind:

> . . . if that can be called so which is a passage a few feet wide, slightly broader at one end, filled in the middle with a stagnant gutter. . . . Here the children eat their meals, unless it be cold or wet, when they eat them round the stove. At the end of this yard, with an open sink or cesspool in front of it is a single privy common to all, boys and girls alike, and in a very bad state. (116)

In this wretched circumstance the workers are very young children, susceptible to the pernicious influences of the place and ill equipped to make substantive complaint. But child labor was a fundamental resource in early filmmaking. The Screen Actors Guild has catalogued numerous statements from former child actors detailing the deprivations and degradations of their working lives on set. Dickie Moore (1925–2015, later a star of *Sergeant York* [1941] and *Out of the Past* [1947]) was one of many who recounted how as a child he was in forced circumstances: insolent to Cecil B. DeMille on the set of *The Squaw Man* (1931), the boy saw the director raise his riding crop to strike his welfare worker and teacher when she "told him she'd close down his set." He reflected, "I think the young kids were protected more by their teachers than by their parents. I know that I was. The parents were so very fearful. Many of our families really depended on our paychecks."

For most performers studio acting was a form of factory work. Mélanie Riffel and Sophie Rouart inform us how, even as early as the mid-eighteenth century, the factory (or manufactory) was elaborated to

facilitate production, maximize labor utility, and recompense the employer rather than provide consideration of worker's needs. Christophe-Philippe Oberkampf's toile production facility in Jouy en Josas, for one example, offered "all the right conditions" for printing calico while the workers had none of the distractions that might deprecate production (18). Workers were isolated, even though their labor sometimes meant being outdoors in the fresh air; and chemicals were omnipresent. The film studio is shown openly to be such a place in John Schlesinger's *The Day of the Locust* (1975), Fellini's *8 ½* (1963), and Truffaut's *Day for Night* (1973), all of which clearly indicate the neglect of actors' needs in such work settings.

What studio departmental reports made possible, once filmmaking had become intensively bureaucratized by the early 1930s, was a minutely detailed supervision of every aspect of work on a picture. The daily production report was a form of punch clock for actors and other on-set personnel. By the 1940s, when H. B. Maynard, J. L. Schwab, and G. H. Stegemerten were conducting their Westinghouse Brake and Signal Corporation methods-time-measurement studies as part of a more general trend toward streamlining labor and labor practice, studio filmmakers routinely calculated, measured, calibrated, scheduled, managed, recorded, and evaluated all aspects of the spatial relationship between workers and their machines and the temporal rate at which they performed.[1] As Leonard Leff reports in his detailed analyses of Hitchcock's labor under David O. Selznick, management at Selznick International took dictatorial control of labor. Efficiency was the hard-and-fast rule (see further Pomerance "Errant Boy"), and there are Selznick memoranda, generally gathered in Rudy Behlmer's collection, that make plain how adamant he was about "operating efficiently and economically" (48ff.).

An actor's skills at enunciation, articulation, bodily movement, expressive gesture, and character construction are routinely put to the test, as are other workers' skills, and while the specific nature of the circumstances may be changed the formal structural arrangements are as they have long been in capital production. For film actors there is a dressing facility attached to the services of clothing designers, seamstresses, catering, and so on; and a soundstage, a cloistered location for setting out one's marshaled expression in a bath of controlled and intensified light, in alignment with the lens of a camera upon the film inside which will be recorded one's gests as "performance." Actors may feel the desire to act, but they must find a way to exhibit this desire in the place where the camera is; and the camera

will never be far from lights, technicians, designers, writers, and others on the producer's staff. The soundstage itself is especially designed to facilitate the hanging and operation of lights,[2] the movement of cameras and sound recording instruments, and the importation of all of this equipment (as well as anything else required for shooting) from the outside world through doors built with size and ease of operation in mind.

The soundstage is not in itself an artfully designed living environment, notwithstanding that set designers routinely erect facsimiles[3] of such environments inside them.[4] The walls of soundstage "homes," "restaurants," and "offices" are painted and decorated on the visible side only, and very routinely built without a ceiling—a fact of which actors are fully aware but that characters seem never to notice. Walls or portions of walls may be made portable, too—"wild" walls, they are called—so that for certain shots they can be swiftly removed and replaced by the camera and camera team.[5] Ingrid Bergman recalled the "nightmare" of working on *Under Capricorn* (1949) with Hitchcock at MGM's Borehamwood Studios:

> The prop men had the job of moving all the furniture while the camera was rolling forward and backward, or from this side to that . . . and the walls were flying up into the rafters as we walked by, so that the huge Technicolor camera could follow us. It just drove us all crazy! A chair or a table for an actor appeared the minute before a cue. The floor was marked with numbers and everybody and every piece of furniture had to be on the cued number at the right moment. What a nightmare! It's the only time I broke down and cried on a movie set. (424)

—cried, one should add, at the producer's expense, since with tears on her face the performer could not (at least for most of this film) also be the character.

The production environment is typically arranged to optimize the rendition on film of the carefully designed profilmic event. Of central importance is the camera and the recording material it uses, with the appropriate operating crew; all of the ancillary equipment and personnel are there in order to heighten, extend, rarify, or polish the camera effect. "The chief quality that is required in a man of my profession," Gubbio the fictional camera operator confesses in Pirandello's *Shoot!*, "is impassivity in face of the action that is going on in front of the camera" (6). It is how he will appear in the rushes that ultimately determines the structure of an actor's work, not what he feels as he acts.

Makeup can enhance or compromise an actor's ease and liberty. Technicolor filming in the twenty-year period commencing in the mid-1930s led to certain discomforts. For instance, David Bordwell notes that the procedure demanded sensitivity to actors' skin:

> The plausible rendering of complexion and expression became the chief goal of Technicolor's research. . . . Complaints about Becky Sharp's 'overripe' and 'scarletina' skin tones made Technicolor ask Max Factor to devise pancake make-up. Throughout the 1930s, Technicolor calmed cinematographers' fears that color would aggravate facial blemishes. (355–56)

Max Factor "had located in Los Angeles in 1908 and supplied make-up, wigs, and hair-pieces to stage and screen" during a period—that did not culminate until the end of the 1920s—when actors were responsible for their own makeup, so that consistent patterns among the players in a single film were not yet striven for or achieved (see Staiger, "Division" 149–50). The 1934 Twentieth Century–Fox black-and-white production *The House of Rothschild* concluded with a long scene that was finally shot in both black-and-white and Technicolor, the former to be used in the event that audiences did not respond well to the colored version (see Basten 52). Here, the discomforts of pancake would have been emphasized for George Arliss, Florence Arliss, and the other players by virtue of the novelty of the Technicolor setup and the fact that until then they had been working comfortably in black and white.

Richard Haines mentions the "vivid amber fleshtones" visible in all threestrip Technicolor features of the 1930s and 1940s. "Sometimes referred to as the 'Technicolor tan,' [these] made the actors look very attractive. The effect was achieved with a combination of makeup and 'bastard amber' gels on the lights" (35; see also Higgins 87–88). Haines goes on to note the use of a more realistic, although still "warm," flesh tone in the 1950s and the change to the "'cold' look currently in vogue" when after the mid-1970s the Technicolor dye transfer process was discontinued. Technicolor's amber tone was created through the use of Factor's yellow Pan-Cake as a way of balancing the extremely intense volume of arc light required for Technicolor filming: arc light had a color temperature that fit into the blue part of the spectrum. When they shot in Technicolor, actors had to wear Pan-Cake on every part of their visible skin, under very intense illumination and often for long hours at a time. Basten notes that "flowers wilted and paint blistered" and quotes a cameraman's recollection of having seen smoke rising from an actor's hair (73).

With Technicolor production, there were challenges to actors beyond makeup. "It took four times as much light to shoot as it did with black-and-white," noted David Butler about directing *The Little Colonel* for Shirley Temple in 1935. "We had to hang lights as well as put them on the floor. . . . It was hard on the actors' eyes" (124; 170). With three-strip Technicolor, light not only had a situated quality for aiding the dramatic construction, it was a kind of situation in itself. "Lovely, rich color," recalled Charlton Heston, "with a separate roll of film for each primary, but the camera was as big as a refrigerator, and damn near as hard to move. Everything was bigger and heavier then, the cables, the lights, the generators. The logistics of a location were awesomely complicated" (*Arena* 104). Because the black-and-white recording film that was passing through the Technicolor camera, three strips of it simultaneously to create the red, blue, and green "records," was until late in the 1940s a relatively low ASA material, and because the red and blue recording strips were bipacked as they went through the camera, a substantial quantity of light was required for filming, considerably more than would have been used for conventional black-and-white films. "Cameramen were trained to use eight-hundred foot-candles—so much light," said famed cinematographer James Wong Howe:

> There was a reason for it, because it would give a good, strong negative, and with a strong negative they could make many matrices to make their prints. . . . With a strong matrix, you could make maybe 150 prints before the matrix wears out. But if you light in low key, you have a weak negative and a weak matrix. That doesn't mean you have bad color or anything, but the studio complains because after ten prints the matrix wears out. (qtd. in Stevens 138)[6]

Numerous intense carbon-arc lamps were required for lighting the three-strip Technicolor on *The Wizard of Oz* (1939). "[Victor] Fleming had to stop shooting every hour or two for an hour, to open up the soundstage and ventilate the set—air-conditioning wasn't sufficient," writes Michael Sragow:

> Frank Leonetti, a lighting technician in Munchkinland, . . . was part of a small army of lamp operators. "The Lamps were a lot larger than the ones you have today," he said in 2004, "and not as efficient. For a carbon-arc lamp, you had to put the two [carbon elements] together, trim and feed them, and they had to be changed every half hour. Today, we use

high-intensity arc lights that don't require igniting. One man can produce the light that ten men did back in 1939; back then you needed one man for every two arcs, and I couldn't tell you how many we had." Hal Rosson, once again Fleming's cinematographer, said the production used enough arcs "to light 550 five-room homes." (294)

Facing this kind of intense illumination some actors may have experienced greater discomfort than others: "I recall hating working in color because my 'sailor's blue' eyes couldn't tolerate the necessary extra bright lights," wrote Douglas Fairbanks Jr. "Even in exteriors, the natural sunlight was augmented by reflectors and arc lights. I had a terrible time keeping my eyes open for more than a few seconds at a time" (162). On Turner Classic Movies on 1 April 2014, Eva Marie Saint made an identical confession to Robert Osborne. There is widespread belief inside and outside the medical community that blond, fair-skinned, blue-eyed people with large pupils have considerably more photosensitivity than people with tiny pupils and brown skin, although there are some findings to the contrary.[7]

Nor have high-tech modern filmmaking methods ameliorated all of the problems besetting film work. Evan Williams, another blue-eyed performer, recounted to me that while shooting *Grey Gardens* (2009), he was confronted at once by numerous difficulties as the camera turned:

> I was wearing a tux. We were underneath these bright, bright lights, hot as fuck. The tux fitted tightly and I was itchy in the heat. It's 6 A.M. and we're acting like we're having a great time in the evening, and I had to look up at a balcony—there were blaring lights. Very often they'll have lights right behind the camera so your eyeline is directly aimed at a great big light. You can keep your eyes closed until "Action" so you're not squinting. You can't act with your eyes open when they're watering.

Performance Woes

The actor's body not only inhabits a work site but becomes one, on set. Even at the best of times, shooting film is taxing, tedious, and exacting for actors, who are oftentimes, as with Simon Callow and friends on James Ivory's *A Room with a View* (1985), "squeezed into our costumes, and gummed

into our hairpieces, and our blemishes are painted out by the make-up artists. . . . All you can do is talk, smoke and eat. The talk becomes more and more abstract. Starting with theatrical anecdotes, by the end of a shoot you're onto Zen Buddhism and the meaning of life" (234–35). The herculean effort expended by actors and crewmembers may reap the scantest of rewards. In one critical scene for that film, Callow, Judi Dench, Denholm Elliott, and Maggie Smith are riding a carriage to Fiesole and a tree has been designed to fall in the horses' path:

> It had to fall late enough to look menacing but early enough to avoid the horses. Every time it fell wrongly, we had to ascend the little hill again, walking through the mud to give the horses a break, clutching our skirts or gaiters. So there we are in our carriage, chattering away, and finally the tree is right. A good take at last. But we need another to be safe. Suddenly Maggie Smith, seconded by Judi Dench, protests. . . . All this has taken over eight hours to shoot—we were on location at seven—and will result in under a minute of film. A brilliant minute, as it happens. About ten minutes out of those eight hours was spent in front of the cameras. (234)

Shooting with weighty makeup, even under clement conditions, could pose specific difficulties. When Charles Laughton was doing Quasimodo for William Dieterle's *The Hunchback of Notre Dame* (1939), he did not want to imitate the makeup that Lon Chaney had produced for himself in 1923, and arranged instead to work with Perc Westmore. As Charles Higham recounts, Laughton had to contrive "to be turned into a deformed monster, with a hunchback, a walleye, and twisted arms and legs." As the makeup developed,

> The hump itself weighed four pounds, and was made of foam rubber. Part of Charles's face had to be pulled down, and the other pulled up, to give a lopsided appearance. Special lenses gave one eye a milky consistency. A false eye hung on the other cheek. Charles's clothes were heavily padded and his body covered in rubber to suggest enormous muscular power, and he had to drag heavy chains in many scenes. The heat was so intense that sweat often ran down his forehead, ruining Westmore's work. . . . His eyes, peering through contact lenses which were so painful they made his eyes run between scenes, had to show no reaction when he heard sudden and violent sounds. To make his part flawlessly realistic, he had special

waxes put in his ears which made it impossible for him to hear anything. (*Laughton* 97)

The effect was profound for those closest to the actor as he worked. "When Laughton acted the scene on the wheel, enduring the terrible torture," wrote the director, "he was not the poor, crippled creature, expecting compassion from the mob, but rather oppressed and enslaved mankind, suffering injustice" (98). This is a testament to the power of great acting to generalize beyond itself, since in the case of this performance the actor was indeed, in a personal way, a poor, crippled being hoping for some compassion from the mob/audience.

Physical and material shocks to the system are potentially as taxing as emotional and psychological ones. (The covering, writes Lawrence Durrell, confers "the disguise which each man in his secret heart desires above all. To become anonymous in an anonymous crowd, revealing neither sex nor relationship nor even facial expression" [*Balthazar* 161].) Ronan O'Casey told me how while playing the corpse in the nocturnal park scene for Antonioni's *Blow-Up* (1966) he was rendered intensely uncomfortable not by having to hold his breath "being dead" but by the noxious green makeup he was required to wear. For him, the labor was literally sickening. So, frequently, was Boris Karloff's work. "Making the Frankenstein film was grueling [for my father]," Sara Karloff, the actor's daughter, recounted to John Gugie:

He lost 25 pounds and the makeup alone took 4 hours each morning to put on and almost that long each night to take off. He did injure his back during that film, and during his life he had 3 back surgeries. He never complained on or off the set. He was the consummate professional. ("Interview")

There are numerous such stories of actorly self-sacrifice and discomfort, standard operating practice in capitalist endeavor, in some ways, yet fascinating in cinema because the end product is a seamless moment that so thoroughly and aesthetically covers the pain and sacrifice. For Stanley Kubrick's *2001: A Space Odyssey* (1968), Dan Richter played the role of the Moonwatcher, the great ape who tosses that legendary tapir bone up into the heavens; but he also taught the mimes who played the other apes:

You really needed to be very, very skinny to do this, because of the padding of the costume. We looked at tens of thousands of people. Once we got

everybody together, it turned into Parris Island [the Marine Corps train-ing site]. I had to make them forget everything they had been trained to do and retrain them—break them and rebuild them. I also had to build up their stamina, because it was going to be really difficult to do all that movement in that costume, on a set where the temperature was over 100 degrees. (Ebiri)

If makeup and costume offer an actor placement—a condition against which one may strive and a space within the confines of which the perfor-mance is seen to occur—they can additionally be a source of identification and self-esteem. Haruo Nakajima, the man inside the Godzilla suit from the beginning of the franchise and for just under twenty years thereafter, took "a tremendous sense of pride" in knowing so much depended on his presence. He studied the movements of animals in order to create "the lum-bering walk of a large creature," but the costume was a genuine taxation:

Katsumi Tezuka and I both tried on the costume during the first day of shooting. The costume was very stiff and heavy. I could walk about thirty feet in it, but Mr. Tezuka could only walk about ten feet. The original cos-tume weighed over 200 pounds. Later costumes were a little lighter but all of the costumes were very heavy. It was also very hot inside the costume. All of the costumes after the first one were easy to work with, as they were made to fit me, whereas the one that had been built for Godzilla had not been made for my body size. (Roberto)

In another interview, with David Milner and Guy Tucker, Nakajima indi-cates how the low ASA rating of the film stock they were using for the first *Godzilla* film (1954) required enormous quantities of light, which made working conditions torporous. But he also opens the door to a bizarre cir-cumstance. "There were three cables coming out of the back of the costume. Two were for the operation of the eyes, and one was for the operation of the mouth. Eizo Kaimai was responsible for the movement of the eyes and the mouth" (Milner and Tucker). Here, then, the characterological body is fragmented, put into operation by two independent actors, both of them functionally invisible and only one in control of the quintessen-tially expressive organs of the face. This modernist fragmentation recalls the curious telephone conversation Charlie Chaplin initiates with Mabel Normand on the Santa Monica pier in *Tillie's Punctured Romance* (1914),

where, as they try to get help for the floundering Marie Dressler, one of them holds the earpiece while the other barks into the mouthpiece of the same phone: this is a "conversation" in which neither can fully participate and thus a perfect model of the division of labor in capitalism.

Extremity of climate can affect even those who wear minimal makeup or prosthetics. Struggling in Spain to film the famous eleven-minute penultimate shot of *The Passenger* (1975), Antonioni and his actors and crew had to withstand a severe windstorm, which prolonged the shoot. Shooting the storm sequence of *The Hurricane* for John Ford (1937), Jon Hall and Dorothy Lamour spent days in the tank stage at the Goldwyn Studio, with water pounding them from wind machines in an arrangement designed by James Basevi. And in the 1926 *Ben-Hur*, a full-sized Roman trireme was sunk in the Mediterranean, causing "considerable anxiety for many extras who could not swim" (Ramírez 77). "Towards the end of the picture [the filming of *Billion Dollar Brain*, 1967] I was doing a shot in which I run across the ice floe as it breaks up, leaping from one floating block to another," Michael Caine recalls, of his experience working in the chill of a Helsinki winter:

As we were shooting this scene, one of the Finnish assistants ran into the middle of the action and yelled at me to get off the ice floe immediately.

"What's wrong?" I queried.

"Where are your ice knives?" the Finn demanded.

"What ice knives?" I asked, not knowing what he was talking about.

"These," he said, reaching back with both hands and pulling two identical short knives from holsters on each hip.

"What are they for?" I asked.

"If you fall between the ice blocks, how do you think you are going to get out with your bare hands? Without these you would be dead. We couldn't get you out." I stood there shaking with more than the cold. (267–68)

Here, by virtue of the actor's newly gained knowledge the heretofore benign setting was suddenly transformed into a landscape of mortality.

Once films were being shot with sound—the sound revolution occurred between 1927 and 1932—external locations, typically used for dramatic settings, were increasingly found less efficient for shooting, since there was no way to control wild sounds (traffic, aircraft engines, animals). It therefore became conventional to film inside large soundproofed barns called

soundstages. Here the microphone boom became a familiar and central inhabitant, tall, gangly, somewhat prepossessing, and essential to labor. To accommodate the movements of the boom, on-set entryways were made larger and taller, and to proportionally balance the size of these entryways sets were generally rather huge. Juan Antonio Ramírez quotes Mordecai Gorelik's ironic observation that "the sound boom is the usual pretext for allowing the most modest interiors to assume elephantine dimensions. Whereas Hollywood will gladly spend money to make settings look lavish, it cannot afford the money to make the settings look normal" (67). We can see this expansion of the set in any number of drawing-room films, such as, for example, George Cukor's *The Women* (1939), in which there is a transitional moment with Joan Fontaine and Norma Shearer marching from a salon into a dining area, the camera panning to follow them. It is evident that Fontaine, a relatively small woman, is taking huge and energetic strides in order to cover the enormous distance in the scant few seconds of the pan, almost as in a play or exercise routine. Joseph Platt and Lyle Wheeler's interiors for the Manderley estate in Hitchcock's *Rebecca* (1940) are similarly vast, expansive, high-ceilinged, and generally capacious—much more so than would be found in most authentic country houses in England; part of Joan Fontaine's winning performance of a sheepish immigrant to these precincts is accomplished by her mere placement in spaces that dwarf her.

In set design, the magnitude of the diegetic spaces required a certain amount of decoration in order to focus the viewer's eye. A lot of dado and cornice work became fashionable among set designers and builders. In order not to fall off visually, walls were set with decorative moldings. Assheton Gorton recounted to me how for English productions, notably *The French Lieutenant's Woman* (1981), the height of skirtings (in North America, baseboards) was a telltale giveaway about the characters' social class ("Gorton"). Ramírez proceeds to note how set decoration had to be simplified, since backgrounds were in "competition" with the faces of stars in close-up and the star faces had to dominate. He notes, too, a propensity for building trapezoidal walls, which would foster an illusion of depth that could contribute to actors' labor while they worked to seem real (67).

In large settings a certain magnification of style was required from actors so that their voices and posture could appear suitably fitted to the grandiose space. Rex Harrison's work in *Anna and the King of Siam* and Roger Livesey's in *A Matter of Life and Death* (both 1946) are good

examples. Modulating facial and body movement could be especially tricky. By the 1940s and 1950s, faster wide-angle lenses and more sensitive sound-recording equipment were being developed, and by the 1970s, according to Barry Salt, lenses with focal lengths from 10 mm to 15 mm were in use by many directors "for the photography of a large proportion of the ordinary scenes in their films" (280). It thus became possible to shoot inside relatively small spaces. In Polanski's *Chinatown* (1974), to take but one case, the bathroom scene in which Evelyn Mulwray (Faye Dunaway) tends to the nasal wound of Jake Gittes (Jack Nicholson) is composed of exceptionally clear, deeply focused, evenly lit shots in a tiny space, and the actors are in a position to diminish the scale of their performed interaction since the lens will be magnifying it.

What one does in performance work is (obviously) integrally related to the size and nature of the place in which one is compelled (or inspired) to do it. Ramírez details some of the meticulous arrangements made in constructing the floors upon which Fred Astaire would work his miracles before the camera. A careful study makes it possible to see how the dances were cultured, in one way, by the dance floors:

> For *Flying Down to Rio* (1933) dance floors were made with strips of hard maple, 3/8 of an inch thick, 2½ inches wide, and 16 feet long, which were glued to canvas. The sound still proved inadequate, and the strips became unglued after a few days under the hot klieg lights. Any number of tests were run, including increasing the ratio of open spaces to solid walls and floors, using Oregon pine and birch instead of pine boards, and so forth. Finally, the crew tried out a floor made from quarter-inch, very dry, highly shellacked, plywood; soon after, this floor surface was additionally covered with bakelite to obtain the high gloss deemed so essential to the final "Astaire" effect. (68)

Astaire's performance certainly glowed because of his talent, style, and commitment to rigorous practice, but also because of the Bakelite, and because the floor was religiously cleaned up take after take; it, too, was starring in the dance number: "Any scratches made during shooting were scrupulously eliminated with 'energine' before the next shot" (68). Various numbers in *Shall We Dance* (1937) required different surface treatments for the floor under the Astaire feet, from sheet metal to cement upon a plaster-and-mesh base daintily "sprinkled" with carborundum.

Time is a kind of place; it can surely make a place (see Tuan 118–35). Exemplifying a form of workload trouble, Ginger Rogers recounted to the Screen Actors Guild how when she was a lowly contract player doing screen duets with Fred Astaire, already a major star,

It was like I was working in a mine, trying to dig myself out. I worked so hard that I had little time to do anything. They'd make my call for the first thing in the morning. I'd rehearse the dances most of the day and then I'd continue all night. I'd ask what happened to Mr. Astaire and they'd say he'd been sent home. It's two o'clock in the morning and they'd want me to do close-ups and I had to be back at the studio at 6:00 A.M. I said to the director, "No, you can't do that." And he said, "Yes, I can. Ha-ha!"

It was the hour of day, not the physical stage design, that was giving Rogers a hard "place" to dance in.

Shooting early in the morning is a staple of work in Hollywood, where production efficiencies are obtained by maximizing the length of the working day. Evan Williams recounts a certain trick for mastering the important, but rarely discussed, "caffeination schedule":

You have to do a master and then coverage, and depending on the number of people, it can take a couple of hours. You've drunk a lot of coffee so it doesn't look like you've just come out of bed. Usually people are jacked for the master and then slowly experience the crash over the course of the coverage so that by the time they get to their coverage there's a big disparity between the quality of their performance in the master and what they do now in the coverage. The lights seem hotter all the time and the wait seems longer. It works a little in your favor because for a close-up you have to be a little bit subdued, so it's not so good if you have coffee right after the master and you're amped, and they put the camera in your face. I don't drink coffee on set for that reason. I've learned to drink only green tea. (Personal conversation)

Caught Up

There are many particular ways conditions extrinsic to the body of the actor work to culture and shape what he or she can manage to do. Editing can

work this way. A performer is engaged in a conversation, uttering lines of dialogue in alternation with other performers doing the same. Presuming clean acoustic breaks between the utterances, produced with characteristic tonal drops at the ends of speeches,[8] and the conversation being shown through a standard shot/reverse shot composition in which both characters are seen in medium shot or close-up as they speak, we find a good case of the camera shifting (or appearing to shift) from one place to another, even if the places are simply two perspectives on the same room. Nothing prevents a gifted set designer from arranging one sort of grouping (of flowers, furniture, paintings, accessories, draperies, windows, etc.) behind one of the speakers and a very different grouping behind the other, so that in the intercutting one really senses oneself bouncing between two places (see for interesting examples Pomerance, *Marnie* 29 and Rothman 291ff.).

But for an editor, another issue arises. How long should the camera rest on a performer's face when her utterance is complete? We see Bette Davis utter a line, walk across a room, and exit. The power of that line may ultimately rest on the length of time we linger on the door or on another character's reaction after she has gone (a piece of "acting" created by her editor, typically Rudi Fehr). To live life in a world of sunshine, streets, friends, offices, and tram cars is one thing; to have action set under lighting and filmed in such a way that the phases of one's movement, already broken out of the continuous flow of life, can be sundered from one another, then curtailed or extended to suit a wholly artistic pattern as they are reassembled, is something else. As Jean-Luc Godard said,

> If direction is a look, montage is a heart-beat. To foresee is the characteristic of both: but what one seeks to foresee in space, the other seeks in time. Suppose you notice a young girl in the street who attracts you. You hesitate to follow her. A quarter of a second. How to convey this hesitation? Mise en scène will answer the question, "How shall I approach her?" But in order to render explicit the other question, "Am I going to love her?," you are forced to bestow importance on the quarter of a second during which the two questions are born. (39)[9]

As we watch performance in film, the brief shot and cutaway seem natural extensions of the character's intent at the instant, as do long reflective gazes-off. But perhaps the drama as acted out before the camera and the drama as we see it onscreen are two different evocations. Selecting out

the relevant phrase of action is always paramount to cinema. This means not only choosing the instants of initiation and termination of a gesture but also designing the rectangle in which part or all of a performer will be seen. In *Psycho*, Hitchcock has Janet Leigh as Marion Crane leaving a realtor's office, a mostly white location, dressed in white (and, as we saw in a previous scene, wearing white underclothing beneath) and carrying a white envelope. She says she is going to go home and go to bed and take this envelope to the bank Monday morning. Hitchcock cuts to a bedroom, with the envelope upon the bed, and Leigh pacing in black bra and panties as she packs a suitcase. In two shots, without her saying a word, we learn of her duplicity; her desperation; and her lack of connection to her job and residence. In combination, these depict her as an energizing force that moves the story forward and with a twist. This modulation of Marion's character is achieved not by Leigh independently but by the cutting.

The cinematographer's lighting can "achieve" an actor's performative expression and tone. Since the issues in cinematographic lighting are more or less universal, we can see reflected here the shaping of performance through technical, not only cultural, forms. In Raj Kapoor's *Awaara* (1951), for example, there is an engaging romantic duet, "Dam Bhar Jo Udha," between Kapoor and his co-star Nargis aboard a little sloop in a tiny moonlit harbor. As they sing and dance here and there upon the decks, clutching alternately the mast or one another, and shifting from delirium to anxiety, to sadness, and then back to joy, we see the moon apparently shifting in the sky, and as though in their pull, because the "moonlight" upon their faces and heads keeps changing orientation even as they keep facing the camera. This magic is accomplished very largely by the cinematographer Radhu Karmakar moving his "moonlight" around to strike their faces on different sides. In short, the lighting continuity is manipulated in order to achieve a rather spectacular dramatic effect.[10]

Cinematographer Aldo Scavarda keeps his angles consistent for the island sequence of Antonioni's *L'Avventura* (1960), but uses substantial fill lighting in bright, partially overcast weather, to achieve a sense of luminous flatness in the near surround and furthest distance at once. As Gabriele Ferzetti, Monica Vitti, and others search for Lea Massari, who has simply disappeared, there are no pronounced angles or shadows on them, no visual urgencies. For Idrissa Ouedraogo's *Tilaï* (1990), shot in a village area of Burkina Faso, Pierre-Laurent Chénieux and Jean Monsigny take full advantage of the brilliant sunlight in order to saturate the colors of the

garments, which help define the emotional states of the characters, and of
the russet earth: in this way all of the performances are literally, optically
grounded.

Focus can assist in producing performance. Stanislaw Lem notes the
"predetermined focus" of film recording (193). In film it is determined in
advance what should be seen clearly. Actors generally benefit, therefore,
from knowing about the lens being employed in a shot, and regardless of
where they are placed in a scene or how they move there they have good
professional reasons for wanting to be in focus (the more any actor is seen
in a film today the more likely he is to be seen in films tomorrow; remuner-
ation is attached to visibility, careers built upon it). In the reality of shoot-
ing, however, what focal presence any performer can establish remains in
the hands of other people.

The Actor's Body in Cinematic Space

The actor's body onscreen, extended through time (by way of shot length
or repetitions of presence) and clarified through focus (in close-ups,
medium shots, long shots, establishing shots) is not, finally, the property of
the actor. Temporal duration by the editor and placement by the director
and cinematographer working together are shaped and structured accord-
ing to the system's, not the actor's, needs. Production trumps expression.
Often, the actor is forced to squeeze his performance in. For an unknown
but talented bit player to gain notice is no small challenge, since she must
sometimes modestly retire from the "spotlight" yet at the same time get
noticed for the skill with which she is doing this. Angela Lansbury's work
in George Cukor's *Gaslight* (1944) is a paradigm: her character, the house-
maid Nancy, is never really the center of an action, yet is often placed to
slyly and subtly comment upon events through small facial gestures or
tonal modulation when she speaks. A long and vibrant career has flowed
out of this performance. Not dissimilar in its effect is the timid, generally
shrinking (and Oscar-winning) humility evinced by Eva Marie Saint as
Edie in Elia Kazan's *On the Waterfront* (1954) as she flutters in Marlon
Brando's and Karl Malden's shadows. She had done a little commercial
work and twenty-three dramatic bits on television before this film, but had
never been seen on the big screen before. Her problem, like Lansbury's,
was in a way every performer's problem onscreen: how to make a successful

It's Not a Man, It's a Place!"

appearance when appearances are guided and limited by forces outside oneself? In film, the actor does not place herself, but is placed.

A film does not merely tell us through its framing what it is important to look at, or through the extensivity of its shots how long we should look. It tells us what characters look like, by way of lighting, film stock, makeup, costuming, hairdressing, and the actor's physiognomy. The cinematographer exhibits considerable control over cinematic space, and the actor who knows how to work with him has some additional opportunity to shape performance. Marlene Dietrich was one of the very few actors of her day who knew enough about what cinematographers do to give specific advice, even detailed instructions, as to how she should be lit. For her work with Hitchcock in *Stage Fright* (1950), Dietrich in fact directed her own lighting throughout the shoot. But most actors on set are dependent upon, and passive to, the cinematographer's choices. In *Camille* (1936) and other films, Greta Garbo allowed her face to be "sculpted" by the lighting of William Daniels (as we learn from Charles Rosher's comment in *Visions of Light* [1992]). This literally means that the shape of her face, the prominence of certain features, the underlying skeletal lines, the "softness" of the skin, the radiance of the gaze—all these were built in a very particular way through the application of key and fill lights (for a textbook about these and other standard practices, see Alton).

Cinematographer George Barnes came to be known as a "woman's photographer" because he had learned to tautly layer a silk stocking over the lens and then burn a tiny hole in its center with his cigarette—where the center of the face would be. Bounced light is shadow-free, so when a photographer uses a significant amount of reflection (typically front white cards or sheets of mylar) to throw light back into a star's face there are no sharp delineating shadows and the character can be given the sense of floating in space—Brooke Adams as shot by Nestor Almendros for Terrence Malick's *Days of Heaven* (1978), or Amanda Langlet, Arielle Dombasle, Simon de La Brosse, and others in Eric Rohmer's *Pauline at the Beach* (1983). To give her face, arms, and legs a uniform peachy quality, Almendros shot Laurence de Monaghan for *Claire's Knee* (1970) under a white-sheet canopy that would produce uniform diffusion (see Almendros). By contrast, direct application of strong light can produce a sharply defined and even aggressive character figure. In Alexander Mackendrick's *Sweet Smell of Success* (1957), James Wong Howe smeared a thin layer of Vaseline onto the surface of Burt Lancaster's eyeglasses and then "hit" him with direct

illumination placed beneath the camera so that the reflected light would obscure J. J. Hunsecker's eyes; this is a major contribution to the malevolent, controlling, yet at the same time obscure quality of the character's persona. If we look at Frank Perry's *The Swimmer* (1968), we find Lancaster lit very differently by David Quaid, at some moments almost merging with the gleaming waters of the Westchester pools through which his character makes his way homeward.

The use of color affords actors legion other opportunities and taxations. A costumer, for instance, can dress a figure in such a way that the color of the garment and the color of the actor's eyes work together to make an evocative statement: Elizabeth Taylor with her lavender eyes, dressed by Edith Head and photographed by the great Jack Hildyard for Joseph Mankiewicz's *Suddenly, Last Summer* (1959): notwithstanding the difficulty of the script and the demands it made on the performer—"The last-act 'aria' . . . was as long and difficult a speech . . . as any ever attempted on the screen" (Carey 113)—the intense quality of the work emerged in part from what she was wearing. "That simple dress," Mankiewicz recollected. "I went up to Edith Head, who did the costumes for the film, and I said, 'Edith, look. I want this girl to look like she's just stepped out of a bathtub. I want an intelligent young woman. No crap. No things hanging from her ears. Simple and beautiful.' And Head did all that and she won an Academy Award for it. And Elizabeth . . . never more beautiful, and, probably, never better as an actress" (Laffel 201). For *The Birds* (1963), where 'Tippi' Hedren's Melanie Daniels must convey a quality of being ground down emotionally as the film progresses, Head designed one single pear-green suit that the performer wears through the entire film, its progressively disheveled look reading onto her persona's fall into disorganization.

Placement and Division

I esteem as profound Haruo Nakajima's comment about his eyes and hands being operated by someone else while he played Godzilla. This is a far cry from that old vaudeville standard—virtually a *lazzo* in the Commedia tradition—of the horse or cow being a papier-mâché head and a spotted blanket thrown upon a pair of stooping performers, one being the front end, one taking up the rear, like Tweedledum and Tweedledee, one of whom began, and the other of whom finished, each sentence. With

Nakajima we have the specificity of the eyes and hands. In principle, the actor is telling us that he does not see what Godzilla "sees"; does not touch what Godzilla seizes and possesses.

The principle underneath this particular mechanical arrangement is interesting in itself. An actor typically stands to perform within, and completely through, his own body, so that what he sees is enhanced and limited by his optical acuity, as well as by the range and diffusion of light around him and any and all obstructions that might partially or fully cover his eyes. For the actor at work, then, seeing is almost always personal. It is by way of his own sight that the actor apprehends the space between him and the other actors, between him and the furniture, between him and the exits. He deduces how many steps it will take him to hit his marks, or to get to that door and walk through, into the obscurity where he can be hidden by the wings or the space out of lens range.[11] But the character's eyes while all this is happening: where are they? The character's eyes are not the actor's, after all; the dramatic construction would collapse if we were given reason to think otherwise, if we could imagine, for example, that the character could see that he stood in front of a movie camera. The character's eyes are in a far-off imaginary zone conceived by the actor yet never seen. The character is always sensorily deprived, and the actor is navigating for him.

As to the hands that are not his hands, the actor must have a strange regard, not only distanced but provoked, since in his name these appendages are getting away with murder. We can think of Robert Wiene's *The Hands of Orlac* (1924), a horror tale but also a small essay on the riddles of performance. A concert pianist (Conrad Veidt) loses his hands in a terrible train accident but, thanks to the persistence of his imploring wife, has them surgically replaced (with the hands of an executed murderer): the hands begin to do what someone else would have them do, and Orlac can no longer touch his wife, then cannot play the piano and loses his power to earn a living. Generally actors can prevent themselves from falling into this undesirable circumstance by concentrating on the reality of their own possession of the hands at the end of the character's arms. They can rehearse. But not Haruo Nakajima.

His "seeing" and "grasping" are performed by someone else, yet Nakajima's eyes are the ones navigating his huge Godzilla body around the set while the optical operator, the mover of Godzilla's eyes, is functionally blind. (With more recent productions through division, such as the monster in Ridley Scott's *Alien* [1979], a video remote could be used to help

the alien creature's puppeteers "see" their way through the diegetic space.) 107
This division of the body is something every actor experiences; the parasitic character, with no eyes and no hands, relies upon the actor whose being it can infest.

Characterization is manipulation and we must remember what Hannah Arendt taught about that: "Man's thirst for knowledge could be assuaged only after he had put his trust into the ingenuity of his hands. The point was not that truth and knowledge were no longer important, but that they could be won only by 'action' and not by contemplation. It was an instrument, the telescope, a work of man's hands, which finally forced nature, or rather the universe, to yield its secrets" (290). For the actor to manipulate his character, in every sense, is for him to gain a kind of knowledge. Acting is learning. In *The Man Who Shot Liberty Valance* (1962), Tom Doniphon's (John Wayne) hand manipulates a six-gun as he shoots the malicious Valance (Lee Marvin); but as Ransom Stoddart (James Stewart) believes that he himself is doing the killing, there is a sense in which Tom is playing Stoddart's "hand." Since Tom Doniphon's hand is really Wayne's, it is through Wayne's eye-hand coordination that Doniphon's gun is lifted, pointed, and triggered—and we realize this when finally we are disabused of Stoddart's misbelief that he himself is the killer. Further, given the diffuse psychological "setting" in which any actor's work takes place (his bounded moral capacity, his life), Wayne has to be morally capable of mounting the sort of Doniphon who would have no problem killing any man threatening to murder an innocent. Whereas a seasoned professional like Wayne had spent years by the time of *Liberty Valance* exercising his moral fiber in the service of performance, an amateur or newcomer might find the challenge confrontational, even frightening.

Yet for the actor's troubles thinking is not necessarily a balm. As a stage manager tells audience member-turned-performer Rice in Julio Cortázar's chilling "Instructions for John Howell," "Analyzing puts you rather at a disadvantage; you'll see, as soon as you get used to the lights, you'll start enjoying it" (100). As to moral incompatibilities: unsuspected, they may spring like a tiger. One young film actor confided to me that in a scene where, as a 1960s rock star, he was supposed to sing onstage and be heckled by his audience, then collapse in wounded fragility, he had trouble in take after take releasing the vulnerability he knew was inside him. Finally he found it almost impossible to work, since his mounting frustration, an unshakeable personal response, caused him to explode rather than implode at the key

"It's Not a Man, It's a Place!"

instant. He had finally to "put a hand to the mouth" of this natural anger (unknowingly giving a secret nod to Anthony Perkins).

Panoptical Setting

The impression is generally given, and audiences generally believe, that the professional actor is as relaxed in his character as he seems to be, working in a bubble of security and repose to articulate the diegetic life. Even when a character is "running for his life," the actor is not running for his own life doing that running. However, "stage fright" is a major component of the actor's experience. The audience, even—as it is for film actors—implied, can induce terror. The director, if nourishing and protective, is also a "threatening figure" (Aaron 41). Of profound necessity the dressing room ritual converts the place into a shelter, "a second home" (71).

The actor's fear is another setting that shapes and guides performance. It is of course the presence of the audience that triggers this problem. The relentless attention of the viewer makes the acting theater into a kind of panopticon. The audience can see anything and everything, and one must open oneself in front of that great gaping maw, the audience's hunger, by "pouring one's heart out," as Saoirse Ronan said: "The camera's like a friend sitting down that's just all ears and wants you to pour your heart out. It's this open, round, black thing and you can tell it whatever you want to say. That's what's so liberating about a camera, I find. Except it stares—that's its way of listening" (Ronan, qtd. in Gilbey). The lens is not the audience, not active and judgmental at all. There is virtually nothing it does not see that is given to it, but it does not presume, does not measure, does not evaluate. The lens is neither mirror nor looker nor enemy, nor, for that matter, friend and aide-de-camp. Stephen Aaron gives a remarkable confession of Paul Newman's: "My fantasy [is that] you get a marvelously inventive director, and you cast it the way it ought to be cast, not because you have to cast it a certain way. You get together and you have four incredible weeks of rehearsal and then you shut it down. And no one ever sees it. You never have an audience to come in and see it" (qtd. in Aaron 112). This fantasy gives the fullest meaning to the word "play" in the actor's sense of "playing together" with a piece of dramatic work. The plasticity possible in such a dream situation, where for hours on end one could stretch oneself in every direction among a happy coterie of associates, with a view only to reaching

the emotional heights of the work and feeling the character to its depths: this is a wish anyone can remember from the Golden Age of childhood, a wish anyone might reasonably strive to fulfill again and again.

The camera represents not an audience itself but the position of an audience. It is a placeholder. Even the cinematographer and his team do not look directly through the lens as shooting happens; in the closest approximation they use a mirrored viewfinder. Only the film sees, only the microphone hears. Newman's fantasy is thus a very good description of the setting in which film acting is most often done. After the shooting and recording, as far as the actor is concerned, the project is shut down and when he sees the final film he is already at work on another project of some kind, already distanced from the event as he knew it. Nor need audience members confront the actor. Yet even so, the actor's fright might impel him to inventions. Beginning rehearsals for *Sleuth* (1972) with the director Joseph Mankiewicz and his scene partner Michael Caine, Laurence Olivier was having trouble, as Caine reflected, getting a handle on the character "to his liking." The first rehearsal day "ended with all of us feeling just a little bit frustrated":

> Larry left first and I stayed behind and was talking to Joe about something when suddenly Larry came rushing back in, a big smile on his face. "Joe, I have a great idea for the part! I will show you in the morning," he said with great secrecy and left. The next morning he came bursting onto the set full of enthusiasm. "I've fixed it!" he cried, and with a great flourish he produced from behind his back a small moustache, which he held to his upper lip. "What do you think, Joe?" he asked, modeling the small piece of hair as though it were a secret weapon.
>
> "It'll be fine, Larry," Joe replied. "If you think that it is necessary."
>
> "I do, Joe. I do," Larry stated, almost in desperation. "I suddenly realized what was wrong as I was leaving here last night."
>
> "And what was that?" Joe was eventually forced to ask, as Larry left a pregnant pause that almost had a miscarriage.
>
> "I can't act with my own face!" Larry yelled. "I always need some sort of disguise." (Caine 334)

Even an experienced performer like Olivier subscribed to the belief, or the trepidation, that the camera had a consciousness. "I think personally that most film actors are interior people," he told Kenneth Tynan in 1966. "It is

necessary for them to be so truthful under the extraordinary microscopic perception of the camera" (Olivier 411).

Setting and Characters

Setting reads onto characters. "The scene contains the act," writes Kenneth Burke. "It is a principle of drama that the nature of acts and agents should be consistent with the nature of the scene. And whereas comic and grotesque works may deliberately set these elements at odds with one another, audiences make allowance for such liberty" (3). For Burke, there is a "ratio" or relation between performance and setting that makes for fit, appropriateness, logic, coherence:

> The occasion: a committee meeting. The setting: a group of committee members bunched about a desk in an office, after hours. Not far from the desk was a railing; but despite the crowding, all the members were bunched about the chairman at the desk, inside the railing. However, they had piled their hats and coats on chairs and tables outside the pale. General engrossment in the discussion. But as the discussion continued, one member quietly arose, and opened the gate in the railing. As unnoticeably as possible, she stepped outside and closed the gate. She picked up her coat, laid it across her arm, and stood waiting. A few moments later, when there was a pause in the discussion, she asked for the floor. After being recognized by the chairman, she very haltingly, in embarrassment, announced with regret that she would have to resign from the committee. (11)

In this example the member's placement was a concrete resignation already, and her announcement a mere acknowledgment of what other members could implicitly have understood, that she was leaving the fold, placing herself outside, becoming alien to the proceedings. The railing and gate were scenic devices that made possible migration back and forth—so that outsiders could come in and insiders could go out—and also abetted definition of status, since this border had to be either respected or crossed, but not both at once.

The background can drape itself over the body, illuminate or enshadow the body, inflect the body, even ornament the body of the character. One possibility: scene as metonym for personality. In Carol Reed's *The Third*

Man (1949), we wait almost an hour to meet Harry Lime (Orson Welles), about whom most of the other characters have been talking, gossiping, and wondering since the film began. It is night. On a gleamy cobblestone street in Vienna the stone houses are lined darkly in a row, their shadowy doorways leading off into channels of uncertainty and speculation. One of these doors is privileged in frame, and in a tiny shaft of light there a kitty meanders around a man's feet. Suddenly he peeks out into the light a little, the pug nose, the penetrating eyes of that face familiar by this time to moviegoers. The shadow and reclusiveness of the setting directly indicate, and also produce, the reclusive shadowiness of Lime with all his nefarious secrets (and the more general shadowiness of Welles, who has agreed to personify a character as horrible as Lime).

A setting such as this goes distinctly beyond containing dramatic action, making it reasonable or possible, instigating gesture, supporting interconnection and emotional involvement. It speaks to and of character by enunciating the character of itself, thus becoming not only a suitable but an ideal place in which this drama should occur, a de facto mirror of the beings who move in it.

Charlton Heston told Joseph McBride that "the actor is the servant of the camera. The camera is what tells the story, and the actor, in a sense, is merely the most important prop" (qtd. in Davis, *Glamour Factory* 103). While a comment like this reflects the general prerogatives of staging cinema—that centrally it is the lens to which all presentations must be oriented—it elides the setting, not only standing beneath and around the performance but an element that can reach forward and modify or emphasize performance directly. In William Wyler's *The Letter* (1940), Bette Davis is driven through the dark streets of Malay for a clandestine meeting in an old antique shop. She is led into a room chockful of artifacts, some cheap and gaudy, some very old and fabulously valuable, and thence into a back chamber where an old man is dozing with an opium pipe and into which, through a jangling beaded curtain, there steps a gaunt, sinister woman all enshadowed, whose eyes, when finally we see them, seem to prod like glinting daggers. This is Gail Sondergaard, performing a kind of "dragon lady" cartoon. Her ability to chill viewers and to suggest unfathomably formidable resolve, cunning, and threat flows from her presence in this dark overcrowded space more or less built from shadow, and from her contrast with the Davis figure, draped over in white lace and therefore shining in this resolute darkness with innocence and helpless vulnerability.

While some American filmmakers, such as Hitchcock and Ford, were persistent about location shooting in the 1950s (see, for instance, *The Wrong Man* and *The Searchers* [both 1956]), and some, like George Stevens, made artful but more limited use of locations (as in *Shane* [1953]), the location style came more broadly into use in the 1960s and onward, accompanying a general trend toward less phantasmal and escapist narrative and more stories with a realist bias. With such films as Martin Ritt's *Hud* (1963), David Lean's *Dr. Zhivago* (1965), and the MGM-Ponti production of Antonioni's *Blow-Up* (1966) we see intensive use of locations (Texas, Alberta, London) mixed with strikingly constructed sets (*Zhivago*'s interiors were done in Madrid; some of *Blow-Up*'s at Borehamwood). When the actor approaches the setting, whether it is a carefully chosen location in the real world or an illusory "place" built on a soundstage, a number of challenges present themselves.

To walk onto a set is to find oneself transposed and perhaps alienated. One leaves the nondiegetic, "real" world and enters the fictive space, but this space has been designed in advance to fit. Most of us who enter new social spaces find that there is a period, however brief, in which we adjust and accommodate ourselves to the look and functionality of a strange environment. We make ourselves fit a space that was designed not exactly and personally for us but for an ideal type, a generalized citizen. We know that the artful arrangement of furniture and emptiness has been set for bodies of all sizes belonging to people of all cultures—one can think of the dentist's waiting room, or the airport departure lounge—or for people in some significant way different from ourselves, as when we visit a friend's home and find his armchair angled for his comfort, not ours, beside the fireplace. In *Dinner at Eight* (1933), John Barrymore's fallen actor character has taken up residence in a hotel, but even long usage of the place hasn't made it quite his own, so that as he makes to commit suicide, in one of those chairs next to a fireplace, he must move some of the objects around to make things "right." The more institutionalized the wider culture becomes, the more one is likely to enter alien space: preconstructions designed without particular personality in mind: settings that are at once stylish and tasteless. But unless the film set is specifically calling up such a space—the moon lounge with its cardinal red modernist chairs and white floor in *2001: A Space Odyssey* (1968); the TGV where Angelina Jolie meets Johnny Depp in *The Tourist* (2010)—it will invoke and imply a particular inhabitant or group, and now, as the actor starts to work there, he must become that person or

join that "family." He must know the set, and make it his character's own, in an appropriate way.

Acting in "Harness"

It is one thing for a setting to be read onto a performance when both take place in the selfsame physical space at the same time. But something else happens when the body being interpreted through the dramatic setting is not really there and never was. In Alfonso Cuarón's *Gravity* (2013), we meet one raw and one notably experienced astronaut (Sandra Bullock, George Clooney) as they struggle for life when a storm of debris destroys their capsule. The astonishing visual effects in this film, the sense of floating in deep space, orbiting the Earth, being outside the pull of gravity, experiencing the depth of the silence, and the shocking contrast between the darkness and the brilliance of sunlit objects—are only some of the attractions Cuarón deftly offers. But for the film to work as a dramatic story, viewers had to believe in the gravity-free zone of high-contrast illumination in which the astronauts were existing. The performances on view had to invoke bodily sensations audiences had only dreamed about.

For reasons that could not have been apparent to viewers, the acting work in this film was supremely difficult, so that it represents not only an enriching visual experience but a true accomplishment for the actors. To Colleen Barry, George Clooney recounted that "moving abnormally slowly to simulate movement in space while speaking quickly 'is the trickiest thing you have ever done,'" and confessed admiration for his scene partner Bullock, who "had it nailed" by the time he arrived on set. Nancy Tartaglione reports that Bullock worked alone for almost the entire project, strapped into a nine-by-nine-foot light box or hanging from ceilings twenty feet high. The actress herself named *Gravity* "physically and mentally, the craziest, most bizarre, challenging thing" she'd ever done; "you find what you're made of." Barry reports Bullock to have survived conditions that "created a sense of extreme isolation not unlike that felt by her character. . . . 'George and I were rarely together, but if I could hear his voice I would feel better. I was grateful for any human contact, even if it was just a breath,' she said."

Pete Hammond reports Bullock's commenting on a central optical/digital problem, that of orientation and alignment, something that can be taken for granted nonchalantly by actors working "on earth": "There was a

metal harness that I had to get up through that clamped around my waist. It was timed mechanically with the camera, so it would turn my body, and the camera was then spinning, and I had to figure out, 'Am I upside down? Or am I right side up?'" British critic Mark Kermode was astounded by the technical proficiency of Bullock's work on this film:

> It's one thing to say, "Oh well, what Sandra Bullock manages to do is to convey the believable emotion of somebody who is both a scientist and a bereaved mother, and the trajectory of her character," but it's completely something else to say, "OK, we'll do all that under circumstances which are actively conspiring to prevent any form of naturalistic acting. Because when you realize that she's completely isolated on a mechanical arm inside a very oppressive LED lightbox into which she's been strapped alone for hours on end, her only contact with the director and indeed with the other actor being through video monitors, then you realize how remarkable what she's doing is.

Of particular significance for Kermode is the invisibility of the actor's work here, its effacement by a cinematic accomplishment that was so effective for audiences they were prone to taking for granted the ontological purity of what they were seeing: the action was all "just happening," as it were, "because we were just there." As Kermode puts it, "In the publicity, Alfonso Cuarón kept bringing [Bullock's achievement] up, because the film is made so well that you don't see any of that stuff. What you see is somebody floating around seemingly effortlessly in apparently zero gravity."

Technology can offer a new "harness" or "grid" within which the actor must work, one that ultimately reads onto the performance by lending it an aura of wondrousness and inexplicability that acts as a second skin. The eventuation of rotoscoping, motion capture, and performance capture as methods for sketching and ultimately rendering screen bodies all make possible actorly involvement through disinvolvement, presence through absence.[12] Often discussed in this light is the case of Andy Serkis "creating" the sympathetic Gollum and the malevolent Smeagle for Peter Jackson's *Lord of the Rings* films (2001–2003). Gollum/Smeagle's visible surface is a computer drawing, originating in a mathematical data set obtained from the actor Serkis in an electronically demarcated arena. Here defining himself as "pretty much the only big name in the [motion capture] business" (Yaniz), Serkis offered the nervous system and musculature beneath an

aesthetically compelling skin layer that would be created later by effects artists working at computer stations. He worked here in the way that he did later for Steven Spielberg's *The Adventures of Tintin* and, as Lisa Bode has perceptively shown, in a more advanced modality for Rupert Wyatt's *Rise of the Planet of the Apes* (both 2011).[13] Examining motion capture in a historical context, Tom Gunning has very usefully pointed us to the work of Étienne-Jules Marey and his assistant Georges Demenÿ, who worked to render "a sort of automatic graft of human motion" ("Gollum" 332). Gunning describes Serkis's work as "synthetic," utilizing a method "not only visually and technically similar to Marey's processes, but derived primarily from medical photography" (333; 332).

Since in this kind of acting the gestural work of the performer is culturing and motoring the activity of a visual artist later on, as he acts the actor actually cannot, even in a mirror, see the ultimate performance he is giving. It could be argued that in motion capture, the character is unperformed; or is performed by the animators who remain even more invisible than actors are when they play characters, since the actors' muscular movements indeed equate to the characters' but what muscles animators must use to make animated characters expressive are almost always unrelated to the expressions.

With animal models, a tremendous concentration of attention is required of animators long before principal photography. For *Life of Pi* (2012), David Conley and his team spent more than a year observing Khan the tiger, who "played" Pi on a boat "at sea." The space of the animal's behavior and that of the character's action could hardly have been more dislocated, with Khan, originally videographed in his home territory of Avignon, finally flown to the United States, "where we did the same but in an environment that had various surfaces built to replicate a boat so that we could get the Tiger jumping up and down off benches so we could study his muscle movements, facial performances etc." The onscreen tiger was built digitally, modeled on Khan. "The success of the Tiger, however, came really from the animators, especially the Senior Leads, who studied the hell out of Tigers for a year, so we could really capture that performance. Often times, we would go back to the reference video we shot and pull a 'select performance' and animate to that if the situation was comparable" (personal conversation). Khan's being photographed in France and the United States for a performance that would "take place" in Asia was only standard operating procedure for effects-generated performance. Blue- or green-screen

work for complex matte sequences is almost always done at a distance from the narrative scene, as happened, for example, with Daniel Radcliffe and company green-screening Quidditch at Warner Bros.' Leavesden Studios in Watford to get optical material for matting against backgrounds shot at Alnwick Castle in Northumberland and at Glen Nevis in the Highlands.

With the tiger, with Gollum, with Harry Potter winning at Quidditch, as with other remotely enacted characters onscreen, the quality of the animated vision attaches to the body and intent of the performer. Thus, Harry becomes more than a little boy at a private school. He is a hypermodern, technologically assisted, true "wizard" of a child, no matter what he does in matted action scenes. We are entranced not only by his feelingful actions but also by the style of their visual rendition.

The Actor's Mirror

An actor may come to be at home in a characterization, but does the performer know what the performance looks like to the audience? On one level it is obvious that performers must know, or at least that they know as much as they need to know in order to further what they are doing. Working with an attentive director helps. But even were an actor to spend hours rehearsing in front of a mirror, would it really be possible to know what the character looks like to a viewer, or how a filmed moment will look onscreen once the work is post-produced? Who can find in his mirror the persona that other people find when they watch him? "You, to the people who do not know you," writes Pirandello, "and they are so many, have no other reality than that of your light trousers or your brown greatcoat or your 'English' mustache" (167–68).

Many and daunting are the ways in which variance can be introduced between the way a character looks and what an actor intends. For *TRON* (1982), a film in which he starred as a lithe thirty-three-year-old, Jeff Bridges did live action that was mixed with stunt work. For *TRON: Legacy* (2010), he was twenty-eight years older, and now frequently in a motion-capture suit, which made it possible for his sixty-one-year-old body to make movements that would be "clothed" by images borrowed from his look in the earlier film. Motion-capture performance thus makes it possible for old actors to play young ones; young actors to play old ones; human actors to play apes; tall actors to play short ones; animals to play animals, and so

on. As the character comes to life, the nervous and emotional substrate is disconnected from the body that is known and felt by the performer.

Another step in the direction of stripping personality from performance is the activity in which invisible actors lend only their voices (that is, their already emotionally energized voices) to characters drawn by graphic artists they may never have met, but who work in a team to provide a "canvas" for a specific actor's voice. While cartooned characterizations are typically visually flamboyant, the acoustic self of the individual can emerge as dominant, voiced by an already-famous screen actor with an audible "personality." The box office can easily be deliriously overrun when Danny DeVito, Eddie Murphy, and Cameron Diaz, all both here and not here at the same time, are advertised on the poster. For young viewers, exposure to the performer is initially by way of the vocalization, not the physique (to which older viewers are accustomed). What is contemporary about this practice of vocal animation is merely that vocalizers are now advertised as stars (because they preexist their vocalizations as star personalities). For example, when in 1966 Sterling Holloway voiced Winnie the Pooh for *Winnie the Pooh and the Honey Tree*, the poster and advertisements did not point to him as one of the allures of the experience.

For the filmgoing audience today, the familiar, already characterized voice of the unseen performer is read onto the visualized character. But for well-known unseen actors the conditions are reversed. They are now placed inside the structure of the visible animation. The visual image reads onto the public persona the performer has been projecting in live screen work and may wish to continue to project there afterward. After *Shrek* (2001), Eddie Murphy is covered by Donkey just as much as during the screenings Donkey was covered by Eddie Murphy.

Hypothetical Performance

Technical facilitation can produce what may be called hypothetical performance. Take as a range any of the now exceedingly numerous cinematic renditions of fabular and distinctly unreal worlds, many discoverable under the label "fantasy adventure" and many as "sci-fi futurism": from Dorothy (Judy Garland) and friends (Ray Bolger, Bert Lahr, Jack Haley, Terry the dog) skipping or scampering off toward the green city in *The Wizard of Oz* to Harry riding the hippogriff through the air in *Harry Potter and the*

Order of the Phoenix (2007); from Scott Carey (Grant Williams) fighting the arachnid in the basement in *The Incredible Shrinking Man* (1957) to Ripley (Sigourney Weaver) confronting the metallic acid-blooded invader in the concluding scene of *Alien* (1979). In enactments as called for by films like these, the performer's diegetic presence belongs to a world that is wholly and entirely divorced from everyday reality in two ways. First, through a phenomenological split, the openly claimed non-actuality of the story. Then, there is an ontological split, the film world being modeled on forms and compositions invented by artists and unlocatable in the everyday.

The requirement that fabular spaces be effected in the mundane reality of soundstages, or through the use of everyday geographical locales, leads to the intensive use of trickery. Matte processes (including blue- and green-screen and sodium vapor photography), rear projections, and prolific painted backings are all to be found in abundant use in such sequences of unreality. Since George Lucas's *Star Wars* (1977), for the space fighter sequences in which a special computer-controlled camera system was devised to make possible repeated, and identical, camera moves take after take, the computer has been a central tool in visual effects work, and it has had a significant additional role in assisting artists to draw and composite spaces, objects, surfaces, and light. There is always some degree to which a visual effect is discretely discernable as such. (Sean Cubitt has suggested the contemporary viewer has become a "connoisseur" of compositing.) In Timur Bekhmambetov's *Wanted* (2008), we see a clear computerized effect in a window crash, and in *Dredd* (2012), the villain experiences a very long, slo-mo plummet to death, highly romanticized but also clearly contrived (see Purse). With each successive innovation of cinematic technology, viewers looking back (as our current distribution and acquisition modes make emphatically necessary) find more and more obtrusive effects in earlier films.

As we focus on the performance in fabular sequences—Astaire and Cyd Charisse "dancing in the dark" in "Central Park" in *The Band Wagon* (1953); Garland chastising that bashful "lion" and slapping his "nose" in *The Wizard of Oz*; Grant Williams hoisting his giant sewing needle into that spider in *The Incredible Shrinking Man*; and so on—we might ask what happens to the nature of acting when the scene being read onto the performance is entirely equivocal, perceptibly constructed, enticingly both real and unreal? What happens to a character like Dorothy when we note that the green Oz

she is spying seems to be painted on canvas, or to Luke Skywalker when, as he pilots his X-wing down the fatal channel of the Death Star, we suspect that we are looking at a traveling matte construction?

Certainly viewers convince themselves that they are seeing Dorothy approach Oz and Luke attack the Death Star, but unless they are impressionable children they also convince themselves that they are convincing themselves. As the performance draws attention to its weight and impact in the fiction, it cannot help but draw attention, too, to the very fictional construction as such. The settings clothe the characters and reflect upon them: the designed skyscraper elevates the hero and the jungle wilds him, the drawing room civilizes and the factory enslaves. But once set in fabular, "hypothetical" unreality the character becomes alluringly as unreal as his surround. Once the character has become unreal and merely constructed, it begins to dissolve before our eyes, so that the actor at work beneath—the least technological aspect of high-tech filmmaking—comes bravely into view.

5

Acting Intimate

To the chagrin of the curious, many actors are unrevealing when they talk about their work and the feelings and intimations that help them create and shape it. In the studio era it was invariably necessary to turn to biographies and autobiographies to find reflections, however soft-edged, on stage and screen work, whereas today the airwaves and Internet are riddled with inescapable but disappointingly elusive personal confessions of one kind or another. Trying to penetrate to the heart of acting—either as a modest viewer watching a scene or, more analytically, as what Roz Kaveney, reviewing Sally Potter's book on screen performance, labels a "connoisseur of acting" (27)—one is often stymied, held off, talked around, directly occluded, in the way "squares" are intentionally kept away from insider knowledge by the hip jazz musician, who "possesses a mysterious artistic gift setting him apart from all other people. . . . The gift is something which cannot be acquired through education; the outsider, therefore, can never become a member of the group. . . . Feeling their difference strongly, musicians likewise believe they are under no obligation to imitate the conventional behavior of squares" (Becker 85–87). Like blowing jazz, acting can be regarded by its practitioners as a sacred and exclusive art, a business that concerns those who are engaged in it more seriously, sincerely, and deeply than it does the paying public, a collection of outsiders who neither care nor find themselves equipped to comprehend what is piquing their enjoyment in the dark.

Moment of Action

Performance is at least purported to be the *agon* of the performer, the outcome of a heroic struggle against demonic forces and thus a source of protracted strain. "We *really* explore ourselves and other people," said the late Philip Seymour Hoffman, surely a secretive type and since *Boogie Nights* (1997) widely considered a paragon of character performance (my emphasis). Trying to pin down the roots of his Scotty J. in that film, he riffed upon the "exhausting" aspect of what actors do:

> I just had a strong feeling that this character, who is my age . . . basically he was 13, so I did a lot of literal expressions of that. . . . I basically wore a wardrobe of a 13-year-old. . . . You know, how does a guy who's really affected, doesn't know he's gay, from the Valley, talk? . . . *I just came up with it . . . I just had* a lot of different voices in my head, and I *kind of meshed them* all together and came up with this voice. And it seemed right, and it informed how I moved my body. . . . And then *I just do* all the internal work which I always do, which is, you know, what's it like . . . to obsess about somebody, you know, what's it like to want somebody so bad? What's it like to go through the day and not be able to think about anything else but this one person? . . . You *just go from there* and see what happens. (Gross "Hoffman"; emphases added)

The interiority and thoroughly personal nature of Hoffman's process, its distance from the broad and objective public understanding it would cultivate, was central to Hoffman:

> Impersonation is really not interesting anymore. It's really about your belief in the circumstances of this character and what they're going through and that you buy that story in that character's journey *as long as what you're doing is honest.* And so . . . that was *just me doing the best I could* to facilitate that transfer of belief, that leap of faith, for everybody in the audience. (emphases added)

For all the sincerity we can infer here, for all the actor's notable commitment and passion, for all the implicit address to introspection and honesty (a value for his appreciation of which Hoffman was again and again ballyhooed), for all the reverential tone and sense of uncontrived presence, for

all the natural magnetism,[1] still Hoffman's words offer precious little about how as a working civilian this actor managed to manufacture his characters. The specific attentions he must have given, the maneuvers he must have learned to execute (and how he learned them), the postures he struck, the vocal work, the tricky habitation of a stranger's body and space—all this we see in accomplishment but not in preparation, retrospectively through the actor's recollection.

To be fair, performers, like many of us, do not treat giving explanation of their work as an occupational requirement, nor are they necessarily trained in pedagogy. But sensing an audience on the hunt for notes, many actors do proffer them, albeit sketchily. Dressing Scotty J. in the wardrobe of a thirteen-year-old, for example: Hoffman must have had someone quite particular in mind, not just a generalized type. As to his claim that actors really "explore" themselves we might wonder, what is the route of such exploration, what monsters lurk along the way, what splendid rivers of feeling and rock formations of conviction line the performer's inside view? He "meshed" voices together in order to come up with the right tone: what sorts of voices, meshed in what way? Through what technique or process could someone "mesh" a group of collected voices—the idea is akin to mixing tracks in a multi-track sound studio, but voices remembered in the mind are not vocal tracks. Obsessing about somebody and wanting them all the time, as Scotty J. wants Mark Wahlberg's Dirk Diggler: this is something readers and listeners might well understand from their own real life in the cinema, being hungry fans of celebrities like Hoffman just as his Scotty is of the celebrated Dirk, but what did Hoffman do to "work up" his desire? Did he, for instance, school himself to yearn for Dirk, or for Wahlberg himself? Did he do this by discovering or rediscovering his own impulses, already born and in hiding, or did he get some photographs and pin them up in his private space as aids to concentration? Not what did the actor *think* but what did he *do*?

In his trade secrecy, Hoffman was not alone. Nicolas Cage is quoted in a 2014 interview with *Cahiers du cinéma* to the effect that he sometimes achieves his characterizations by "listening to the music in my head" (Béghin 90). Considerably more articulate, if equally impenetrable, is Anthony Hopkins's admission of how, while "[poring] over the script" of *Silence of the Lambs* (1991), he "started to hear a voice and conjure an image very powerfully in his head": "I could sense Lecter. I just knew how to do it. I somehow knew everything about this man. I'd see him in this

half-light, in his oakwood office in Baltimore, dark hair slicked back, white shirt, black suit, beautifully-manicured hands, black shiny shoes. A man with luminous eyes. Like a machine" (Falk 177). Hopkins, then, mentally painted a portrait, using language. But it is evident he left gaps and leapt across them, since nothing about half-light, an oakwood office, the city of Baltimore, slicked back dark hair, white shirt, dark suit, manicured hands, shiny shoes, or luminous eyes necessarily suggests the "machine" that Hopkins found. The actor's vivacious phrase "like a machine" comes out of an unspecified cradle, after a kind of preamble. And of course it is *Lecter as machine* that Hopkins succeeded in devising for the screen, a man who is less than a man. Was Lecter machinic for Hopkins because Hopkins who made him was horror-stricken at the thought of a human slicing up other humans to make his meal? A completely malevolent fleshy robot: he knew he could simulate that, yes, but how did he know? And how did he work the simulation? Does he have access to a global secret, that notwithstanding our clean presentations of self we are all, truly, machines? Or does he believe himself to be this way?

The actor's work is essentially internal and invisible, born and developed in a space of consummate intimacy. All acting is "acting intimate" in this sense. Audiences receive the tangible fallout, but the grinding of the work is not for their pleasure. Indeed, an actor may as often as not spot the core of his own performance in a thoroughly esoteric epigram. To Charlie Rose on 16 February 2014, Colin Farrell smiled that for him, perfection was "a true moment, an honest moment." What could any student of acting take an "honest moment" to be? One in which a person is sincere, believes himself not to be lying? Given that there is so much in life even the actor cannot know, it is very difficult for her to be certain of not lying, certain of committing the self to "an honest moment." As to a "true moment," what is that and where is it to be found—in the mundane everyday, or in the transcendence of everyday life, on the street or in the library? If Farrell's "truth" is fully and only whatever he says it is, he surely knows when he has found it but his self-revelation is empty of communicable content.

The actor's private sense of his own acting is quicksilver to our grasp, even when, as does Joaquin Phoenix speaking with Terry Gross about *The Master* (2012), he submits a tactical revelation. Asked how he made Freddie Quell talk out of the side of his mouth, Phoenix actually accounts for the gesture in detail:

My dad sometimes would talk out of the side; he'd clench down one side of his mouth. And I just thought it represented tension in this way, somebody that's just blocked and tight.

So I actually went to my dentist and I had them fasten these metal brackets to my teeth on the top and the bottom and then I wrapped rubber bands around it to force my jaw shut on one side. . . . After a couple weeks, the bands, they weren't really strong enough to kind of hold it so I ended up getting rid of the rubber bands and I still had these metal brackets in and so it made me constantly aware of my cheek. You know, they had these pointy tips so they'd tear up the cheek a little bit, so I just then was constantly aware of it.

This is so fucking stupid. Why am I talking about this? . . . It's not interesting, it's so stupid. If I was driving and I heard this, I'd change the channel . . . I'd be like, "Joaquin, shut up."(Gross "Phoenix")

That culminating self-critique—"Joaquin, shut up"—reveals professional modesty, points to his (respectful) belief that non-actors really *wouldn't be interested* in the dynamics of his professional work, but it also reproaches curiosity. Why, after all, should tradecraft be imagined to hold real fascination for the stranger who had no genuine need to employ it?

Private Actions

Joaquin Phoenix's twisted mouth as Freddie Quell (his tongue always touching metal), Anthony Hopkins's "sensing" the machine in Hannibal Lecter: these acts are personal, in the sense that the individuality and life experience of the performer are wrapped up ostensibly with the work. The actor's body is at once both public and private.

Theorists have long been fascinated by this duality between private and public experience. In 1896, George Herbert Mead taught that each of us is in some respects like every other person, in some respects like only some other people, and in some respects like no one else at all. Béla Balázs comments in this direction when he writes, "The language of gestures is far more individual and personal than the language of words":

Admittedly, facial expressions have their own vocabulary of "conventional," standard forms, so much so that we could and indeed should compile

a comparative "gesturology" on the model of comparative linguistics. However, although this language of gestures has its traditions, it is unlike grammar in that it lacks strict and binding rules, whose neglect would be severely punished in school. . . . On the other hand, the screens of the entire world are now starting to project the *first international language*, the language of gestures and facial expressions . . . the actors' facial expressions must be comprehensible to the entire world. (13–14)

As each person has a biological self, a social self, and a personal and psychological self, each actor reflects biology, sociality, and personality at each and every instant, and all three together. In *Nouvelle vague* (1990) Jean-Luc Godard sounds this theme in asserting that our *gestes* are inseparable from us. Following Walter Benjamin's notation of the eclipse of the aura in the age of mechanical reproduction, Balázs sees personality migrating outward into the sphere of general biology, thanks to motion pictures and their global distribution.

In "realist" film from the mid-1960s and onward (when Hollywood filming became concerned with the hard-edged depiction of real life) we witness characters involved in personal, sometimes potentially embarrassing, private actions. An especially touching and extreme example is given in Martin Ritt's *Hud* (1963), when Brandon De Wilde's Lonny, injured in a cattle pen and then carried upstairs to his bed, is nursed by Alma the housekeeper (Patricia Neal), who brings him cool fresh lemonade. Taking a sip, he makes a movement with his mouth, hesitating, looking into her eyes. "Here," says she, offering her hand, "they're just lemon pips." And he spits his pips into her hand. Lon spitting into Alma's hand; Brandon spitting into Patricia's, with James Wong Howe's camera tightly focusing the interaction between that mouth and that hand. Gesture here emerges from within the actor's personal body—the lungs, the tongue, the lips. Lon's lemon pips are material and private before they emerge as a public response to Alma's invitation. For scenes of personal intimacy to be realized as such, the actor must find a way to foster the impression that, like his character, he is experiencing intimacy, too: here, now, before the lens, while strangers watch. With De Wilde in this scene, the action seems improvised, spontaneous, innocent, as though he did not know beforehand there would be pips in that lemonade and he would find himself spitting them out on camera. His mouth and Neal's hand are *revealed* and fully, unself-reflectively alive in the shot, nakedly present.

Because self-awareness is a form of clothing, innocence attaches to per-
formances that call for nudity. Here is a reviewer's comment about a recent
London stage performance of Kevin Elyot's *My Night with Reg*:

> In order to evoke a mood of relaxed intimacy, the final scene opens with
> nudity. This is scripted by Elyot and is certainly not intended to shock. How-
> ever, while nakedness is no doubt a fine way to convey natural ease, there is
> nothing natural about naked men walking around in a room full of clothed
> strangers. Onstage nudity makes perverts of the rest of us. (Jensen 17)

Perverts because with stage performance we are no less in the room than
the actors are, and no more deserving than they of having skins to cover our
skins while they do not. We may find that the onscreen nudity in Sally Pot-
ter's *Orlando* (1992), Philip Haas's *Angels and Insects* (1995), and Bernardo
Bertolucci's *The Dreamers* (2003) doesn't jostle our self-conceit in the same
way. The shift in indexicality—that we recognize pictures for what they
are—both pushes us back from direct (perhaps self-critical) confronta-
tion and lures us to wonder about, perhaps attempt to break through, that
very withdrawal, to deflect the directness of the moment. Does the rotund
naked body presenting itself, as Ortega has it "in bulk," directly motivate an
urge to touch, an urge that is only recollected, dimly regained, through the
image, which functions like a memory (111)?

Paul Mazursky's account of a touchy scene he intended to film for *Bob
& Carol & Ted & Alice* (1969) with Robert Culp, Natalie Wood, Elliott
Gould, and Dyan Cannon is illustrative of nudity issues in filming:

> There was an air of great expectancy on the set as the foursome arrived.
> I had ordered a closed set, no visitors, thereby raising the expectation of
> something very wild and sexual. The actors were mostly giggling ner-
> vously. I arranged Natalie, Bob, and Dyan in the king-sized bed, sitting up
> under the covers. They were waiting for Elliott (Ted) to join them. He was
> in the bathroom doing a last-minute breath spray and underarm cleanup.
> He was very funny.
>
> When Elliott entered the bedroom, he climbed in next to Natalie. I told
> him I wanted him to take his jockey shorts off under the blanket and then
> toss them out so we could see them. Elliott did it perfectly. Only later did I
> learn that he wore two pairs of jockey shorts so that he wouldn't be totally
> naked under the blanket. (162)

Actors playing intimate need not be intimate with one another in practice. The hygiene products that Mazursky tells us Gould was using constituted both an etiquette and a defensive shield, guaranteeing that scene partners would not be directly contacted. With De Wilde, Neal, and the lemon pips, no such prophylaxis was possible: even had the one used mouthwash before the shot and the other worn hand cream, the pips were coming out of that very buccal cavity onto that palm.

The actor thus works within an envelope of intimacy. But characters, too, may be seen to have an inner life, and in psychological drama after the 1990s watching characters' innerness has become a regular feature of filmgoing. A glimpse of a character's intimate life can charge audiences with discomfort, whether or not the actor must invoke the private self to produce the effect. In Stanley Kubrick's *Eyes Wide Shut* (1999), Alice Harford (Nicole Kidman) is found sitting on the toilet urinating while her husband, William (Tom Cruise), carries on a conversation with her. This is not difficult to understand as a salient example of character intimacy and the fact that Alice and William are married.[2] As a cultural formality owing to longstanding taboos and tightly organized routines, Alice's behavior tends to be treated with reticence by viewers, since we do not typically find ourselves surveilling other people urinating (this scopic reticence and withdrawal while viewing being something of a function of the theater's public space). In Western culture, this avoidance of inspection is habitual: even as in urination and defecation we must recognize any person's ultimate affinity with all other people (as Godard bluntly emphasizes in repeated moments of defecation in *Adieu au langage* [2014]), we habitually treat such behavior as though it reflects something intensely personal.[3] Eating is also taken to affront the sensibilities, hence table etiquette.[4]

Ironically, we reserve to darkest privacy what most exemplifies our common humanity. Consider the symphonic breathing that opens *Citizen Kane* (1941) or the revelations of skin that permeate *The Dreamers* (2003). Qualities that are personally idiosyncratic such as the voice and the face are freely offered to all. These are consummately intimate, as intimate as intimate can be, yet they are treated in cinema as public resources. Indeed, in Hollywood's classical cinema the face was in many cases treated as a local, subcultural resource, belonging appropriately to a limited genre or studio. To frame the face, one costumer might help present an idiosyncratic personality to the public over and over (Orry-Kelly designing for Bette Davis

or Edith Head for 'Tippi' Hedren), and when the performer changed work
venues a new team would take over, sometimes redesigning the presenta-
tion (Cary Grant's newfound suavity as he moved from RKO to MGM).
That the personal becomes not only public but intensely commercial in the
case of actors' faces was reflected in a little joke of Carrie Fisher's: "Every
time I look in the mirror I have to pay George Lucas a dollar."

Interestingly, while we might "politely" turn away from the sight of a
character urinating we typically do not turn away when he bleeds. Screen
actors wear blood on their persons in the way that they carry costumes,
as part of the graphically organized material that details character and
moment. An actor might wear a blood-drenched shirt (Bruce Dern in
Marnie), nervously rinse blood off his hands (Anthony Perkins in *Psycho*),
stand while blood trickles down his neck or dries on his face (Jack Nich-
olson in *Chinatown*), all without "working" the blood in such a way as to
play to (or against) the viewer's desire to not see. In Ridley Scott's *Alien*
(1979), a preeminent example of blood spatter is given at a strange birth,
and surrounding characters retract their postures in horrified alarm; but
theater audiences, who can see the blood but not what is causing it, scream
in surprise, not abject horror. Other notably bloody scenes, such as the
disposal of Neil Patrick Harris's character in *Gone Girl* (2014), are viewed
as unproblematic morally and aesthetically, although the gore is intensive.

Of course, viewers take the bleeding character body to be distinct from
the actor body producing it; and the blood is not assumed to be the actor's
blood, if blood in fact it is.[5] But filming *Django Unchained* (2012) for Quen-
tin Tarantino, Leonardo DiCaprio did bleed real blood, that is to say, dis-
played for viewers in a completely intimate way an intimate part of his
only-personal self:

> In an intense scene with co-star Samuel L. Jackson, Leo pounds a table,
> where a shot glass is sitting. "But what happened was the shot glass some-
> how slid over underneath where he was always slamming his hand down.
> And in one take, he slams his hand down and the shot glass goes through
> his hand," co-star Jamie Foxx explained. . . ."And now blood is shooting out
> [of] his hand and I'm like 'Does everyone else see this? This is crazy!' and
> he keeps going. And I almost turned into a girl looking at it! But what was
> amazing is he was so into his character that even when they finally said
> 'Cut,' he was still this guy. . . . People almost gave him a mini ovation. It was
> amazing to see that." (Gibson)

At least in retrospect, DiCaprio's bravura commitment to the performing self can be seen not only as a sign of strength but also as an homage, in this case to James Dean's being nicked in the neck during the Griffith Park Observatory knife fight scene with Corey Allen in *Rebel Without a Cause* (see Frascella and Weisel 115; Pomerance, *Horse* 41). Angelfire.com reports an injury Orson Welles sustained to his hand on *Citizen Kane* while filming the scene where Charles destroys Susan's bedroom: "Orson Welles actually cut his hand ... but tape [*sic*] kept rolling. While you can't see actual blood, you can see that he is hiding his left hand after he smashes the mirror" ("Citizen Kane"). Filming *Lawrence of Arabia* (1962), Peter O'Toole "seriously injured his hand by punching it through a glass window" (Steven).

Whether an injury is hidden from the camera, as in the case of Welles, or revealed to the camera, as in the case of DiCaprio or Dean, it brings into play the tenuous and intimate relation between the actor's body doing and the viewer's body viewing. De Wilde and Neal, Cruise and Kidman, Dean and Allen, Jackson and DiCaprio invite us into their intimate moments, compromise our modesties by bringing us into the zone of contact, which is always, too, a zone of mortality. The issue migrates beyond injury, thrill, or contamination into the delicate territory of personal sensibility, dignity, and interpersonal delicacy for actors who have very often never previously met the person with whom they are physically caught up onscreen.

The Self Within

Connected as it may be with style, culture, form, and etiquette, the kind of action we find in films devoted to physique and physical engagement (Linda Williams writes of "body genres" that strive "to *move* the spectator— either to tears, terror, sexual arousal, or some mixture of all three" [*Porn* 415]) is only sometimes the sort of material I would here term "intimate." I mean to refer to scenes in which viewers are confronted with the actor's discreet bodily self-awareness in play. While torture (*The Kingdom* [2007], *Syriana* [2005]), bodily violation (*The Accused* [1988], *Irréversible* [2002]), derring-do (*Casino Royale, Mission: Impossible III* [both 2006]), exceptional agility real or purported (*Shine* [1996], *Black Swan* [2010]), sportsmanlike brutality or aggression (*Rocky* [1976], *Any Given Sunday* [1999]), toughness in the face of nature (*Deliverance* [1972], *The Edge* [1997]), hand-to-hand combat however stylish (*Rambo: First Blood* [1985], *Crouching Tiger, Hidden*

Dragon [2000]), and mechanical utility (*Edward Scissorhands* [1990], *Iron Man* [2008]) all parade character embodiments, sometimes even spectacularly, they do not necessarily bring the performer into the palpable state of bodily compromise in which we might sense the acting body touching itself, as it were, as an acting body. Torture is almost instantly distancing, since however realistic it may look we remain convinced of simulation. There is more intimacy when a character picks up a telephone receiver and we see it brush the side of the actor's face.

Extremity of pose or motion can produce a sense of intimacy in performance, as can manipulations or transformations of the body that imply an actor's sacrificial devotion to a role. Playing Martha in Mike Nichols's adaptation of *Who's Afraid of Virginia Woolf?* (1966), a high point in the actress's long career, Elizabeth Taylor had to gain weight and age twenty years through makeup, this in the face of an internationally recognized celebrity status as a "beauty" that was erased as she embodied Martha as a chubby, eccentric harridan with a javelin sharp voice. When for the Peter Jackson *Lord of the Rings* trilogy he contracted to play the role of Samwise Gamgee, Sean Astin was nowhere near as large as the director wanted and had to put his body through considerable stress to gain the necessary weight for an extended period of time (all three *Rings* films were shot seriatim). Astin's work stood upon other models, including, of course, Robert DeNiro's celebrated self-fattening for *Raging Bull* (1980), discussed at some length and with illuminating incisiveness by Jerry Mosher (303ff.). "Deliberate weight gain," writes Mosher, "is intended to evidence the actor's physical sacrifice and professional commitment, but in an era when fat-suit prosthetics, special-effects cosmetics, and computer graphics imaging make such labor unnecessary, the feat requires advance publicity to assure viewers it is real and thereby secure their admiration" (305). Mosher quotes Astin:

> I just didn't watch what I ate. I ate anything and everything that I wanted. I did a lot of weightlifting right away, and didn't run a lot. But I stopped weightlifting, because once you have the prosthetic feet and ears on, you don't want to move around too much, because your sweat can loosen the glue, and the feet can come off. So I had fifteen-hour days of sitting still and eating. (306)

Non-actors might wonder at how "sitting still and eating" could have constituted labor. Indeed, my own fascination about Astin resides in

his "sitting still and eating" *as work*. It is dramaturgically necessary that Astin's Sam give some evidence of insatiable appetite so as to ongoingly legitimate his chubbiness for other characters and the viewing audience. (Sam's friends must see him as we do, and react as we would react, else they seem incompetent and the dramatic construction is fractured.) Any eating that Sam does onscreen is thus part of an openly acknowledged dramatic strategy: "Here I am, in effect *making* the body of which all who see me are so conscious." Astin's off-camera eating lies behind this strategy, not only nourishing but supporting, guying, orienting, and illuminating it even as it builds the intimately embodied character. And the character, we must note, cannot simply be stripped off each day after work is done as can be effected when actors are wearing prosthetics, makeup, and costumes.[6]

Nor is weight increase the only possible outcome for actors: for *The Machinist* (2004), Christian Bale lost "a staggering 63 pounds," but not, sumonova.com emphasizes, because his director, Brad Anderson, wanted it that way:

> He never requested Bale lose as much weight as he did. I was completely shocked by this because if this wasn't at the request or demand of the director, then why in the world would you care to lose that much meat off of your bones?! . . . His weight loss wasn't part of a specific diet or elimination of certain foods. In fact, it was the elimination of almost all foods and a lot of exercise. . . . His goal for the movie was to look like as if he had not slept for a year. . . . Bale received little assistance in the way of medical attention. ("Christian Bale")

The Actor's Touch

Generally, screen characters touch each other in dramatically emphatic moments of crisis: during courtship (Ryan Gosling embracing Rachel McAdams in the rain, in *The Notebook* [2004]), in lovemaking (Michael Pitt having "intercourse" with Eva Green in *The Dreamers*), or while battling (Edward Norton vs. Brad Pitt in *Fight Club* [1999]); in life-saving attempts (Kate Winslet and Leonardo DiCaprio in *Titanic* [1997]) or killing (Al Pacino with Bruno Kirby in *Donnie Brasco* [1997]); in religious epiphany (Charlton Heston's Judah offering water to Jesus with his cross

in *Ben-Hur* [1959]); in tactile formalities like handshakes (Faye Dunaway
meeting William Holden in *Network* [1976]), grooming (Louise Latham
brushing Kimberly Beck's hair in *Marnie* [1964]), or assisting the elderly to
move (Kate Winslet guiding Eli Wallach in *The Holiday* [2006]). Outside
crisis moments, as these may be seen to be, expressive but casual physical
contact is by and large missing from narrative cinema. One might expect
to see chummy shoulder patting, indicative finger prodding, and so on, yet
these are usually elided. A virtual text on physical avoidance is the elevator
scene in Jerry Lewis's *The Errand Boy* (1961), where bubble gum and cigar
smoke threaten spatial violation but people keep their hands to themselves.

For performing bed scenes and violent fights actors work with their
scene partners in shared knowledge that touching will occur, meticulously
working out their moves in such a way that the most telling possible ver-
sion of an action is presented to the camera with the greatest coopera-
tion and the least compromise of dignity between workers, although most
workers, being workers only, are not often in a position to kvetch about
loss of dignity or attune themselves to its maintenance. The performer
must be thorough enough to "sell" action to the audience, while at the same
time being polite enough not to hurt or otherwise violate a co-worker's
physicality. (In fist fights, the tradition has been to use the camera angle
to foster the illusion of contact when there isn't any.) Touch onscreen is
dramaturgically notable: action heats up, produced through efforts that
appear extreme even if in practice they are not, and what is touched gains
a perfume of reality. Here and always we may keep in mind what Ortega
taught about the material aspect of our "reality," that things only seem real
through contact. "An age-old habit, founded in vital necessity, causes men
to consider as 'things,' in the strict sense, only such objects solid enough to
offer resistance to their hands. The rest is more or less illusion" (111). When
touching occurs, the manner of its execution is central to our belief in the
directness, actuality, and presence of the acted event.

In more banal moments, characters can tend toward considerably
reduced indications of physical contact. In *My Sister Eileen* (1942) Brian
Aherne might take Rosalind Russell by the hand gently and lead her a
few steps across a room. For the gesture to establish gallantry and prevent
a viewer concluding that between the characters there is antipathy, hand
contact need be only superficial. In *Johnny Guitar* (1954), one protagonist
might lean forward, cigarette in his teeth, to permit another to offer him
a light.[7] In *The Wizard of Oz* (1939), Dorothy, the Lion, the Tin Man, and



And can an actor touching an object give it a quality of seeming materially grounded? In Rouben Mamoulian's *Queen Christina* (1933), as the crown is lifted from Garbo's head at her abdication, it loses the gravitational weight that her presence conferred upon it. By contrast in *The Godfather* (1972) Marlon Brando performs his side of a conversation with Salvatore Corsitto while holding and petting a pussycat: his repetitive gesture establishes a rhythm, but also connects him to animality and to the material reality of the situation, where the cat has jumped up to be near him. More than affectionate bonding is played out here. Corporeality is awarded the cat through Brando's touch; and denied the crown when it is separated from Garbo.

Displayed before other parties, touch produces a kind of "evidential bubble" that surrounds the interaction of the moment. Made plain is that the touchers have a link and understanding surpassing any bond of which information can be conveyed by mere speech, and any bond pertaining simply to situation, setting, and narrative contingency. The touch brings us beneath or beyond the surface of the story as situation. In the touch, the character descends as far as possible toward the precinct of the actor who secretly inhabits him. Characters cannot touch, after all, unless actors do; and when we see a character feeling a touch we can imagine the actor feels it, too.

An interesting structural problem arises from this fact. Screenwriters know that if two characters touch onscreen and a third is observing them, this third is instantly cast out. Actors also know this formula, so when two actors make their characters touch in front of a third they will expect this observer to perform his or her exclusion—the *not being touched*—appropriately for the instant, as if aware of it: treating one's space as a sort of "waiting room" and hesitating there patiently as an outsider is one way of handling this issue. More broadly, however, actors are profoundly conscious of the audience as an observing third party. The audience is ideally placed to observe screen goings-on, and is eager to have expression directed their way. When one actor expressively touches another onscreen, even in mortal moments, he pushes the audience away to some degree; indicates a briefly intense bond of privacy that is beyond the limits of viewers' direct apprehension. If one character is only speaking to another, after all, we hear what the hearing character is hearing (any listening character's auditory system is taken to be like ours). Thus, in hearing we are similar to the hearing character, and by way of our hearing we enter the dramatic space

in the hearing character's stead.[8] When a character is touched, however, we can stand in his place only with difficulty, by retrieving and transposing into our present experience some already displaced memory of contact.

Screen love and fight scenes are thus actually off-putting to the viewer. They rouse awareness of being disconnected, of sitting in a darkened theater watching all this on a (protected) screen. The screen touching is determinedly exclusive. A middle ground is established in *The Bourne Identity* (2002), when the protagonist, an amnesiac intelligence agent and trained hit man (Matt Damon), in flight from the CIA, the police, and, we sometimes feel, even from himself, and his female companion, Marie (Franka Potente), stow themselves at the shabby Hôtel de la Paix in Paris. There, in a picayune bathroom, they stand chest to chest as, reaching around her with the greatest tact, he carefully uses a pair of shears to lop off her long hair after dunking her in the sink and giving her a professional re-coloration job. It is impossible for viewers not to see the extreme gentleness, affection, and care with which Bourne touches Marie (Damon touches Potente) or the signs of growing trust and affection on her face. The blushing in the two faces indicates a certain arousal and modesty, even, we may imagine, from the actors. Here, Damon and Potente are required to occupy what Edward T. Hall has called "close personal distance," where "one can hold or grasp another person . . . [it is] the distance of the erotic, the comforting and protection" (120).[9] As they performed proximity for the camera both actors were known to be romantically attached to other people, so the attraction was only an "attraction," a matter of performance business (however authentic it may have seemed to either of them at the instant). Having Bourne operate on Marie's hair is a dramatic necessity (they need to go incognito, and fast); but the filmmaker's setting the shoot in a tiny space where the bodies will inevitably touch offers an opening for dramatic intimacy and erotic reverie. We can see how Bourne's instrumental work breaks its boundary and modulates into something else. The performers accomplish the modulation not by touch alone, since their hands are at work in the mechanical transformation, but by the way they pause in mid-gesture to look at one another with a genuine animal curiosity that brings up the carnal aspect of the activity. Slowly, Marie lifts Jason's tank top up and off to create a dramatic space in which his sensitivity is augmented and her curiosity peaks.[10]

The friction, the Barthesian *punctum* of this moment, is in Jason/Matt's adoring and meticulous attentiveness as, "working on" Marie/Franka, he

watches her face and head. His reconstruction of Marie's appearance is a kind of foreplay, as it turns out, but Bourne performs it (Damon performs Bourne performing it) with a substantial tact, respect, and truth, and shows himself interested in the professional, not the sexual, implications of his action. This moment gains its power—the actors must certainly have known—through its juxtaposition with other nearby moments in which Bourne is cold-bloodedly, brutally violent. Here he moves to another gear, another mode of touch, another self.

Overt love scenes are quite different, since the characters must behave as though touch is not only permitted but expected and *de rigueur*, and the actors mobilizing the action know that "passion," as dramatized, is the sole purpose and key of the scene. In a love scene, then, the actors know they must perform their characters as already stimulated. But in this hair-cutting scene the characters are not already stimulated, they are already at work adjusting an identity, and the work involves a strategically unavoidable embrace.

Anxious Interiors

More intimate than flesh, more complex than organs, more devious than muscles, is thought—including the hyperactive, frenetic form we call anxiety. An anxious actor will work hard to make his anxiety invisible. One actor told me that in doing a bed scene for a 1970 film, "I broke out in hives, I was so nervous." The character he was playing was not nervous. This is an example of a body problem that production personnel shifted out of clear focus through makeup and choreography. But audiences may be intentionally confronted with an anxious character, one whose situational nerves are overstimulated and fully on view: Roy Scheider's Sheriff Brody the first time he sees the Great White in *Jaws* (1975); Robert MacNaughton unskillfully driving a van and pursued by government agents as he chauffeurs E.T. to freedom (1983).

Identifying with the characterological body, however, and moving with the character's moves, the viewer might conceivably "catch" very well performed anxiety, then become discomfited with his own discomfiture. Screen "anxiety" must be played in such a way as to avoid obstructing the general dramatic purposes, which call upon a free play of the viewer's relaxed perception, even when seeing and "feeling" terror, fear,

nervousness, or horror. The horror film, as a case in point, inevitably depends upon viewers sitting still to see in pleasurable detail what people are purportedly too freaked out to watch. A typical response of viewers to what they deem an exceptional horror film is to claim muscular or visceral impairment—that they wanted to vomit or lose control of their bodily fluids, or that they felt paralyzed—but not that their optical function was disturbed. The screen drama must never make it impossible to watch the screen drama.

It is sometimes necessary for a character to seem worried, to be fearful or nervous or fidgety, with the direct implication that he is having thoughts that motivate the fretting. As with any case of acting, the script is a largely unseen and uncredited collaborator in the action, and here, once conditions of threat have been established by the sequence of events in the film it can seem entirely natural and plausible for a character to be in a state of perturbation. Seeming to have troubling thoughts is then not a challenging project. Consider this rather apt description of Peter Lorre's Ugarte in *Casablanca* (1942):

> Like a blanched weasel, he whisks into view, fawning and fulsome, oozing greasy charm and puffing on a cigarette, turning even the simple act of smoking into a menacing art. His long delays are highly charged and followed by a softness of speech that explodes as if another man had yelled. . . . Bogart's self-containment is no match for Lorre's nervous animation. (Youngkin 204)

The long delays helped produce the high charge. Bogart was the tranquil background against which Lorre easily seemed animated.

There is no doubt he was artful in his interactions with scene partners: "He'd light a cigarette in rehearsal," Broderick Crawford remembered of Lorre after working with him on *Black Angel* (1946), "and then you'd wait for him to light a cigarette when you got into the take, [but] he wouldn't light the cigarette, which threw your timing off. These are little tricks that actors have and do to each other" (qtd. in Youngkin 242). Thus, he could create a nervous moment by forcing another actor's move. With *The Maltese Falcon* (1941), we find in Lorre's Joel Cairo an anxiety of desire, suppressed diegetically because of his intensely socialized fear and sense of otherness (and secretly, by production personnel, because the Breen office could not "approve the characterization of Cairo as a pansy" [Joseph Breen to Jack

> Fastidiously arrayed in a black three-piece suit, wing collar, and bow tie, the actor articulates with delicate exactness as he mindfully fondles his umbrella, suggestively brushing the phallic handle across his lips. Each nuance finds its own pose and posture; meticulously gaited movements pause his body language; his forehead furrows, rustling his greasy curls; groomed fingers ceremoniously smooth a white glove over the brim of his upturned hat; the lines of his mouth bend to a shy intimacy, then twist to a silkily menacing grin. (181)

In short, the fingers, the lips, the forehead, the mouth all conspire in pointing. Because we see pointing, we take Cairo to be pointing *to something*, and then project the something as residing in the dark interior territory of his unknowable mind. Actors will make use of facial muscles for the production of emotional signs,[11] but here Lorre goes well beyond mimicry by subtly indicating a mind that can never rest, his gestures, broad and minute, intimately chained to one another, his ingratiation working against his withdrawal, his pensiveness complementing his self-congratulation. Beyond anxiousness, this is a portrait of anxiousness about anxiousness, therefore a basis for comedy. And as nothing is more private, more wholly of the self, than thought, in giving us Ugarte or Joel Cairo physically acting out—gesturing—a state of mind, Lorre is engaged publicly in the least public kind of action.

As a former concentration camp inmate and experimental scientist in Peter Godfrey's *Hotel Berlin* (1945), Lorre is given a lengthy anti-Nazi diatribe that he performs in a state of what seems total inebriation, throwing himself around a hotel room in the presence of a stunned Helmut Dantine while managing this talk with a calculated, rhythmical alternation of slurred and articulate mouthwork. Letting his lips go flaccid or rolling his eyes for dramatic emphasis (and also situational accuracy), Lorre produces a delirium of self-torture, accusatory, politically incendiary, astute, poetic, and wallowing in despair. The speech, concluding tragically, "There are not ten good Germans left. . . . We shall be wiped off the face of the earth. Serves us right, absolutely right," is performed as a gradually building tour-de-force cadenza, in which the actor calls upon bodily movement, facial musculature, vocal modulations, rhythmic stuttering, and

depressions and elevations of tone while simultaneously playing to the proximate and distant camera. All of this embodiment constitutes a portrait of mentality in decay.

Writing of acting in the studio era, Cynthia Baron astutely observes that in some cases actors "worked themselves into agitated states by remembering traumatic experiences,"[12] but that "it makes no sense to discuss stars' agency and expertise in cases where established, experienced actors chose not to prepare for parts, and instead relied on habit, guidance from directors, and support from fellow actors" (31). One could exemplify this casual lack of preparation with Richard Burton's magnificently eroded, even flaccid Alec Leamas in *The Spy Who Came in from the Cold* (1965), achieved, we learn from a key insider, while "he was still drinking very hard. A slight tremor in his hands early in the morning was always lessened by that first cup of 'coffee,' sipped from a mug emitting a whiff of something stronger" (Bloom 129). Claire Bloom goes on, caught between intrigue and rejection, with reminiscences that both drum home the profound mortality of the actor's body and hint slyly that, Burton's drinking having been so ritualized, preparation may have been out of the question for him:

> That was around nine. At noon he was drinking champagne in his dressing room, followed by several bottles of wine, which he consumed with his cronies at lunch. By late afternoon, Richard was pretty well out of commission. When I held his arm in our first scene together, it wasn't the powerful arm I remembered holding not so many years before; like the spirit of the sturdy miner's son I had known and loved, the muscle tone had vanished. (129)

Note the intimate tone of the performance itself, with Bloom (his former wife) clasping Burton by the arm and actually sensing, registering, and storing in memory the quality of his muscle tone. In all physical acting, intimacies of this sort are possible to some degree. The actor also has a sense of self, regardless of how much he has been drinking, so Burton could feel his scene partner touching the character Leamas's nervous innerness. The touching was unchoreographed, thus distinctly of the moment.

For most actors, serious and intimate work was at hand as they went into roles:

> Training in tone production and diction were seen as important for work on both stage and screen. Training to create and maintain a body

flexible enough to represent different types of characters was seen as a basic requirement of both stage and screen acting. Doing exercises to develop one's sensibilities, emotional recall ability, and skill in observation and concentration were considered part of any actor's work. The labour of building a character by analyzing the script as a whole, creating a backstory for the character, and breaking down each scene to discover its purpose and the character's task, was seen as central to an actor's preparation for performances. (Baron 36)

While Peter Lorre often gave his scene partners the impression in rehearsal that he was clowning around, he was as serious as could be in the work itself. Sydney Greenstreet, recalled Richard Matheson, "was this theater trained perfectionist and he would deliver a line and Lorre would just throw something back at him that seemed to have no relationship to the picture." But when the cameras rolled, "Greenstreet marveled at Lorre's sangfroid" (Youngkin 219). In Lorre's performances we can believe we are seeing how the character's mind responds to events and people, and perhaps even detecting the actor's contrivance to lead us inside that responsive mind through externalized signs.

Because it invokes a sense of the viewer's being led to imagine an invisible substrate producing extrinsic signs about itself, acting as an expression of emotion is related to the "doctrine of natural expression" discussed at some length by Erving Goffman in his book *Gender Advertisements*:

It is, of course, hardly possible to imagine a society whose members do not routinely read from what is available to the senses to something larger, distal, or hidden. Survival is unthinkable without it. Correspondingly, there is a very deep belief in our society, as presumably there is in others, that an object produces signs that are informing about it. (6)

Of sign-producing objects, Goffman later goes on to suggest that we believe they "not only give off natural signs, but do so more than do other objects. Indeed, the emotions . . . are considered veritable engines of expression" (7). We may see actors this way. At least by legend, an actor's emotions are taken in our culture to be exceptionally ripe, robust, irrepressible, not to say dominant over more rational exhibitions. Until some evidence of them floods out, emotions are also heralded as essentialist and intrinsic by show business itself, in, for a stunning example, the "backstage

musical" dramas that fill the history of Hollywood productions from the 1930s onward and amount to textbooks about acting technique. Gene Kelly's "Joe," for example, easing Judy Garland's rather anxious "Jane" into the world of show business in *Summer Stock* (1950) by pointing to her greasepaint: "You like it? . . . You can wipe that off your face but you'll never get it out of your heart."

Not only does the doctrine of natural expression direct us to the belief in actors as generators and originators of the emotions we see in the characters who are their presentations, it leads us to think that the flow of emotional expression is unavoidable and unstoppable. Thus, when an actor gives an accounting of her own behavior as emanating from inner sensitivity and feeling, one may decline to search for further explanations. For a scene in Michael Mann's *Manhunter* (1986), Joan Allen, as a blind young woman taken for a visit backstage at a zoo, pets a fully grown anesthetized tiger. The close shots of her face betray a tremendous inner joy, as though she is having a magical experience. The actor told me the beast was real, and anesthetized in fact; its fur was coarser than she thought it would be, and they shot for hours. She did indeed find the experience transformative, a dissipation of anxiety, just as it appears her character does (personal conversation). Baron explicitly points to cases where internalized work seems obvious and natural, where it "makes no sense" to think of actors' behavior as having been produced through their response to directors or supporting workers, that is, to think of their behavior as having been created from without.

Wise Guys

Especially challenging is the presentation of genius. For most of Hollywood's classical era, a period steeped in culturally diffused anti-intellectualism, genius characters were artfully mocked onscreen. Richard Hofstadter suggests a widespread cultural cause of this anti-intellectualism: "The status of schoolteaching as an occupation is lower in this country than elsewhere, and it is far lower than that of the professions in the United States" (309–11). The denigration of teachers and teaching is a longstanding and deeply entrenched attitude in popular cinema. If the teacher is wise and kindly in an old-fashioned homey sort of way, as in *Goodbye, Mr. Chips* (1939), he is usually not a person with a theoretically or analytically advanced mind.

Even the ostensibly heroic John Keating (Robin Williams) in *The Dead*
Poets Society (1989), high on charm and volubility, is never really shown to
be a genius (and defaces books). Shirley MacLaine's eponymous Madame
Sousatzka (1988) is a demanding diva, sensitive and flamboyant but again,
not exceptional intellectually.

The filmic "genius" is more often than not a mad inventor, a goofy
recluse, a sidekick nobody listens to, or else a nefarious and manipulative
megalomaniac. In the Bond films of the 1960s we have Ernst Stavro Blofeld
(Ian Fleming's pop amplification of Fritz Lang's Dr. Mabuse), most memo-
rably, perhaps, in the chilling performance by Charles Gray (with his twin
white cats). Diegetic genius can be transcendentally elevated (the ineffably
blissful High Lama [Sam Jaffe] in Frank Capra's *Lost Horizon* [1938]) or
morally depraved (Moriarty [George Zucco] in *The Adventures of Sherlock
Holmes* [1939]), even alienated through scientific obsession (Colin Clive's
eponymous lead in *Frankenstein* [1931]): but it always inheres in a crea-
ture of extremity, thus, parody, his eyes bulging mercurially with unfixable
knowledge or theory, his soul sold off for the futuristic rewards of "prog-
ress." Ina Rae Hark notes that "a mad scientist in a purely secular milieu
cannot have a horrific resonance any different from that of the serial killer,
the greedy plutocrat, the totalitarian oppressor" (310).

In the New Hollywood, audiences were charmed to meet Einstein
in the stooping, blithering persona of Walter Matthau (*I.Q.*) or chilled
at the satanic brilliance of morbid Soran (Malcolm McDowell) in *Star
Trek: Generations* (both 1994). But these represent genius caricatured, not
genius—or suggest that caricature is the only mode that can handle genius
onscreen. Once we have assembled a mythic aggregation of genius *types*,
any particular instantiation is inevitably a caricature of that ideal type: any
Sherlock Holmes (Nicol Williamson, Jeremy Brett, Ian Richardson, Peter
O'Toole, Basil Rathbone, Robert Downey Jr., Benedict Cumberbatch);
any Einstein (Matthau, Eugene Levy, Maximilian Schell, Andrew Sachs);
any evil genius (McDowell, Joseph Wiseman, Gerd Frobe, Mads Mikkel-
son, Yaphet Kotto).

More recent examples of character "genius" brought off onscreen with-
out caricature are Geoffrey Rush's pianist-prodigy David Helfgott in *Shine*
(1996), Matt Damon's silent mathematician Will in *Good Will Hunting*
(1997), Russell Crowe's John Nash in *A Beautiful Mind* (2001), Jodie Fos-
ter's Eleanor Arroway in *Contact* (1997), and Matthew Broderick's Ferris in
Ferris Bueller's Day Off (1986). Crowe's achievement in *Mind* was a matter

of him holding back on the physical prowess and forthright directness he knew audiences had grown accustomed to (in, for example, *No Way Back* [1995], *The Insider* [1999], and *Gladiator* [2000]). As Nash he lowered the register and amplitude of his voice, affected a slight slurring and mumbling of lines as though speaking distinctly were less important than working out mathematical problems. Beyond this gesture, the script gave him "smart" things to say—or socially awkward situations, since Nash was also autistic. The contrivance of having him soap complex formulae on the cut-glass windows of the Princeton library left viewers confronted with a vast scape of unintelligible glyphs (that must surely, if so unfathomable, be brilliant).[13]

As to Damon's Will Hunting, the genius was in the delivery: long, exceptionally verbose statements delivered by an actor who had written them and who had carefully rehearsed his line readings, so that the speech would be as notably swift as it was fluid. To say so much in so short a time, audiences could presume, one would have to possess superior intelligence. For a bold contrast, consider Michael Rennie's apparent cosmic genius Klaatu in *The Day the Earth Stood Still* (1951): he says very little, and what he says is phrased in one-syllable words a child could understand, but backing up his assertions of mental power he has the sleek spaceship on which he stands, and the sleek robot who will disintegrate anyone who stands up to disagree, each of which must have been fashioned, audiences think, by some mammoth superior intelligence.

A particular, and recurring, case is that of Jesse Eisenberg, among whose "genius" characters are the speed-thinking motor-mouth Walt in *The Squid and the Whale* (2005) and Mark Zuckerberg in *The Social Network* (2010). It is broadly presumed that with Eisenberg, screen genius seems actually and stunningly to stem from a genius offscreen. His close friend Lee Gabay "paints a picture of the real Eisenberg as a brainy Everyman, more confident than his characters but no cockier than the average urban creative. . . . He thinks too much" (Kachka 140; 142). Yet there persists the prodding question: since neither Gabay nor any other observer has direct access to the interior Eisenberg, what gives the impression of genius at the core? Is it the persistently penetrating gaze, the pale green irises accentuating the dark pupils drawing in everything of the surround? Is it the unkempt hair, as though Eisenberg knows the decoration of self is nothing but a vanity and has his mind on more elevated matters? Is it, as with Damon in *Hunting*, a verbal articulateness stunningly sharp and seemingly improvised,

even, as in *American Ultra* (2015), stoned? Writers compose for Eisenberg at the scholarly level, and he speaks the lines as though his character understands them (and is a writer himself [in fact, he is: his *Bream Gives Me Hiccups and Other Stories* was published in 2015]). Is it a thoroughgoing—and genuine—self-consciousness, as though his perceiving mind is poised outside his own experience, and he can see himself seeing himself? "I don't know what I'm doing here really," he tells an interviewer for *New York* magazine; "I felt bad the other day after we left. I felt really guilty all night. Why did I say that stuff? Why did I talk about myself and my life? No one wants to know—maybe they do want to know, but I don't want them to know. . . . I wish I didn't have to—I'm sorry. Yeah. And I shouldn't have this kind of—yeah, it's embarrassing, even now. Yeah, right" (Kachka 140).

As with anxiety and other mental states, genius presents the peculiar dramaturgical problem of being expressly invisible in itself. Virginia Heffernan puts it somewhat glibly:

> It's never easy to depict intelligence on film. Repartee in the script takes you only so far. You can put your hero arbitrarily in tears to show he has depth; . . . You can show him having revelations—college kids want to know who's single; we should put a "relationship status" entry on Facebook!—and there's some of that, too. For shorthand, you can make your intelligent hero schlubby, Jewish and unathletic. That historically reads as intelligence to movie audiences. You can also make him awkward with girls. (32)

But, it must be emphasized, every one of these stereotypes springs from myth no less than reality: geniuses may or may not be awkward with girls, may or may not be athletic and schlubby, and don't necessarily spend time squatting in a soft chair and reading books. Even before schlubbiness, Jewishness, and gawkiness, convention employs absent-mindedness, usually emphasized ironically: the character is capable of writing a formula that no other mathematician or physicist has been able to come up with (Will Hunting, Professor Lindt in *Torn Curtain* [1966], Professor Barnhardt [Sam Jaffe] in *The Day the Earth Stood Still*) but cannot manage a mundane task like going for coffee, finding his keys, chatting politely, finding his way home from a bus stop. The genius mind, we are to believe, is occupied with "higher" thoughts; occupied and stuffed full. Another convention, more palpable and obvious, is that the genius character will often speak incomprehensibly, devolving into math-speak or intensively elided gibberish that

other characters only strain to grasp, never succeed in grasping. Leonardo DiCaprio is elusive this way as Arthur Rimbaud in *Total Eclipse* (1995). Further, while in life there are clearly many kinds of genius—musical genius, poetic genius, the genius of kindness and understanding, to cite three—cinema plays to an audience prepared principally for intellectual genius, these days an especially alienated entity. "Many of the most spirited younger intellectuals," writes Hofstadter, "are disturbed above all by the fear that, as they are increasingly recognized, incorporated, and used, they will begin merely to conform" (393).

Given its essential intangibility, genius is a quality the performance of which can easily become a marker of status and moral designation. We frame people by calling them geniuses, locate and bound their actions through our projection. When a character's *mind* is the thing being acted, the performer comes in front of us bearing a secret he can never reveal, yet a secret we presume to divine. The actor must know how the audience regards genius, possesses his own similar regard. All of this in the face of the truth that genius is a conclusion we come to, not a fact that stands before us. What stands before us, ultimately, is the character living with the intimate experience of personal thought, the character mentally touching the self, which is to say, the performer being accepted as a thinker through a pantomime of thought.

But Who Was I?

Perhaps most compelling dramatically, and strangest as performance, is amnesia. To say that a character forgets is as insubstantial a claim as to say that he remembers, that he wonders, or that he knows. Characters do not know, although they make and organize claims to knowledge. Similarly, a "forgetful" character who presumably once "remembered" is making a claim. Moreover, a character who forgets *is* a claim being made by the authorial team.

The actor who is co-present with his character, whose every breath is also his character's breath and whose body is therefore quintessentially his character's body, cannot afford to forget who he is or what he is doing, lest the filmmaking operation grind to an expensive halt. Thus our presumption in watching cinematic amnesiacs must be that of two persons who inhabit one body, one who cannot remember and the other who cannot

forget. In amnesia films the schizoid quality of multiple beings inhabiting a single flesh is palpable and always manifest.

In cinematic convention, the lie a character tells when he claims amnesia, or when he permits others to claim amnesia on his behalf, is covered by the complicity of the camera. The camera makes a gesture of agreement, and through this gesture the audience comes to accept the "amnesiac's" self-portrait as real. How does this happen? A second character we have come to love and trust is seen in clear focus accepting the "amnesiac" as such. Or, through an expressive meta-signal, wavy lines interrupt the character's vision, as though to flag an interruption in his consciousness. Or—another meta-signal—there is heard a musical cue, haunting, usually somewhat eerie (involving the Ondes Martenot or xylophone or high-pitched strings), to gesture that the film itself takes seriously the "amnesiac" and his basic claim. Characters who doubt the "amnesiac" are depicted as twisted or suspicious types, generally lit and scripted for darkness. The "amnesia" is accompanied by a delirium shown through optical tricks and sometimes by the claim and display of symptoms that mobilize our sympathy: headache, dizziness, helplessness, anxiety, desperation, all these dramatized through a body that is generally attractive and amicable, so that in watching the depletions and debilities we come to worry.[14] There is no automatic convention for inducing belief in, or for believing, the claims characters make about themselves, absent the viewer's committed will and the kind of substantiation she is openly offered by some feature of performance. Character claims about mental states are subject to the same laws of proof as claims about proprietorship, anticipation, and human relations, except that in the case of mental states direct proof is always categorically impossible. Think, by contrast, of physical wounds as characterological claims supported by costume and makeup. When memory runs out, there is no wound, no bleeding, no torn flesh where a weapon went in.

Yet the inability to know who one was, who one is, who one will be, can be thought a deeply crippling misfortune—especially in post-capitalism, where the "individual" and his "self-image" are centrally positioned in the cultural myths by which society is regulated: the feudal serf, by comparison, never knew who he was, who he used to be, or who he would be tomorrow, but experienced his life (as Tolstoy observed) in relation to the always-present, always-perduring country, which "was good because it was the scene of labour, of the usefulness of which there

could be no doubt" (257). In desiring to help a character make up his wounding loss, regain the memory that has inadvertently disappeared, the audience aligns itself with, and invokes, the working of the script that typically now proceeds—point by point and step by cautious step—to fill in the blanks. Amnesia narratives weave us in, lead us to pay strict attention. Without sympathy, we could not manage to care that a character had "lost his memory"; the memory itself could have no value for us, to such a degree that we would participate in a search for it among the ruins of a story.

The amnesia claim is thus an artful storytelling device guaranteed in most cases to invoke the audience's willing participation and hunger for continuity. The memory of the amnesiac must work dramatically as a treasure, yet one he himself wishes to hunt for even less than we do; he is helpless without it, vulnerable, weak, and endangered, but it is for the viewer that the treasure has ultimate meaning. The audience needs to know what it is that the character has forgotten.

If it is to be present for the viewer, however, a screen character's memory—lost or found—must ultimately take the same visual form as any other referent in a filmed narrative. A character who has found a memory will demonstrate relief or pleasure with a facial expression or posture, will be able to accomplish a deed that had formerly been prohibited, will be seen to utter a code word or phrase that had been eluding his tongue. In short, we will see the memory capture in demonstration. In many cases, the lost memory will be played out again, here and now, so that by seeing it we touch the forgotten (forsaken) object now regained. It is in large part because a character must be capable of demonstrating "recuperated memory" that we will need to be suspicious when he complains of "memory lost." Where, after all, has it been lost, except in him where, after a suitable hunt, it can be found? For surely that we can be convinced the memory is found again can only mean the existence of an invisible storehouse inside the character's head, but also—and confoundingly for us, since this is a lie—a general negation of any supposition we might have that inside him there is nothing at all. The lost memory, we must believe, is not nothing; it occupies space in an existent territory, which is the "self" the character seems not to recognize. When he does not know who he is, nevertheless we believe firmly that there *is* an identity secreted away, waiting to be rediscovered one day (when, of course, we will be attentively watching). Thus, the character's ability to claim forgetting

emerges from some reservoir that it is increasingly difficult or painful for the viewer to imagine vacant the more intensive the claim. But it is the viewer who has a reservoir, and the actor we do not know. The character is nothing but a surface.

A contrapuntal and contradictory force obstructs our acceptance of the forgetter fully finding himself: this is cinema's perpetual assertion that memory is beyond it. Watching film is all about forgetting. We are bound to a forceful and expansive experience of the present, and as a motion picture unspools this present seems to grow with dramatic slope. So absorbing is the image onscreen that all our powers of concentration are sapped in tasting and relishing its contours and crevices. Tom Gunning has discussed the progressive exploration of the screen, indeed, noting how the "unfolding space" of the screen "affords action and allows contemplation" ("Rounding Out"). Even the viewer's own past can be obfuscated by the heightened present of cinema, as the memory function is effectively erased in the flood of immediate perception. Later, over a coffee, one tries to reassemble the film. This is one of the reasons why it can be difficult, if even possible, to recollect the shot order of a sequence; and why proffered plot synopses of films are so often bold, vague, undetailed, and elliptical, not to say unreflective of actual film-watching experience.

Watching is overwhelming. Aesthetic intensification, as is generic to cinema, expands and enriches the momentary present experience as given onscreen, magnifies the proportions, saturates the colors, upgrades the illumination, and refines the sounds, as well as generally ameliorating the quality of costumes, locations, and objects. If it is true, as David Hume suggested, that "we are nothing but a bundle or collection of different sensations, which succeed each other with an inconceivable rapidity, and are in a perpetual flux and movement" (qtd. in Sacks, "Lost" 28), cinema aggravates our appreciation of this condition.

Reporting an extraordinary, extreme case of Korsakov's Syndrome, Oliver Sacks draws our attention to the sort of memory at work in cinema. Jimmie G., Sacks's patient at the time, was able to retain in his short-term memory the events and feelings of his life for a period of only a few minutes. Prior to that, and going back as far as thirty-six years or so, his memory had been evacuated, due to neuron destruction in the mamillary bodies. "Jimmie," writes Sacks, denotating neurological symptoms in such a way that calls up, I believe, how it is with any of us when we are caught up watching cinema,

so lost in extensional "spatial" time, was perfectly organized in Bergsonian "intentional" time; what was fugitive, unsustainable, as formal structure, was perfectly stable, perfectly held, as art or will. . . . If Jimmie was briefly "held" by a task or puzzle or game or calculation, held in the purely mental challenge of these, he would fall apart as soon as they were done, into the abyss of his nothingness, his amnesia. ("Lost" 57)

Our amnesiac attention to the screen is catered to by certain paradigmatic habits of scriptwriting, directing, and performance whereby a system of re-cueing is put in place that repeats information, on each successive appear-ance by a dramatically important character, as to the person's status and narrative placement. Familiar locations identified a thousand times before are identified again. Every entrance of the villain poses him in compromis-ing darkness with that compromising sneer, as though we recall no such entrance earlier; every entrance of the hero or heroine repeats the casual presence of gilding light. There is no end to the need for labeling. The labels must never come off. It is only a metaphorical Korsakov's that cin-ema induces in the viewer. But the condition becomes habitual to viewing. The viewer is always addressed as a creature who at each present point of a film fully remembers nothing that preceded it.

Caught in front of a display that he is in no position to verify, the cin-ematic amnesiac is very like those who watch him in the dark. With each image, he searches energetically but without resolution for a certain lacuna in his past, to which his experience can be assimilated and in relation to which his present can be understood. But, as with film watchers, all images of the past have lost their clarity and optical resolution, and the colors have changed. Caught up in present perception, the "amnesiac" and his avid watcher see all as delirium and fantasia. Other characters bring to his expe-rience a parental orientation; guidance and shepherding are called for, else in the fabulously unterminating array of perceptual stimuli he becomes lost, even irretrievable.

To lose an identity is to lose a social world. The present-day stress of the fictional "amnesiac" is inflected with guilt, a sense that he is in violation of some earlier moral code if now lost yet nevertheless overwhelming and true (thus meriting mourning). His failure to comply with it is a denial of a pre-vious self. In performance, then, the "amnesiac" is built by an actor making use of his scene partners' reactions, ostensive memories, and expectations rather than claiming his own "bedrock." Orientation to others is central to

the protagonist's knowledge of, and feeling about, self. But a similar social matrix involves any non-amnesiac character, too. *Not* to lose an identity is also to have a social world. Any character's amnesia must be enacted onscreen by a whole ensemble of performers, as other conditions must, but the "amnesiac" has no personal view to trade. The narrated "amnesiac" suffers a double moral crisis. He has lost an original moral compass because geographical, mental, coincidental, happenstantial, or biographical circumstances have distanced him from the social company in which that compass was built and solidified. But he is also presently surrounded by others, usually naïve to the "amnesia," who press moral dictates upon him without knowing that the person they create through their expectations is patently unreal. If in the face of present friends and strangers the amnesiac might know when he was violating taboos or wandering outside the precincts of normativity, with respect to the true (lost) morality that he can no longer grasp he remains in the dark.

A piquant case study is William Powell's Larry Wilson in *I Love You Again* (1940). Larry was a big-time no-good crook, but he has forgotten. In his current life he is a loveable fellow. This perfect model of correct behavior in current terms is a downright sociopath when viewed according to the now-invisible, suspended (albeit criminal) moral code. All of his commitments to present company are terminable, Larry knows (just as he knows himself to be amnesiac). He can reach a boundary where his original identity will be recovered and his present one dissolved. *But when?* Thus it is that he acts with a kind of hesitation, agreeing to the terms of a contract that, for all its appearance of solidity, is nothing but circumstantial. The contract applies, as it were, to a mere role he is playing, the mere character that is his present "self," not to the *real him*.

Further, in the case of this film, the "character of the present 'self'" is not being played by an actor; it is being played by another character, who is the presently unknown amnesiac working to survive until he can be reborn. In this respect, amnesia films confront their audience with a repeating structure, the play-within-the-play, the bulk of the "amnesiac" story being only a staged fakery put up by a central character with the typically (although not always) unwitting assistance of others. Goffman makes the interesting observation that such structures work to solicit our conviction in the reality of those staged characters who are now functioning as an "onstage" audience watching the drama-within-the-drama (*Frame Analysis* 474–75). Here, the more Powell's "real" George Carey puts on the only-apparently-real Larry,

the more his gal Kay Wilson (Myrna Loy) gains solidity and credibility as she watches the show. An even more central structural effect here is the story's inevitable mirroring of another amnesiac reality: that quite beyond the amnesiac himself, every character onscreen, here and always, acts in a particular amnesia to ostensibly "forget" the person he really is. Characters do not remember the actors who are playing them.

Forgotten Moralities

A notable recurring feature of amnesia films is the cathartic awakening, when the deep "actual" past suddenly comes flooding over what must now be seen as the sham of the present self: "Smitty" (Ronald Colman) struck by a car in the street in *Random Harvest* (1942), then coming to with the sudden knowledge that he is Charles Rainier, heir to a vast estate. The protagonist we have been knowing and following is revealed swiftly as nothing but a spurious carapace grown out of desperation to cover a vulnerable and unprotected "true" self that we now meet for the first time, never having suspected its dimensions before. The reveal is a radically historicizing event, in that our character is seen through and through to be at this moment, and to have been all along, only what his history made him (at a time, possibly, before the diegesis began). His continuing present, meanwhile, is thrown off as a hollow mask.

Since the conditions of the character's earlier "real self" may be entirely discontinuous with, even unrelated to, those of his present feigned persona, and since once the plot has turned it is the "real self" who dictates what eventually happens, amnesia films may be generally seen to depend on sudden twists of morality, to be resolved through surprise endings that could not have been predicted from what came before. Nor need the resolutions of these films follow a strict and coherent line of moral improvement, an ostensibly benevolent character possibly turning out, once his actual past has returned, to have been a cad; exactly as a cad may turn out to have been a hero. The point is that one's moral status is tied to what one can know about the self, and while one is "amnesiac" one can hold a moral status that is false but seems entirely bona fide. The actor, of course, needs to code the character's various selves, in order never to ruin the overall production by slipping from one "identity" to another, penetrating the wall, at the wrong moment. The actor playing an "amnesiac" can trust

that the scriptwriter has built the walls sturdily, even the ones that might fall down diegetically. But for the actor, there are multiple personalities to be managed on his own, walls he must put up and maintain at his own personal expense.

In all amnesia films, it is only the primary amnesia—the dramaturgical amnesia—that gains resolution. The secondary one, involving actors and characters, is of a more permanent nature, just like an affliction mentioned by Luis Buñuel, and quoted by Sacks. "You have to begin to lose your memory, if only in bits and pieces, to realize that memory is what makes our lives. Life without memory is no life at all. . . . (I can only wait for the final amnesia, the one that can erase an entire life)" ("Lost" 22). An actor turning himself into a character in front of an audience manifests one of these "final amnesias," a virtual mortality, since no matter what he is to himself for the audience he is gone, never ever to return. It is only the character who remains.

Finale

In the amnesia narrative, that "finally" the amnesiac is back among us as himself or herself is the concluding cadence. Wherever he was lost and for whatever duration he existed that way are now magically become immaterial, just as the world of the screen drama becomes immaterial for watchers after the end credits have signaled that they may return to the street. But beyond the compelling "amnesia" diegesis, nothing could be further from the truth. Surely the former amnesiac does not really lose his memory a second time when he finds his truth. Must he not actually retain his memories of the *other place*, and now consider himself doomed to live in a double world, where the factual surround and the artificial dream persist side by side at an alluring shore? He is still at sea, while walking the land; or still a man who has forgotten his true self, while living in that self, too. And this was, it seems, always the case. He was always living as his real self when he didn't know it, just as our glittering performers onscreen are always living as themselves even when we think they are not. At film's end, the conditions of the amnesiac's (the actor's) existence are intensified, since his adventurous, perilous, demanding, and exciting dream life, powerful enough to hold our attention for the bulk of the film, is surely powerful enough to hold his attention, too.

The actor must experience this double life, performing a story today while crippled with memories of past performances of other stories; performing the "today" of the story while unable to escape from either the "yesterday" of his actual life or the tickling presence of his real being while he is trapped still in the sheath of the fiction. For the actor, the recipe and the curse is a sense that one is absent from home, *unheimlich*, working in a state where home is inaccessible. If one is "at home" in one's character, that character is only provisional. Or one could be "at home" away from the character, but cannot find the necessary release. Viewers, too, stunned and provoked by cinema, can fail to escape from their great cinematic voyages. They fail to escape by seeing and re-seeing films or filmic moments of the past again and again.

What we must imagine for our "amnesiac" we must accept for the actor who plays him, and for ourselves, too, as the overriding outcome of the whole cinematic exploration: a divided, torn, perpetually unsatisfied life. This is the life that was experienced by Lazarus returned from the dead in Robert Browning's 1855 poem "An Epistle Containing the Strange Medical Experience of Karshish, the Arab Physician":

> He holds on firmly to some thread of life—
> (It is the life to lead perforcedly)
> Which runs across some vast distracting orb
> Of glory on either side that meager thread,
> Which, conscious of, he must not enter yet—
> The spiritual life around the earthly life:
> The law of that is known to him as this,
> His heart and brain move there, his feet stay here.

Now brought back (or forward) to another (real?) self, Karshish must endlessly wonder what would have happened if without limit he had continued to forget. If he had not come back. And must we not ask what it would be never to emerge from the oblivious and marvelous world of the screen?

For the screen character who cannot remember, the answer might have been, "Utopia." For the rest of us, in front of the camera and in front of the screen, the riddle is unsolved.

Notes

1. Fantastic Performance

1. Bette Davis at the San Francisco Film Festival, 1969, online at https://www
.youtube.com/watch?v=UkyEaLkXZRs.
2. And at the same time pays homage to a moment in George Stevens's *Shane*
(1953) when as the slimy villain Wilson, Jack Palance reverses his horse
away from the noble Shane after their first face-to-face meeting.

2. Beaux Gestes

1. With my use of the word "performative" here, I am not following the bright
beacon of J. L. Austin, not a metaphysician himself, who in 1958 argued
about the way that word is employed by those interested in metaphysics.
He contrasted "performative" utterances with "constative" ones, the latter
being either true or false and making declaration, the former accomplish-
ing action through talk. "I declare you man and wife" would be "per-
formative," for example, since the speech itself performs an action. I am
interested in language, gesture, and action as "performative" insofar as they
are parts of a staging, principally for camera; thus "performative" implies
for me issues of authenticity and sincerity (and their converses) and is to be
attached to explicit simulations—what actors (as performers) build when
they are acting (giving a performance), pictures of social realities but not
the selfsame realities they are pictures of.
2. For an extension on this ideation, see my article on Jerry Lewis, "A Sensa-
tional Face."
3. Walker's death may not have been widely appreciated by those who
watched the film, though he was, strikingly, only thirty-two and had been
thought a "tragic figure." The *New York Times* obituary of 30 August 1951,

by Gladwin Hall, ran on page nineteen. Other newspapers did not feature their obits. The Charleston, S.C., *News and Courier*, for one case, placed it beneath a "lost diplomats" story and above some drive-in movie ads, and kept it short.

4. An automaton need not resemble an animal or person to "digest": visible at the Museum of Old and New Art in Hobart, Tasmania, is Wim Delvoye's *Cloaca Professional*, a gigantic set of tubes, glass containers, and pumps running some twenty or more feet in length that is fed routinely by attendants at one end and later produces excrement at the other.

3. Curtains

1. Reading this pungent little tale was my second exposure to it. Before it was published, Vivian Sobchack shared it with me live and in person, thus proactively converting the published account, for this audience of one, into a performance of its own kind.
2. Recall Matthew 9:6–7, the story of Jesus and the crippled man: "'Is it easier for me to tell this crippled man that his sins are forgiven or to tell him to get up and walk? But I will show you that the Son of Man has the right to forgive sins here on earth.' So Jesus said to the man, 'Get up! Pick up your mat and go on home.' The man got up and went home."
3. A thoughtful analysis of an occurrence of play that involved talk-show "selfing" is provided by Nina Martin.
4. I am grateful to Victor Perkins for sharing this interview with me.
5. For one interesting exploration in the variation of star identity across variously amplified performances, see my *Johnny Depp Starts Here*.
6. I am grateful to Adrian Martin for drawing my attention to Lubitsch's comment.
7. For a series of accounts of rehearsal spaces and processes in movie-making, see Lumet.
8. For a full analysis of color theories and early cinema, see Yumibe. For comment on color, drama, and emotional experience, see Sacks, *Musicophilia* 183n.11.
9. An interesting discussion of the role of laughter in subverting ritual performance is given by Ivan Karp.
10. The "Fatty" Arbuckle case of September 1921 was an early hallmark of this public-private linkage.
11. A persistent rumor has John Malkovich, working in Toronto, rushing up to a woman who has collapsed on the sidewalk and gently calming her

until the ambulance arrives. There are numerous such tales of performer heroism: that is, the extraordinary behavior of an ordinary person, not the extraordinary behavior of the extraordinary person a celebrity has become inside the celebrity mask.

12. My earliest experience with this wondrous permeability between diegetically performed beings and the workers who produce them occurred as my father shepherded me through a moving railway car in December of 1958 and there I met, sitting peaceably with his newspaper in his brown tweed suit, freckles, and horn-rims, the elegant Leo G. Carroll. I had known him as Topper, and would soon know him in *North by Northwest*, but here he was only a very pleasant grandfatherly type.

4. "It's Not a Man, It's a Place!"

1. Steven Spielberg's bitter factory sequences in *Schindler's List* (1994) comment acerbically on such processes.

2. In MGM's Stage 27, the largest in Hollywood, the ceiling hangs eighty feet above the floor (Hitchcock's Mount Rushmore sequence was shot here, as was Munchkinland), but above that there are ten additional feet for stage-hands to rig spots from above. My sincere thanks to Polo Ornelas for the guided tour.

3. Or sometimes working models. The apartment set for Hitchcock's *Rear Window* (1954), built on Paramount's Stage 18 by "Mac" Johnson and his crew, had a number of fully working apartments with running water and private telephone connections.

4. While he was making *Rebel Without a Cause* (1955) there, James Dean installed himself day and night on one of Warner Bros.'s stages and refused to leave.

5. Legendary are the wild-wall sets built by Donald Desmond for Alfred Hitchcock's *Rope* (1948), which was shot in complicated ten- or eleven-minute masters with a roving camera; and the Moroccan restaurant built by Henry Bumstead for *The Man Who Knew Too Much* (1956). Bumstead confided to me Clint Eastwood's preference for shooting *without* wild walls on films like *Mystic River* (2003) (personal conversation).

6. For more details on the relationship between the back-and-white record, the matrix, and the final print in the Technicolor process, see Pomerance "Notes." Essentially, the three b/w color "records" were contact printed one by one onto a stock coated with a soft and permeable emulsion that hardened when washed. Each of these "stamps" was a matrix, and each

was rolled with a saturated dye, yellow for the blue record; magenta for the green; cyan for the red. When the three matrices were pressure-rolled against blank stock one by one, a full-color dye (or "imbibition") print resulted.

7. I am grateful to Dr. Barbara Caffery for consultation on this matter.

8. We can here disregard the amazing but also exceptional case of Alfred Lunt and Lynn Fontanne, who spent years mastering a technique of speaking over one another intelligibly (a technique replayed by Richard Burton and Elizabeth Taylor in *Who's Afraid of Virginia Woolf?* [1966]).

9. My thanks to Steven Rybin for sharing this Godardian reflection.

10. I am grateful to William Rothman for sharing this film with me.

11. In a 4 September 2000 interview, the British actor Ian Carmichael emphasized his urgent need to rehearse intensively with props. For a breakfast scene with some children, once, he had to work out exactly how to touch and move a milk bottle, again and again, before he was comfortable playing the scene.

12. The Disney studio rotoscoped the human female figure in *Snow White and the Seven Dwarfs* (1937).

13. For *Apes*, very often only key frames of Serkis's work as Caesar were used, with the remainder digitally produced to fit (Conley).

5. Acting Intimate

1. As Anthony Lane eulogized, "What have we been robbed of, by his death? Not so much a movie star, I think, as somebody who took our dramatic taxonomy—all those lazy, useful terms by which we like to classify and patronize our performers, even the best ones—and threw it away. Leading man, character actor, supporting player: really, who gives a damn? Either you hold an audience, so tight that it feels lashed to the seats, or you don't" (116).

2. Notwithstanding audiences' memory that at the beginning of the decade the actors beneath these characters had indeed been married.

3. This delicacy of attention is usually not played out in hospitals, where personalities are reduced to bodies, while in *films about hospitals* there is usually a retreat to the modesties of everyday intercourse (see, for example, Arthur Hiller's *The Hospital* [1971] or Oliver Stone's *Born on the Fourth of July* [1989]).

4. Table modesties are explored in *Babette's Feast* (1987) and *The Age of Innocence* (1993).

5. In Technicolor films, for example, David Cronenberg told me, technicians used a mixture of food color and glycerine; the substances used to make the blood must produce a suitable viscosity, since some dramatic situations call for faster flow than others. For Cronenberg's recipe for "Technicolor Blood, " see Pomerance, *Random Soup* 213.

6. On a visit to Paramount Studios in 1998 I was informed as to how the latex prosthetics being used on several different stages there, every day, for the various programs in the *Star Trek* franchise were physically destroyed each evening to prevent them falling into the black market.

7. An extremely telling moment in which a glowing match in one hand is passed to someone else occurs in Curtis Bernhardt's *A Stolen Life* (1946). Both persons are played by Bette Davis. See, for a discussion of the visual effects employed, Pomerance, *Eyes* 111–15.

8. A good example of how far this can go is provided in Roland Emmerich's *Independence Day* (1996) when Will Smith, dragging an alien carcass across the desert, addresses it with snide reproachfulness in a way that audiences typically respond to by laughing with recognition; to some extent, watching and hearing, we feel dragged by Will, too, thus bonding to his character and his acting self at once.

9. Because of the cramped quarters, indeed, this scene differs in tone and effect from one to which it pays homage, where George O'Brien is giving Janet Gaynor a fulsome egg wash in Frank Borzage's *Lucky Star* (1929). In the Borzage, the hair treatment is performed outdoors, and there is a kind of expansiveness in the gestures that is reversed by Liman. My thanks to Michael Hammond for pointing the film out to me.

10. The carnal touch can be implied (elided) as well as enacted. Tom Gunning has graciously recollected to me "The Greatest Love of Don Juan," a tale in Barbey d'Aurevilly's *Les diaboliques* (1874), in which the libertine, asked by a bevy of his former lovers to recount his greatest sexual triumph, points to an innocent yet sensitive young girl who one day, after their conversation ended and he stood and removed himself, got up and sat in his still warm chair.

11. See Darwin 297ff. for an extended discussion of "fright" and how we produce signs of its various stages, including anxious horror.

12. Child actors are often encouraged to work this way. In his casting session with Henry Thomas for *E. T. the Extra-Terrestrial*, Steven Spielberg's assistant actually put the young actor through what at least sounded like real emotional trauma (a dying puppy) to elicit the tears that poured out. When the test was done, however, Thomas instantly reverted to his happy self, as reported by Linda Ruth Williams ("Tears") and discussed in her new book, *Steven Spielberg's Children* (forthcoming).

13. The hieroglyphic tactic reprises Hitchcock's usage of formulae as Professor Lindt (Ludwig Donath) meets with Armstrong (Paul Newman) in *Torn Curtain* (1966).

14. The generally appealing quality of screen amnesiacs is apotheosized by Goldie Hawn's turn in *Overboard* (1987), a remake of the William Powell vehicle *One Way Passage* (1932). My thanks to Matthew Bernstein for discussing this connection.

Works Cited and Consulted

HER = Margaret Herrick Library, Academy of Motion Picture Arts and Sciences, Beverly Hills
WB = Warner Bros. Archives, University of Southern California

Aaron, Stephen. *Stage Fright: Its Role in Acting*. Chicago: University of Chicago Press, 1986.

Adorno, Theodor W. "A Portrait of Walter Benjamin." In *Prisms*, trans. Samuel and Shierry Weber. London: Neville Spearman, 1967.

Agamben, Giorgio. *Infancy and History: On the Destruction of Experience*. Trans. Liz Heron. London: Verso, 2007.

"Alfred Hitchcock Closed Circuit Press Conference." Transcript. 23 March 1976. *Family Plot* file 200, Alfred Hitchcock Collection, HER.

Alleborn, Al. Inter-Office Communication to T. C. Wright, 15 May 1945, regarding Glenn Ford medical condition. *A Stolen Life* picture file, WB.

Allen, Joan. Personal conversation, October 2008.

Allen, Richard. "An Interview with Jay Presson Allen." *Hitchcock Annual* 2000–2001, 3–22.

Almendros, Nestor. *A Man with a Camera*. New York: Farrar, Straus & Giroux, 1986.

Altick, Richard D. *The Shows of London*. Cambridge, Mass.: Harvard University Press, 1978.

Alton, John. *Painting with Light*. Berkeley: University of California Press, 1995.

Arendt, Hannah. *The Human Condition*. Chicago: University of Chicago Press, 1958.

Atkins, Irene Kahn. *David Butler Interviewed*. Los Angeles: Directors Guild of America, 1993.

Auiler, Dan. *Vertigo: The Making of a Hitchcock Classic*. New York: St. Martin's Press, 1998.

Austin, J. L. "Performative-Constative." In *Philosophy of Language: The Central Topics*, ed. Susana Nuccetelli and Gary Seay. Lanham, Md.: Rowman and Littlefield, 2008. 329–36.

Badiou, Alain. *Cinema.* Sel. Antoine de Baecque. Trans. Susan Spitzer. Cambridge: Polity Press, 2013.

Balázs, Béla. *Béla Balázs: Early Film Theory: Visible Man and the Spirit of Film.* Ed. Erica Carter. Trans. Rodney Livingstone. New York: Berghahn, 2011.

Baron, Cynthia. "Acting in the Hollywood Studio Era." In *Screen Acting,* ed. Alan Lovell and Peter Krämer. London: Routledge, 1999. 31–45.

Baron, Cynthia, and Sharon Marie Carnicke. *Reframing Screen Performance.* Ann Arbor: University of Michigan Press, 2008.

Barry, Colleen. "I Just Mostly Drank." *National Post* (28 August 2013). Online at /arts.nationalpost.com/2013/08/28/i-just-mostly-drank-how-sandra-bullock -and-george-clooney-approached-the-physical-challenges-of-gravity/. Accessed 19 January 2014.

Barrymore, John. "Maxims of an Actor." In *Actors on Acting: The Theories, Techniques, and Practices of the World's Great Actors, Told in Their Own Words,* ed. Toby Cole and Helen Krich Chinoy. New York: Crown, 1970. 593–94.

Barthes, Roland. *Camera Lucida: Reflections on Photography.* Trans. Richard Howard. New York: Hill and Wang, 1983.

Barton, Sabrina. "Hitchcock's Hands." *Hitchcock Annual 2000–2001,* 47–72.

Basten, Fred E. *Glorious Technicolor: The Movies' Magic Rainbow.* Cranbury, N.J.: A. S. Barnes, 1980.

Baudry, Jean-Louis. "Ideological Effects of the Basic Cinematographic Apparatus." Trans. Alan Williams. *Film Quarterly* 28:2 (Winter 1974–75), 39–47.

Bazin, André. "Hitchcock contre Hitchcock." *Cahiers du cinéma* 39 (October 1954), 25–32.

Becker, Howard S. *Outsiders: Studies in the Sociology of Deviance.* New York: Free Press, 1966.

Béghin, Cyril. "Le feu et le serpent: Entretien avec Nicolas Cage." *Cahiers du cinéma* 699 (April 2014), 90–95.

Behlmer, Rudy, ed. *Memo from David O. Selznick.* New York: Modern Library, 2000.

Belton, John. "Technology and Aesthetics of Film Sound." In *Film Sound: Theory and Practice,* ed. Elizabeth Weis and John Belton. New York: Columbia University Press, 1985. 63–72.

Benjamin, Walter. "The Work of Art in the Age of Its Technological Reproducibility." In *Selected Writings,* Vol. 3. Trans. Edmund Jephcott, Howard Eiland, and Others. Cambridge, Mass.: Harvard University Press, 2002. 101–33.

Berg, A. Scott. *Kate Remembered.* New York: Berkeley Books, 2003.

Bergson, Henri. *Laughter: An Essay on the Meaning of the Comic.* Trans. Cloudesely Brereton and Fred Rothwell. Rockville, Md.: Arc Manor, 2008.

Bloom, Claire. *Leaving a Doll's House: A Memoir.* London: Virago, 1996.

Bode, Lisa. "Astounding Transformations and Risible Masks: On the Reception of Prosthetic Makeup Effects." Paper delivered at "The Magic of Special Effects" conference, Montreal, 7 November 2013.

Boorstin, Daniel. *The Image: A Guide to Pseudo-Events in America.* 1961. Reprint. New York: Vintage, 1992.

Bordwell, David. "Technicolor." In *The Classical Hollywood Cinema: Film Style and Mode of Production to 1960,* by David Bordwell, Janet Staiger, and Kristin Thompson. New York: Columbia University Press, 1985. 353–57.

Bordwell, David, Janet Staiger, and Kristin Thompson. *The Classical Hollywood Cinema: Film Style and Mode of Production to 1960.* New York: Columbia University Press, 1985.

Boswell, James. *Boswell's London Journal 1762–1763.* Ed. Frederick A. Pottle. New Haven, Conn.: Yale University Press, 2004.

Braun, Eric. *Doris Day.* London: Orion, 1994.

Brewster, Sir David. *Letters on Natural Magic, Addressed to Sir Walter Scott, Bart.* London: John Murray, 1832.

Brook, Peter. "The Act of Possession." In *Actors on Acting: The Theories, Techniques, and Practices of the World's Great Actors, Told in Their Own Words,* ed. Toby Cole and Helen Krich Chinoy. New York: Crown, 1970. 423–29.

Brooks, Jodi. "Crisis and the Everyday: Some Thoughts on Gesture and Crisis in Cassavetes and Benjamin." In *Falling for You: Essays on Cinema and Performance,* ed. Lesley Stern and George Kouvaros. Sydney: Power Publications, 1999. 73–104.

Bumstead, Henry. Personal conversation, November 1997.

Burke, Kenneth. *A Grammar of Motives.* Berkeley: University of California Press, 1969.

Burnett, David. *Cineplex Odeon: The First Ten Years.* Toronto: Cineplex Odeon, 1989.

Butler, Jeremy, ed. *Star Texts: Image and Performance in Film and Television.* Detroit: Wayne State University Press, 1991.

Caine, Michael. *What's It All About? An Autobiography.* New York: Turtle Bay, 1992.

Calvino, Italo. *Invisible Cities.* Trans. William Weaver. New York: Harcourt, Brace, Jovanovich, 1974.

Cardullo, Bert, Harry Geduld, Ronald Gottesman, and Leigh Woods, eds. *Playing to the Camera: Film Actors Discuss Their Craft.* New Haven, Conn.: Yale University Press, 1999.

Carey, Gary. "More About *All About Eve.*" In *Joseph L. Mankiewicz Interviews,* ed. Brian Dauth. Jackson: University Press of Mississippi, 2008. 46–124.

Carroll, Noël. "Toward a Theory of Point-of-View Editing: Communication, Emotion, and the Movies." *Poetics Today* 14:1 (Spring 1993), 123–41.

Casetti, Francesco. *Eye of the Century: Film, Experience, Modernity.* New York: Columbia University Press, 2008.

Cavell, Stanley. *Pursuits of Happiness: The Hollywood Comedy of Remarriage.* Cambridge, Mass.: Harvard University Press, 1981.

———. *Themes Out of School: Effects and Causes.* Chicago: University of Chicago Press, 1984.

———. *The World Viewed.* Cambridge, Mass.: Harvard University Press, 1979.

Chauvin, Jean-Sébastien. "Kim Novak." *Cahiers du cinéma* 690 (June 2013), 41.

"Christian Bale's Weight Loss for *The Machinist*: This Dedicated Actor Lost a Whopping 63 Pounds to Play the Lead in This Movie." Online at www.sumon ova.com/christian-bales-weight-loss-for-the-machinist-this-dedicated-actor -lost-a-whopping-63-pounds-to-play-the-lead-in-this-movies. 27 September 2006. Accessed 3 November 2015.

"Citizen Kane." Online at www.angelfire.com/film/robbed/citizenkane.htm. Accessed 12 February 2014.

Clark, Mark. *Smirk, Sneer and Scream: Great Acting in Horror Cinema.* Jefferson, N.C.: McFarland, 2004.

Clayton, David. "Hitchcock Hates Actors." *Filmindia* 13:7 (July 1947), 59–60.

Coleman, Herbert. Personal conversation, November 1995.

Comolli, Jean-Louis, and Sylvie Pierre. "Two Faces of *Faces*." *Cahiers du cinéma* 205 (October 1968). Trans. Annwyl Williams. Repr. in *Cahiers du cinéma: 1960–1968: New Wave, New Cinema, Reevaluating Hollywood*, ed. Jim Hillier. Cambridge, Mass.: Harvard University Press, 1992. 324–27.

Conley, David. Personal conversation. 30 March 2015.

Cook, Pam. "Duplicity in *Mildred Pierce*." In *Women in Film Noir*, ed. E. Anne Kaplan. London: BFI, 2008. 69–80.

Cortázar, Julio. "Instructions for John Howell." In *All Fires the Fire and Other Stories*. New York: Pantheon, 1973. 99–113.

Countryman, Edward. "John Wayne: Hero, Leading Man, Innocent, and Troubled Figure." In *What Dreams Were Made Of: Movie Stars of the 1940s*, ed. Sean Griffin. New Brunswick, N.J.: Rutgers University Press, 2011. 217–34.

Crawford, Jerry L., Catherine Hurst, and Michael Lugering. *Acting in Person and in Style.* 5th ed. Long Grove, Ill.: Waveland Press, 2010.

Cubitt, Sean. "Making Space." *Senses of Cinema* 57 (December 2010). Online at sensesofcinema.com/2010/feature-articles/making-space. Accessed 28 April 2014.

Cukor, George. Letter to Fredric March, 12 December 1939. *Susan and God* file 233, George Cukor Collection, HER.

———. Night Cable to Audrey Hepburn, 3 July 1962. *My Fair Lady* file 197, George Cukor Collection, HER.

Darwin, Charles. *The Expression of the Emotions in Man and Animals.* 1873. Reprint. Chicago: University of Chicago Press, 1965.

Davis, Ronald L. *Duke: The Life and Image of John Wayne*. Norman: University of Oklahoma Press, 2001.

———. *The Glamour Factory: Inside Hollywood's Big Studio System*. Dallas: Southern Methodist University Press, 1993.

———. *Hollywood Beauty: Linda Darnell and the American Dream*. Norman: University of Oklahoma Press, 1991.

Day, Doris. Personal correspondence, January 1996.

Deleuze, Gilles. *Cinema 2: The Time-Image*. Trans. Hugh Tomlinson and Robert Galeta. Minneapolis: University of Minnesota Press, 1989.

DeRosa, Steven. *Writing with Hitchcock: The Collaboration of Alfred Hitchcock and John Michael Hayes*. New York: Faber & Faber, 2001.

Desjardins, Mary. "Not of Hollywood: Ruth Chatterton, Ann Harding, Constance Bennett, Kay Francis, and Nancy Carroll." In *Glamour in a Golden Age: Movie Stars of the 1930s*, ed. Adrienne L. McLean. New Brunswick, N.J.: Rutgers University Press, 2011. 18–43.

———. *Recycled Stars: Female Film Stardom in the Age of Television and Video*. Durham, N.C.: Duke University Press, 2015.

Desser, David. *Ozu's Tokyo Story*. New York: Cambridge University Press, 1997.

Dixon, Wheeler Winston. *It Looks at You: The Returned Gaze of Cinema*. Albany: State University of New York Press, 1995.

Donath, Ludwig. Letter to Alfred Hitchcock, 22 February 1966. *Torn Curtain* casting file 879, HER.

Duckett, Victoria. "The Silent Screen: 1895–1927." In *Acting*, ed. Claudia Springer and Julie Levinson. New Brunswick, N.J.: Rutgers University Press, 2015. 25–48.

Durgnat, Raymond. *A Long Hard Look at 'Psycho.'* London: BFI, 2002.

Durrell, Lawrence. *Balthazar*. London: Faber & Faber, 1963.

———. *Justine*. London: Faber & Faber, 1963.

Dyer, Richard. *Stars*. New ed. London: BFI, 1999.

Ebiri, Bilge. "Dan Richter on Playing the Ape in '2001,' Life with John and Yoko." Online at www.vulture.com/2008/04/dan_richter_on_playing_the_ape.html. Accessed 20 January 2014.

Ekman, Paul, and Wallace V. Friesen. *Unmasking the Face: A Guide to Recognizing Emotions from Facial Clues*. Los Altos, Calif.: Malor, 2003.

Fairbanks, Douglas Jr. *The Salad Days: An Autobiography*. New York: Doubleday, 1988.

Falk, Quentin. *Anthony Hopkins: The Biography*. London: Virgin Books, 2000.

Fiedler, Leslie A. *The Return of the Vanishing American*. New York: Stein & Day, 1969.

Film Culture. "A Talk with Michelangelo Antonioni on His Work." In *Michelangelo Antonioni Interviews*, ed. Bert Cardullo. Jackson: University Press of Mississippi, 2008. 21–45.

Fischer, Lucy. "Sick Jokes: Humor and Health in the Work of Jerry Lewis." In *Enfant Terrible! Jerry Lewis in American Film*, ed. Murray Pomerance. New York: New York University Press, 2002. 137–51.

Fishgall, Gary. *Pieces of Time: The Life of James Stewart*. New York: Scribner, 1997.

Foucault, Michel. *The Birth of the Clinic*. London: Routledge, 2003.

Frankenheimer, John. Letter to Burt Lancaster, 31 December 1963, regarding *The Train*. File 125, John Frankenheimer Papers, HER.

———. Letter to Eva Marie Saint, 3 May 1995, regarding *Grand Prix*. Correspondence 1990–1995 file, Eva Marie Saint Collection, HER.

Frascella, Lawrence, and Al Weisel. *Live Fast, Die Young: The Wild Ride of Making "Rebel Without a Cause."* New York: Touchstone, 2006.

Gardner, Lyn. "Are Curtain Calls a Clapped-out Convention?" Online at www.theguardian.com/stage/theatreblog/2012/apr/03/curtain-calls-clapped-out-convention. Accessed 26 April 2014.

Gélin, Daniel. Personal correspondence, November 1995.

Gibson, Cristina. "DiCaprio Continued Filming Despite Injury." *Entertainment* (17 December 2012). Online at www.sheknows.com/entertainment/articles/979921/leonardo-dicaprio-injured-on-set-kept-filming. Accessed 12 February 2014.

Gielgud, John. "Creating My Roles." In *Actors on Acting: The Theories, Techniques, and Practices of the World's Great Actors, Told in Their Own Words*, ed. Toby Cole and Helen Krich Chinoy. New York: Crown, 1970. 398–402.

Gilbey, Ryan. "Sandra Bullock, *Gravity*, and the 'Single Actor' Movie." *New Statesman* (7 November 2013). Online at /newstatesman.com/culture/2013/11/every-move-you-make. Accessed 19 January 2014.

Gish, Lillian. Letter to Alfred Hitchcock, re working with him, 28 March 1975. *Family Plot* production file 200, HER.

Godard, Jean-Luc. "'From Critic to Film-Maker': Godard in Interview." In *Cahiers du Cinéma 1960–1968: New Wave, New Cinema, Reevaluating Hollywood*, ed. Jum Hillier. Cambridge, Mass.: Harvard University Press, 1986. 59–67. An excerpt of material originally published in *Cahiers du cinema* 138 (December 1962).

———. "Montage, mon beau souci." In *Godard on Godard*, trans. Tom Milne. London: DaCapo, 1986. 39–41.

Goethe, Johann Wolfgang von. *Italian Journey 1786–1788*. Trans. W. H. Auden and Elizabeth Mayer. London: Penguin, 1970.

Goffman, Erving. *Forms of Talk*. Philadelphia: University of Pennsylvania Press, 1981.

———. *Frame Analysis: An Essay on the Organization of Experience*. Cambridge, Mass.: Harvard University Press, 1974.

———. *Gender Advertisements*. New York: Harper & Row, 1976.

————. *The Presentation of Self in Everyday Life.* Garden City, N.Y.: Doubleday Anchor, 1959.

————. *Relations in Public: Microstudies of the Public Order.* New York: Basic Books, 1971.

Gould, Elliott. Personal conversations, June 2013, January 2014, February 2014.

Gould, Stephen Jay. "The Dynasty of Dichotomy." In *The Hedgehog, the Fox, and the Magister's Pox.* New York: Three Rivers Press, 2003. 69–112.

Gross, Kenneth. *Puppet: An Essay on Uncanny Life.* Chicago: University of Chicago Press, 2012.

Gross, Terry. "Philip Seymour Hoffman on Acting: An 'Exhausting' and 'Satisfying' Art." Online at www.npr.org/2014/02/03/270954011. Accessed 16 February 2014.

————. "Phoenix to Self: 'Why Am I Talking about This? . . . Joaquin, Shut Up.'" Online at www.npr.org/2014/01/21/264524233. Accessed 16 February 2014.

Gunning, Tom. "Gollum and Golem: Special Effects and the Technology of Artificial Bodies." In *From Hobbits to Hollywood: Essays on Peter Jackson's Lord of the Rings,* ed. Ernest Mathijs and Murray Pomerance. Amsterdam: Rodopi, 2006. 319–49.

————. "Rounding Out the Moving Image: Camera Movement and Volumetric Space." Paper delivered at the Society for Cinema and Media Studies, Montreal, 26 March 2015.

Haines, Richard W. *Technicolor Movies: The History of Dye Transfer Printing.* Jefferson, N.C.: McFarland, 1993.

Hall, Barbara. *Oral History with Alexander Golitzen.* Beverly Hills, Calif.: Academy of Motion Picture Arts and Sciences, 1992.

Hall, Edward T. *The Hidden Dimension.* Garden City, N.Y.: Doubleday Anchor, 1990.

Hammond, Pete. "Sandra Bullock on the Challenges of 'Gravity.'" *Deadline Hollywood* (8 December 2013). Online at /deadline.com/2013/12/Sandra-bullock-gravity-george-clooney-alfonso-cuaron-oscars. Accessed 19 January 2014.

Hark, Ina Rae. "Crazy Like a Prof: Mad Science and the Transgressions of the Rational." In *BAD: Infamy, Darkness, Evil, and Slime,* ed. Murray Pomerance. Albany: State University of New York Press, 2002. 301–13.

Harris, Marvin. "Mother Cow." In *Cows, Pigs, Wars, and Witches: The Riddles of Culture.* New York: Vintage, 1989. 11–32.

Harrison, Rex. Letter to George Cukor, re *My Fair Lady,* 9 November 1962. *My Fair Lady* file 197, George Cukor Collection, HER.

————. *Rex: An Autobiography.* London: Macmillan, 1974.

Harvey, James. *Watching Them Be: Star Presence on the Screen from Garbo to Balthazar.* New York: Faber & Faber, 2014.

Hearn, Maxwell K., and Wen C. Fong. *Along the Riverbank: Chinese Paintings from the C. C. Wang Family Collection*. New York: Metropolitan Museum of Art, 1999.

Heffernan, Virginia. "Network Error." *New York Times Magazine* (12 December 2010), 30–32.

Hepburn, Audrey. Telegram to George Cukor, re *My Fair Lady*, 4 July 1962. *My Fair Lady* file 197, George Cukor Collection, HER.

Heston, Charlton. *In the Arena: An Autobiography*. New York: Simon and Schuster, 1995.

———. Letter to Hildegard Neil, 7 December 1971, re post-sync In *Antony and Cleopatra*. *Antony and Cleopatra* file 26, Charlton Heston Collection, HER.

Higashi, Sumiko. *Stars, Fans, and Consumption in the 1950s: Reading Photoplay*. New York: Palgrave Macmillan, 2014.

Higgins, Scott. *Harnessing the Technicolor Rainbow: Color Design in the 1930s*. Austin: University of Texas Press, 2007.

Higham, Charles. *Charles Laughton: An Intimate Biography*. Garden City, N.Y.: Doubleday, 1976.

———. *Kate: The Life of Katharine Hepburn*. New York: W. W. Norton, 1975.

Higham, Charles, and Roy Moseley. *Cary Grant: The Lonely Heart*. New York: Harcourt Brace Jovanovich, 1989.

Hiller, Arthur. Personal conversation, September 1971.

Hitchcock, Alfred. "Actors Aren't *Really* Cattle." 1 June 1945, Publicity materials file 1522, Alfred Hitchcock Collection, HER.

———. Inter-Office Communication to David O. Selznick, 19 July 1939, regarding "Girl for 'Rebecca.'" *Rebecca* production file 628, Alfred Hitchcock Collection, HER.

———. Telegram to Jessica Tandy, re wig for *The Birds*, 19 February 1962. *The Birds* file 34, Alfred Hitchcock Collection, HER.

Hofmannsthal, Hugo von. *Die Berührung der Sphären*. Berlin: S. Fischer Verlag, 1931.

Hofstadter, Richard J. *Anti-Intellectualism in American Life*. New York: Vintage, 1963.

Hotchner, A. E. *Doris Day: Her Own Story*. New York: Bantam Books, 1976.

Hunter, Evan. *Me and Hitch*. London: Faber & Faber, 1997.

Hunter, I. Q. "Liking *The Magus*." In *B Is for Bad Cinema: Aesthetics, Politics, and Cultural Value*, ed. Claire Perkins and Constantine Verevis. Albany: State University of New York Press, 2014. 197–214.

Hurley, Neil P. "The Many-Splendored Actor: An Interview with Jimmy Stewart." *New Orleans Review* 10:2–3 (Summer-Fall 1983), 5–14. Reprinted in *Playing to the Camera: Film Actors Discuss Their Craft*, ed. Bert Cardullo, Harry Geduld, Ronald Gottesman, and Leigh Woods. New Haven, Conn.: Yale University Press, 1998. 200–209.

"Interview with Sara Karloff, Daughter of the Late Horror Legend Boris Karloff." Online at sumonova.com/interview-with-sara-karloff-daughter-of-the-late-horror-legend-boris-karloff/. Accessed 18 October 2015.

Ironside, Michael. Personal interview. October 1986.

Jensen, Hal. "The Music of Absence." *Times Literary Supplement* 5814 (5 September 2014), 17.

"Jimmy Stewart at AFI Life Achievement Award: A Tribute to Alfred Hitchcock." 1979. Online at youtube.com/watch?v=Vhoh8Eg_PPw.

Kachka, Boris. "Jesse Eisenberg, Revised." *New York* (18–25 February 2013), 139–42.

Karp, Ivan. "Laughter at Marriage: Subversion in Performance." *Journal of Folklore Research* 25:1/2 (1988), 35–52.

Kaveney, Roz. "Review of *Naked Cinema* by Sally Potter." *Times Literary Supplement* 5814 (5 September 2014), 27.

Keniston, Kenneth. "Morals and Ethics." *American Scholar* 34:4 (Autumn 1965), 628–32.

Kermode, Mark. Personal conversation, 23 January 2014.

King, Barry. "Articulating Stardom." In *Star Texts: Image and Performance in Film and Television*, ed. Jeremy Butler. Detroit: Wayne State University Press, 1991. 125–54.

Klevan, Andrew. *Film Performance: From Achievement to Appreciation*. London: Wallflower, 2005.

Kracauer, Siegfried. *From Caligari to Hitler: A Psychological Study of the German Film.* 1947. Reprint. New York: Noonday Press, 1959.

———. *Theory of Film: The Redemption of Physical Reality.* Princeton, N.J.: Princeton University Press, 1997.

Krämer, Peter, and Alan Lovell. *Screen Acting.* London: Routledge, 1999.

Krohn, Bill. *Hitchcock at Work.* London: Phaidon, 2003.

Lacan, Jacques. "The Subversion of the Subject and the Dialectic of Desire in the Freudian Unconscious." In *Hegel and Contemporary Continental Philosophy*, ed. Dennis King Keenan. Albany: State University of New York Press, 2004. 205–36.

Laffel, Jeff. "Joseph L. Mankiewicz." In *Joseph L. Mankiewicz Interviews*, ed. Brian Dauth. Jackson: University Press of Mississippi, 2008. 189–204.

Lane, Anthony. "The Master: Remembering Philip Seymour Hoffman." *New Yorker* (17 and 24 February 2014), 166–69.

Lazar, Irving. Telegram to George Cukor, 2 July 1962, re Audrey Hepburn. *My Fair Lady* file 197, George Cukor Collection, HER.

Lehman, Ernest. "Introduction." In *Alfred Hitchcock's North by Northwest*. London: Faber and Faber, 1999. vii–xi.

Lem, Stanislaw. *Summa Technologiae*. Trans. Joanna Zylinska. 1964. Reprint. Minneapolis: University of Minnesota Press, 2013.

Leroi-Gourhan, André. *Gesture and Speech*. Trans. Anna Bostock Berger. Cambridge, Mass.: MIT Press, 1993.

Lewis, Robert. *Advice to the Players*. New York: Theatre Communications Group, 1980.

Lindsay, Vachel. "Photoplay Progress." *New Republic* (17 February 1917), 76–77.

Lubitsch, Ernst. "Film Directing." In *The World Film Encyclopedia: A Universal Screen Guide*, ed. Clarence Winchester. New York: Gordon Press, 1933. 442–44.

Lugowski, David M. "Norma Shearer and Joan Crawford: Rivals at the Glamour Factory." In *Glamour in a Golden Age: Movie Stars of the 1930s*, ed. Adrienne L. McLean. New Brunswick, N.J.: Rutgers University Press, 2011. 129–52.

Lumet, Sidney. *Making Movies*. New York: Alfred A. Knopf, 1995.

Mahmoud, Marwa, and Peter Robinson. "Interpreting Hand-over-Face Gestures." Doctoral Consortium in International Conference on Affective Computing and Intelligent Interaction, Memphis, Tenn., October 2011.

Mann, William J. *Kate: The Woman Who Was Hepburn*. New York: Picador, 2006.

Mannoni, Laurent. *The Great Art of Light and Shadow: Archaeology of the Cinema*. Exeter: University of Exeter Press, 2000.

March, Fredric. Letter to George Cukor, 6 December 1939. *Susan and God* file 239, George Cukor Collection, HER.

Martin, Nina K. "'Does This Film Make Me Look Fat?' Celebrity, Gender, and *I'm Still Here*." In *Star Bodies and the Erotics of Suffering*, ed. Rebecca Bell-Metereau and Colleen Glenn. Detroit: Wayne State University Press, 2015. 29–54.

May, Lary. *The Big Tomorrow: Hollywood and the Politics of the American Way*. Chicago: University of Chicago Press, 2000.

Mazursky, Paul. *Show Me the Magic*. New York: Simon and Schuster, 1999.

McBride, Joseph. Interview with Charlton Heston." In *Filmmakers and Filmmaking II*. Los Angeles: J. P. Tarcher, 1983. 83–99.

McCarthy, Todd. *Howard Hawks: The Grey Fox of Hollywood*. New York: Grove Press, 1997.

McGilligan, Patrick. *Alfred Hitchcock: A Life in Darkness and Light*. New York: Regan, 2003.

———. *George Cukor: A Double Life*. New York: St. Martin's Press, 1991.

McKenna, Kenneth. "Linda Darnell." In *The Lonely Beauties*, ed. Norman Hill. New York: Popular Library, 1971. 157–82.

McLean, Adrienne L. "Introduction: Stardom in the 1930s." In *Glamour in a Golden Age: Movie Stars of the 1930s*, ed. Adrienne L. McLean. New Brunswick, N.J.: Rutgers University Press, 2011. 1–17.

McLuhan, Marshall. *Understanding Media: The Extensions of Man*. New York: McGraw-Hill, 1964.

Mead, George Herbert. *Mind, Self, and Society: From the Standpoint of a Social Behaviorist.* Chicago: University of Chicago Press, 1934.

Meisner, Sanford (with Dennis Longwell). *Sanford Meisner on Acting.* New York: Vintage, 1987.

Miller, Jonathan. *The Body in Question.* London: Jonathan Cape, 1978.

Mills, C. Wright. *The Power Elite.* New York: Oxford University Press, 1963.

Milner, David, and Guy Tucker. "Haruo Nakajima Interview." Trans. Yoshihiko Shibata. Online at davmil.org/www.kaijuconversations.com/nakajima.htm. Accessed 21 January 2014.

Mitry, Jean. *The Aesthetics and Psychology of the Cinema.* Trans. Christopher King. Bloomington: Indiana University Press, 2000.

Moore, Dickie. Statement to SAG-AFTRA, re early working conditions. Online at www.sagaftra.org/early-members-1937. Accessed 26 April 2014.

Mosher, Jerry. "Morphing Sean Astin: 'Playing Fat' in the Age of Digital Animation." In *From Hobbits to Hollywood: Essays on Peter Jackson's Lord of the Rings,* ed. Ernest Mathijs and Murray Pomerance. Amsterdam: Rodopi, 2006. 301–18.

Mourlet, Michel. "Sur un art ignoré." *Cahiers du cinéma* 98 (August 1959), 23–37.

Nabokov, Vladimir. *Speak, Memory: An Autobiography Revisited.* New York: Vintage, 1989.

Narboni, Jean, Sylvie Pierre, and Jacques Rivette. "Montage." Trans. Tom Milne. In *Cahiers du Cinéma: 1969–1972: The Politics of Representation,* ed. Nick Browne. London: BFI, 1990. 21–44. Originally published as "Montage," *Cahiers du cinéma* 210 (March 1969).

Naremore, James. *Acting in the Cinema.* Berkeley: University of California Press, 1988.

Naylor, David. *American Picture Palaces: The Architecture of Fantasy.* New York: Van Nostrand Reinhold, 1981.

Nesbitt, Cathleen. Letter to Alfred Hitchcock, re working with him, 3 April 1976. *Family Plot* production file 200, HER.

Nugent, Frank S. Review of *Rebecca. New York Times* (29 March 1940). Online at /freerepublic.com/focus/chat/2482147/posts. Accessed 28 June 2013.

Ohmer, Susan. "Jean Harlow: Tragic Blonde." In *Glamour in a Golden Age: Movie Stars of the 1930s,* ed. Adrienne L. McLean. New Brunswick, N.J.: Rutgers University Press, 2011. 174–95.

Olivier, Laurence. "The Art of Persuasion." In *Actors on Acting: The Theories, Techniques, and Practices of the World's Great Actors, Told in Their Own Words,* ed. Toby Cole and Helen Krich Chinoy. New York: Crown, 1970. 410–17. First published as an interview with Kenneth Tynan in *Tulane Drama Review* 11:3 (Winter 1966).

Ortega y Gasset, José. "On Point of View in the Arts." Trans. Paul Snodgress and Joseph Frank. In *The Dehumanization of Art and Other Essays on Art, Culture,*

and Literature. 1948. Reprint. Princeton, N.J.: Princeton University Press, 1972. 107–30.

Oudart, Jean-Pierre. "Cinema and Suture." Trans. Kari Hanet. In *Cahiers du Cinéma: 1969–1972: The Politics of Representation,* ed. Nick Browne. London: BFI, 1990. 45–57. Originally published as "La Suture." *Cahiers du cinéma* 211/212 (April and May 1969).

"Parkinson's Interview—Sir Alec Guinness." 1977. Online at www.youtube.com /watch?v=he11MAVjisw. Accessed 3 November 2015.

Pease, Allan, and Barbara Pease. *The Definitive Book of Body Language.* New York: Bantam, 2006.

Perkins, Victor F. Personal conversation, 22 February 2013.

Pike, E. Royston. *Human Documents of the Victorian Gilded Age.* London: Allen & Unwin, 1974.

Pinteau, Pascal. *Special Effects: An Oral History.* Trans. Laurel Hirsch. New York: Harry N. Abrams, 2005.

Pirandello, Luigi. *Shoot! The Notebooks of Serafino Gubbio, Cinematograph Operator.* Trans. C. K. Scott Moncrieff. 1926. Reprint. Chicago: University of Chicago Press, 2005.

Poe, Edgar Allan. "The Man of the Crowd." In *Selected Tales,* ed. David Van Leer. New York: Oxford University Press, 1998. 84–91.

Pomerance, Bernard. *The Elephant Man.* New York: Grove Press, 1979.

Pomerance, Murray. "Assheton Gorton: A Life in Film." *Film International* 13:1 (Summer 2015), 56–104.

———. "The Errant Boy: Morty S. Tashman and the Powers of the Tongue." In *Enfant Terrible! Jerry Lewis in American Film.* New York: New York University Press, 2002. 239–55.

———. *The Eyes Have It: Cinema and the Reality Effect.* New Brunswick, N.J.: Rutgers University Press, 2013.

———. "James Dean and James Stewart: The Darkness Within." In *Larger Than Life: Movie Stars of the 1950s,* ed. R. Barton Palmer. New Brunswick, N.J.: Rutgers University Press, 2010. 61–85.

———. *Johnny Depp Starts Here.* New Brunswick, N.J.: Rutgers University Press, 2005.

———. *Marnie.* London: BFI/Palgrave, 2014.

———. "A Modern Gesture." *Film International* 5:5, Issue 29 (Fall 2007), 42–53.

———. "Notes on Some Limits of Technicolor: The Antonioni Case." *Senses of Cinema* 53 (Winter 2010). Online at www.sensesofcinema.com.

———. *A Random Soup.* Toronto: Gabbro Press, 1992.

———. "A Sensational Face." *La Furia Umana* (April 2012). Online at www.lafuria umana.it/index.php/2-uncategorised/46-murray-pomerance-a-sensational -face. Accessed 20 April 2014.

————. "Some Hitchcockian Shots." In *A Companion to Alfred Hitchcock*, ed. Thomas Leitch and Leland Poague. Malden, Mass.: Wiley-Blackwell, 2011. 237–52.

————. "Stark Performance." In *Rebel Without a Cause: Approaches to a Maverick Masterwork*, ed. J. David Slocum. Albany: State University of New York Press, 2005. 35–52.

————. "Two Bits for Hitch: Small Performance and Gross Structure in *The Man Who Knew Too Much* (1956)." *Hitchcock Annual 2000–2001*. 127–45.

Pop, Iggy. "Johnny Depp." *Interview* (April 2014), 69–81, 142.

Prince, Stephen. *Digital Visual Effects in Cinema: The Seduction of Reality*. New Brunswick, N.J.: Rutgers University Press, 2012.

Proust, Marcel. *Swann's Way*. Trans. C. K. Scott Moncrieff. New York: Random House, 1934.

Purse, Lisa. "A Playful Materiality: Watching the Digital Body in Digital Space." Paper delivered at "The Magic of Special Effects" conference, Montreal, 7 November 2013.

Quintilian (Marcus Fabius Quintilianus). "Action and Delivery." In *Actors on Acting: The Theories, Techniques, and Practices of the World's Great Actors, Told in Their Own Words*, ed. Toby Cole and Helen Krich Chinoy. New York: Crown, 1970. 26–30.

Ramírez, Juan Antonio. *Architecture for the Screen: A Critical Study of Set Design in Hollywood's Golden Age*. Jefferson, N.C.: McFarland, 2004.

Raubicheck, Walter, ed. "Working with Hitchcock: A Collaborators' Forum with Patricia Hitchcock, Janet Leigh, Teresa Wright, and Eva Marie Saint." *Hitchcock Annual* (2002–03), 32–66.

Ray, Nicholas. *I Was Interrupted: Nicholas Ray on Making Movies*. Ed. Susan Ray. Berkeley: University of California Press, 1993.

Rebello, Stephen. Interview with Kim Novak. *The MacGuffin*. 2003. Online at www.labyrinth.net.au/~muffin/kim_novak_c.html.

Riccoboni, Luigi. "Advice to Actors." In *Actors on Acting: The Theories, Techniques, and Practices of the World's Great Actors, Told in Their Own Words*, ed. Toby Cole and Helen Krich Chinoy. New York: Crown, 1970. 59–63.

Rickitt, Richard. *Special Effects: The History and Technique*. New York: Billboard, 2007.

Riffel, Mélanie, and Sophie Rouart. *Toile de Jouy: Printed Textiles in the Classic French Style*. Trans. Barbara Mellor. London: Thames & Hudson, 2003.

Roberto, John Rocco. "An Interview with Godzilla: Hauro [*sic*] Nakajima." Trans. Shigeko Kojima. Online at /historyvortex.org/NakajimaInterview.html. Accessed 21 January 2014.

Roberts, Randy W. *John Wayne: American*. New York: Free Press, 1995.

Rogers, Ginger. "Ginger Rogers." Online at www.sagaftra.org/ginger-rogers. Accessed 18 October 2015.

Rothman, William. *Hitchcock—The Murderous Gaze*. 2nd ed. Albany: State University of New York Press, 2012.

Sacks, Oliver. "The Lost Mariner." In *The Man Who Mistook His Wife for a Hat*. London: Duckworth, 1985. 22–41.

———. *Musicophilia: Tales of Music and the Brain*. Rev. and expanded ed. New York: Vintage, 2008.

———. *Seeing Voices: A Journey into the World of the Deaf*. London: Stoddart, 1989.

———. "Witty Ticcy Ray." In *The Man Who Mistook His Wife for a Hat*. London: Duckworth, 1985. 86–96.

Salt, Barry. *Film Style and Technology: History and Analysis*. 2nd expanded ed. Los Angeles: Starword, 1992.

Santopietro, Tom. *Considering Doris Day*. New York: St. Martin's Press, 2007.

Schatz, Thomas. *Hollywood Genres: Formulas, Filmmaking, and the Studio System*. New York: Random House, 1981.

Schivelbusch, Wolfgang. *Disenchanted Night: The Industrialization of Light in the Nineteenth Century*. Trans. Angela Davies. Berkeley: University of California Press, 1995.

Schutz, Alfred. *The Phenomenology of the Social World*. Trans. George Walsh and Frederick Lehnert. 1932. Reprint. Evanston, Ill.: Northwestern University Press, 1967.

Serkis, Andy. *Gollum: How We Made Movie Magic*. Boston: Houghton Mifflin, 2003.

Shawn, Wallace, and André Gregory. *My Dinner with André: A Screenplay for the Film by Louis Malle*. New York: Grove Press, 1981.

Smilgis, Martha. "Philip Anglim Had to Go through Contortions to Import and Star in 'The Elephant Man.'" *People* (10 December 1979). Online at www .people.com/people/article/0,,20075279,00.html. Accessed 8 February 2014.

Sobchack, Vivian. "Being on the Screen: A Phenomenology of Cinematic Flesh, or the Actor's Four Bodies." In *Acting and Performance in Moving Image Culture: Bodies, Screens, Renderings*, ed. Jörg Sternagel, Deborah Levitt, and Dieter Mersch. Bielefeld: Transcript Verlag, 2012. 365–81.

Solomon, Matthew, ed. *Fantastic Voyages of the Cinematic Imagination: George Méliès' Trip to the Moon*. Albany: State University of New York Press, 2011.

———. "Laughing Silently." In *The Last Laugh: Strange Humors of Cinema*, ed. Murray Pomerance. Detroit: Wayne State University Press, 2013. 15–29.

Spoto, Donald. *The Dark Side of Genius: The Life of Alfred Hitchcock*. Boston: Little, Brown, 1983.

Sragow, Michael. *Victor Fleming: An American Movie Master*. New York: Random House, 2008.

Staiger, Janet. "The Central Producer System: Centralized Management after 1914." In *The Classical Hollywood Cinema: Film Style and Mode of Production to 1960*, by David Bordwell, Janet Staiger, and Kristin Thompson. New York: Columbia University Press, 1985. 128–41.

———. "The Division and Order of Production." In *The Classical Hollywood Cinema: Film Style and Mode of Production to 1960*, by David Bordwell, Janet Staiger, and Kristin Thompson. New York: Columbia University Press, 1985. 142–53.

Stern, Lesley. "Acting Out of Character: *The King of Comedy* as a Histrionic Text." In *Falling for You: Essays on Cinema and Performance*, ed. Lesley Stern and George Kouvaros. Sydney: Power Publications, 1999. 277–305.

———. "'Always Too Small or Too Tall': Rescaling Screen Performance." In *Acting and Performance in Moving Image Culture: Bodies, Screens, Renderings*, ed. Jörg Sternagel, Deborah Levitt, and Dieter Mersch. Bielefeld: Transcript Verlag, 2012. 11–48.

Steven, Alasdair. "Obituary: Peter O'Toole, Actor." *The Scotsman*. Online at www.scotsman.com/news/obituaries/obituary-peter-o-toole-actor-1-3234480. Accessed 12 February 2014.

Stevens, George Jr., ed. *Conversations with the Great Moviemakers of Hollywood's Golden Age*. New York: Alfred A. Knopf, 2006.

Tandy, Jessica. Telegram to Alfred Hitchcock, re arrival in San Francisco. *The Birds* file 34, Alfred Hitchcock Collection, HER.

Tartaglione, Nancy. "Sandra Bullock Calls 'Gravity' the 'Most Challenging' Thing She's Ever Done." *Deadline London* (28 August 2013). Online at /deadline.com/2013/08/vince-sandra-bullock-calls-gravity-the-most-challenging-thing-shes-ever-done/. Accessed 19 January 2014.

Thinnes, Roy. Letter to Alfred Hitchcock, 25 May 1975, re shaving. *Family Plot* file 190, Alfred Hitchcock Collection, HER.

Thomson, David. *Movie Man*. New York: Stein & Day, 1967.

———. *Why Acting Matters*. New Haven, Conn.: Yale University Press, 2015.

Tolstoy, Leo. *Anna Karenin*. Trans. Rosemary Edmonds. 1954. Reprint. Harmondsworth, Middlesex: Penguin, 1973. Originally published 1873–77.

Toumanova, Tamara. Wire to Alfred Hitchcock, 16 December 1965. *Torn Curtain* file 890, HER.

Truffaut, François. *Hitchcock*. New York: Simon and Schuster, 1985.

———. Unpublished full interview tapes with Alfred Hitchcock. Online at /letsmakebetterfilms.hopeforfilm.com/2011/02/the-complete-hitchcocktruffaut-audio-interviews.html. Accessed 30 June 2013.

Tuan, Yi-Fu. *Space and Place*. Minneapolis: University of Minnesota Press, 1977.

Vonnegut, Kurt Jr. *The Sirens of Titan*. 1959. Reprint. New York: Dial Press, 2009.

Wilder, Billy. Telegram to Arthur Miller, re Marilyn Monroe. *Some Like It Hot* file 78, Billy Wilder collection, HER.

Williams, Evan. Personal conversation, 31 January 2014.

Williams, Linda. *Porn Studies.* Durham, N.C.: Duke University Press, 2004.

———. "Something Else besides a Mother: 'Stella Dallas' and the Maternal Melodrama." *Cinema Journal* 24:1 (Autumn 1984), 2–27.

Williams, Linda Ruth. "The Tears of Henry Thomas." *Screen* 53:4 (Winter 2012), 459–70.

Williamson, Colin. *Hidden in Plain Sight: An Archaeology of Magic and the Cinema.* New Brunswick, N.J.: Rutgers University Press, 2015.

Wilson, Frank R. *The Hand: How Its Use Shapes the Brain, Language, and Human Culture.* New York: Pantheon, 1998.

Wilson, George M. *Narration in Light: Studies in Cinematic Point of View.* Baltimore: Johns Hopkins University Press, 1986.

Winecoff, Charles. *Split Image: The Life of Anthony Perkins.* New York: Advocate Books, 2006.

Wolfe, Tom. "The Shockkkkkk of Recognition." In *The Pump House Gang.* New York: Farrar, Straus & Giroux, 1968. 277–91.

Wood, Gaby. *Edison's Eve: A Magical History of the Quest for Mechanical Life.* New York: Anchor Books, 2002.

Worringer, Wilhelm. *Abstraction and Empathy: A Contribution to the Psychology of Style.* Trans. Michael Bullock. 1953. Reprint. New York: International Universities Press, 1980. Originally published as *Abstraktion und Einfühlung*, 1908.

Yaniz, Robert Jr. "Andy Serkis Talks 'Rise of the Planet of the Apes' Sequel, 'Animal Farm.'" Online at /screenrant.com/andy-serkis-rise-planet-apes-animal-farm. Accessed 21 January 2014.

Yeats, William Butler. "The Sovereignty of Words." In *Actors on Acting: The Theories, Techniques, and Practices of the World's Great Actors, Told in Their Own Words,* ed. Toby Cole and Helen Krich Chinoy. New York: Crown, 1970. 386–87.

Young, C. "Winona Ryder Busted for Shoplifting." *People* (14 December 2001). Online at www.people.com/people/article/0,,623102,00.html. Accessed 18 October 2015.

Youngkin, Stephen D. *The Lost One: A Life of Peter Lorre.* Lexington: University Press of Kentucky, 2005.

Yumibe, Joshua. *Moving Color: Early Film, Mass Culture, Modernism.* New Brunswick, N.J.: Rutgers University Press, 2012.

Index

Pages in italic denote images.

About the Author

Murray Pomerance is professor in the Department of Sociology at Ryerson University and the author, most recently, of *Marnie, Alfred Hitchcock's America, The Eyes Have It: Cinema and the Reality Effect*, and *The Horse Who Drank the Sky: Film Experience Beyond Narrative and Theory*, as well as the novels *The Economist* and *Tomorrow*. Editor or coeditor of numerous volumes, including *Thinking in the Dark: Cinema, Theory, Practice and Cinema and Modernity*, he also edits two book series, Techniques of the Moving Image at Rutgers University Press and Horizons of Cinema at SUNY Press.

CPSIA information can be obtained at www.ICGtesting.com
Printed in the USA
BVOW11s0004040316

439003BV00003B/11/P

9 780813 564951